OLD IRELAND IN COLOUR 2

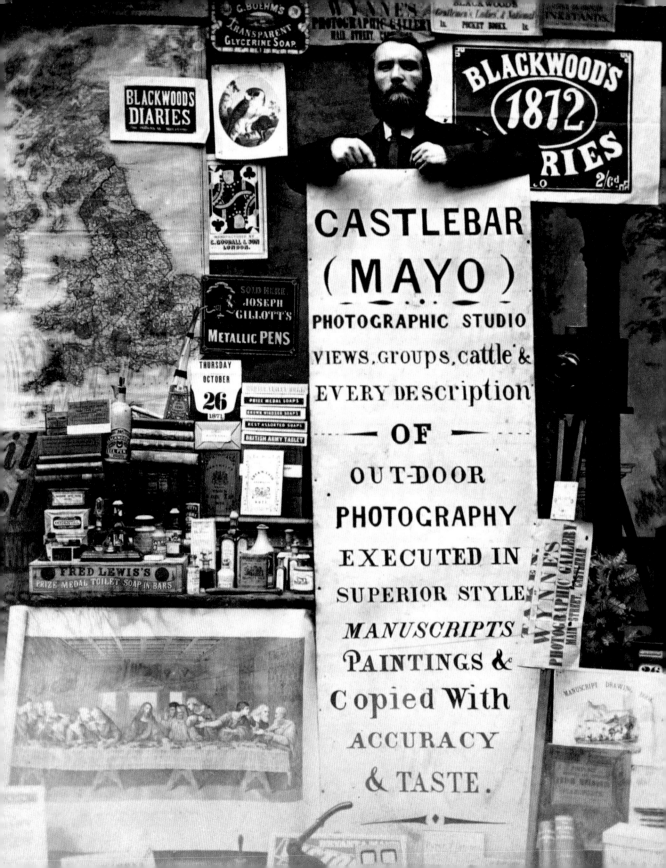

OLD IRELAND IN COLOUR 2

John Breslin & Sarah-Anne Buckley

MERRION
PRESS

First published in 2021 by
Merrion Press
10 George's Street
Newbridge
Co. Kildare
Ireland
www.merrionpress.ie

9781785374111 (Cloth)

9781785374135 (Epub)

A CIP catalogue record for this book is available from the British Library.

Typeset in Adobe Caslon Pro, Garamond and Avenir.

Cover design and typeset by: RIVERDESIGNBOOKS.COM

Front cover image: **SUBLICHS**; May 1954, Loughrea, Co. Galway; Members of the Sheridan and O'Brien families from the Irish Travelling community. Sublich is the Cant (a language spoken by the Travelling community) term for boys; Photographer: Elinor Wiltshire; Source: National Library of Ireland Ref.: WIL 13[54].

Back cover image: **BALLYVAUGHAN**; c.1880–1900, Co. Clare; A late-nineteenth-century scene of Ballyvaughan in the north-west of Clare; Photographer: Robert French; Source: National Library of Ireland; Ref.: L_ROY_04085.

Opening credits:

MR WYNNE; 26 October 1871, Castlebar, Co. Mayo; Thomas Wynne (1838–1893) set up his photographic studio in 1867. Mike Hannon, Thomas's great-great-grandson, told us how Thomas's daughter, Mary, set up her own studio in Loughrea in the 1890s. After 144 years in business, Wynne's of Castlebar closed in 2011. Photographer: Thomas Wynne; Source: National Library of Ireland; Ref.: WYN1.

EUCHARISTIC CONGRESS; 28 June 1932, Waterford; The Quinn family pictured outside their home, which was elaborately decorated for the 1932 Eucharistic Congress. While the main events were held in Dublin, there were expressions of piety across the country; Photographer: Poole Studio; Source: National Library of Ireland Ref.: POOLEWP 3922.

KILKENNY HURLER; c.1923, Kilkenny; A member of the winning 1922 All-Ireland Kilkenny team; Photographer: WD Hogan; Source: National Library of Ireland Ref.: HOG 94.

ALL CREATURES GREAT AND SMALL; 1946, Lough Gowna, Co. Galway; Photographer: Fáilte Ireland; Source: Dublin City Library and Archive Ref.: vital: 17400.

'THE IRISH WOMEN DEMAND THE VOTE'; c.1907–1914; A girl holding a basket containing a *Votes for Women* newspaper and placard. It was taken in a photographic studio and is part of a campaign of pro-suffrage publicity; Photographer: Unknown; Source: London School of Economics Ref.: TWL.2002.588.

CATHERINE 'KITTY' KIERNAN (1893–1945); 1922, Granard, Co. Longford; A portrait of Kitty Kiernan, who was engaged to Michael Collins when he was shot dead in August 1922; Photographer: Unknown; Source: Wikimedia Commons.

Merrion Press is a member of Publishing Ireland

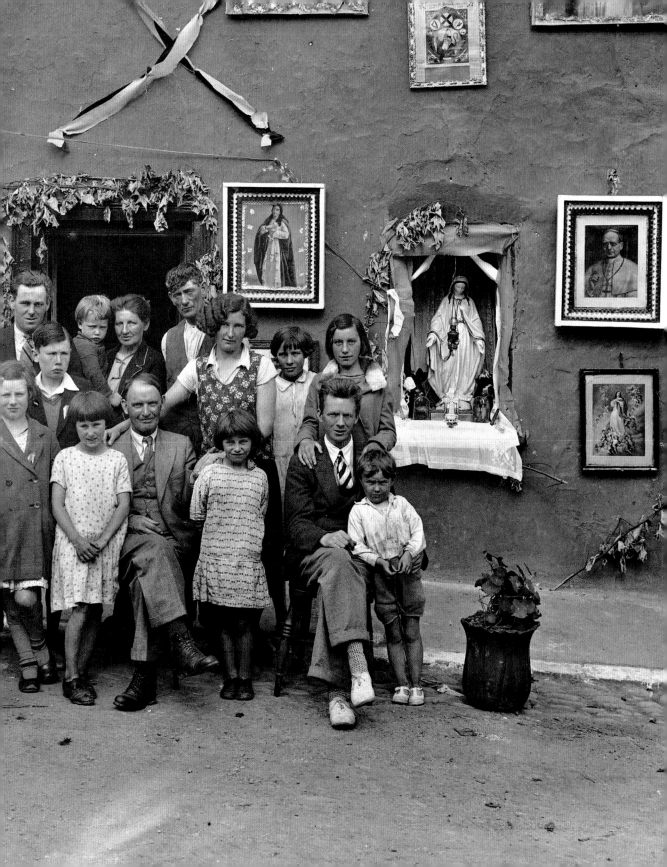

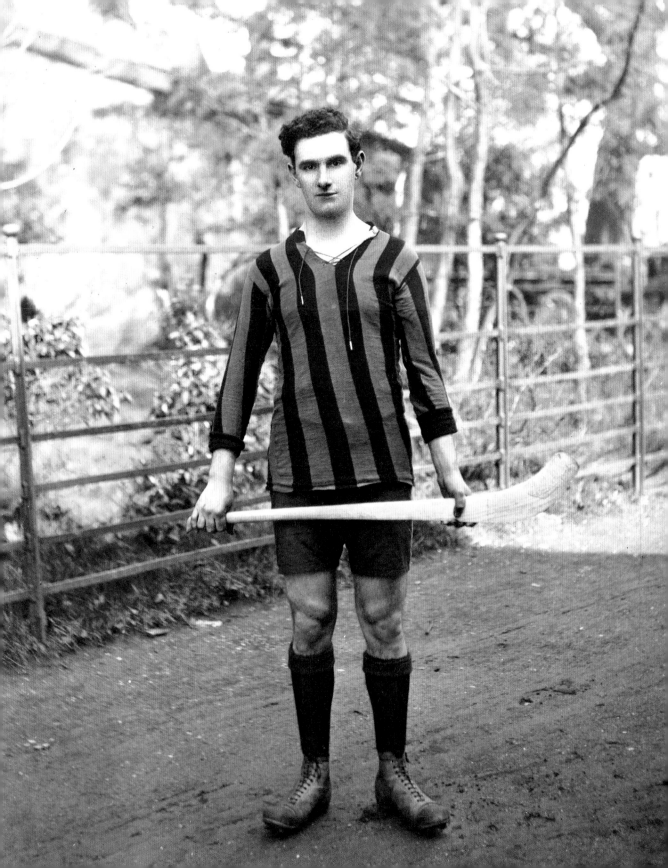

POLITICS AND REVOLUTION

CHILDHOOD AND YOUTH

WORKING LIFE

SPORT AND LEISURE

THE IRISH AND THE WORLD

SCENIC IRELAND

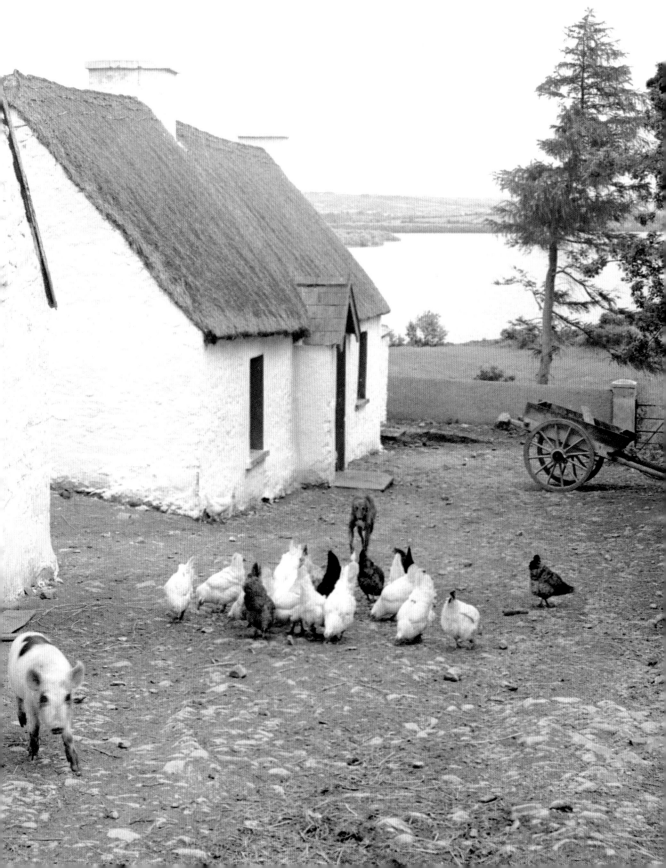

ACKNOWLEDGEMENTS

We could never have imagined how phenomenal the response to the first volume of *Old Ireland in Colour* would be, but the generosity and enthusiasm for the book has been extraordinary. We would like to start by thanking everyone for their support; for contacting us and telling us about your experiences, your families' experiences, and your love for the project.

Everyone at Merrion Press has encouraged this book, and us, from the very beginning. To Conor, Pa, Maeve and Wendy, our publicist Peter, and designer Latte, a huge thank you for your work. Critically, this book could not exist without the work and generosity of those in our libraries, archives and museums. A sincere thanks yet again to Jason Antic and Dana Kelley of DeOldify, without whom this project would not exist, and to ColorizeImages.com.

Thank you to John Borgonovo, Ann Mhaidhcí, Kevin O'Hanlon, Kieran Campbell, Cillian Joy, David Hoare, Joanne Kenney, Lydia Syson, Sadhbh Byrne, Nicola Brennan, Kathryn Donohue, Ciara Breathnach, John Cunningham, Conall Ó Fátharta, Robert Gardiner, Brian John Spencer, Elaine Farrell and Eliza McKee. Thanks also to Derek Nagle of Bo Media for creating our wonderful promotional videos, and to Darren Sheehan (Dashka), who composed the amazing accompanying *Old Ireland in Colour* theme music.

Finally, we want to thank our families, new and old, for their support. We hope we made you proud.

ABOUT THE AUTHORS

John Breslin is a Personal Professor in Electronic Engineering at the National University of Ireland Galway, where he is director of the TechInnovate entrepreneurship programmes. He is co-PI of the Insight and Confirm SFI Research Centres. He is a co-founder of boards.ie, adverts.ie, and the PorterShed. From the Burren, he lives in Connemara.

Dr Sarah-Anne Buckley is a Lecturer in History at the National University of Ireland Galway. Chair of the Irish History Students' Association, co-PI of the Tuam Oral History Project and Senior Research Fellow in the UNESCO Child and Family Research Centre, she has authored/edited eight books and over fifty other publications.

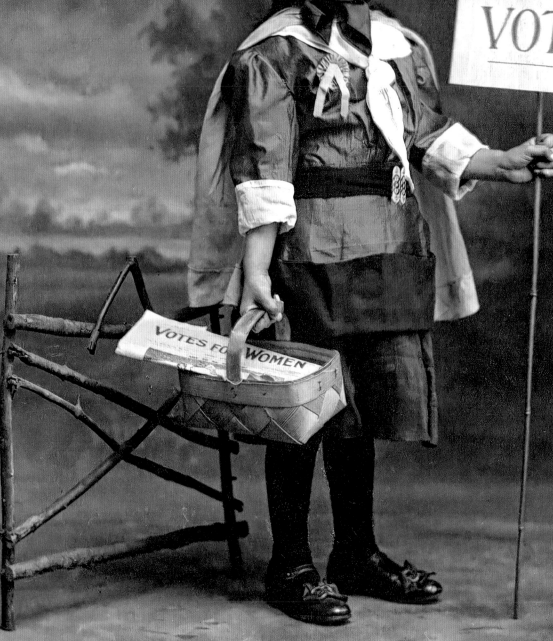

INTRODUCTION

In January 2021, we began considering a follow-up to the first volume, initially with some reticence. The response to the first book had been so overwhelmingly positive, how could we add to it? Yet we knew there were so many moments, places and personalities that had to be excluded from the first book. We wanted to include more sport, leisure and work, more images of 'ordinary' life. School and childhood had emerged as being of particular interest to people, as had the diverse landscapes, streetscapes and domestic spaces Irish people occupied during the nineteenth and twentieth centuries. Our aim remained the same – to bring Ireland's modern history to life through the colourisation of black and white photographs. As a result of connections and communications from readers, we knew that *Old Ireland in Colour* had impacted unexpected groups. It has helped open conversations, many intergenerational, between families. It has been used in reminiscence therapy. It has allowed us all to be reflective and nostalgic during an extraordinary year.

After deciding to create another volume, the question became: what format? We chose a thematic and broadly chronological structure again – starting the volume with an image of Miles Byrne, one of the participants of the 1798 Rebellion. Images of the broad theme Politics and Revolution lead into sections on Childhood and Youth, Working Life, Sport and Leisure, the Irish and the World, and, finally, Scenic Ireland. While the emphasis on Ireland's photographic collections is dominant, we also included new 'unseen' images from John's recently created 'Breslin Archive'. All thirty-two counties are represented, and gender, social class, ethnicity, age, geography and religion are key to the narrative created. The photographs span from one of the earliest Irish photographs, taken in 1843 of St George's Church, Hardwicke Place, to an iconic image of Samuel Beckett taken in 1964. This collection of images, as with the first, does not claim to be a history of photography or a comprehensive history of modern Ireland. It is, however, a snapshot of Ireland's political, social, economic and cultural life with many known and unknown faces. Personalities like Cardinal Paul Cullen, Lady Mary Heath, Jim Larkin, Christy Ring and Muriel Murphy MacSwiney all feature. Iconic moments are included – the funeral of Jeremiah O'Donovan Rossa, the occasion of the Second Dáil, the Irish Republic declared and the first time the Sam Maguire Cup crossed over the border. It is the story of how we worked, laughed, and played, how we loved, how we lived. Change and transformation, be it technology, religion, politics, labour or work, remain key tenets, and with each image we can view our past and those who lived in the past with empathy and humanity.

The 156 images in this book address a key period from the Great Famine to the mid-1960s. They reflect changes in housing, dress, the increasing influence of sport and leisure, the importance of religion, the growth in schooling and changes in gender roles. Politics and Revolution covers a broad period from the 1798 Rebellion to the day the Republic of Ireland came into existence in 1949, and shows the influence of nationalism, unionism, feminism, and socialism, and changes to our political system. The rare or 'unseen' images are poignant and give us a glimpse of life across the class spectrum. The influence of the Irish around the world remains prominent, as do the changes we can see in Ireland's towns and cities. Death and destruction are a feature – Terence MacSwiney,

the burning of the Four Courts, the impact of the Great Famine, the Niemba Ambush. Deviance is often intertwined – the Phoenix Park murders, the Cairo Gang, images of infamous Irish Fenians.

We see glimpses of families – a grandmother and her grandchildren from Inis Meáin, family businesses that lasted generations and a family portrait. Poverty is also very prominent – be it the images from the Congested Districts Board or of Ireland's institutional history. But it is often the photographic depictions of key moments that evoke the most empathy or interest – Bloody Sunday 1920, the crew of the *John Stevens*, the Big Snow of 1947, the construction of the Fastnet Lighthouse or the aftermath of the Harcourt Street train crash. Through these moments, and through these colourised images, we can see more vividly the impact of these events. In the captions, we have tried to give a clear overview, but also to spark an interest that may lead the reader down many rabbit holes of research! We have relied upon excellent open and available sources like the *Dictionary of Irish Biography*, and other key references are contained near the end of the book.

As with the first volume, we have used records of eye and hair colour where available, and often, as in the case of the 'Invincibles', these can be found in written records. James FitzHarris is noted in various prison records as having grey eyes and light-brown hair, while prisoner James Carey (with his birthplace listed as James Street) is recorded as having hazel eyes and brown hair. Charles Gavan Duffy describes John Mitchel as having 'pensive blue eyes and masses of soft brown hair'. O'Donovan Rossa's 'clear blue eyes' are described by his descendants. Muriel Murphy MacSwiney is listed in Ellis Island travel records as having light-brown hair and blue-grey eyes, and we used paintings of others to help with eye and hair colour – in particular, Thomas Francis Meagher, Lord Cavendish and Lord Kelvin.

The History of Dress and Material Culture

The history of dress and material culture are critical to this volume. The history of dress has received more attention in recent years, but Mairead Dunlevy's *Dress in Ireland* remains the key text. Dunlevy demonstrates how, for the poor, clothing was hardwearing and practical, with regional variations. In regard to changes in fashion, Connemara and West Cork were very slow to change, maintaining many trends for decades longer than other areas. Throughout the nineteenth and early twentieth centuries, evidence points to more colourful clothes for men and women from the Aran Islands and Galway, while in Donegal we see the version of the Scottish navvy dress well into the late nineteenth century. Striped red or blue petticoats were often worn under skirts or gowns, and 'madder' red was popular, as was indigo, shades of blue, green, brown and grey. Children dressed very similarly to their parents. Breeching was very important for boys and there were regional variations in the colours of the breeches. We have taken all of this into account when choices needed to be made with regard to colourising clothing and consulted every available source in interrogating each image to give it as authentic a representation as possible.

The Colourisation Debate

In 2004, philosopher Julie C. Van Camp wrote an article for *Contemporary Aesthetics* entitled 'Colorization Revisited'. It built on earlier work looking from a philosophical and moral perspective at the process of colourisation. She concluded by stating: 'Perhaps the most important lesson learned from the colorization debate in its heyday is that looking for absolute principles of right and wrong do not help much in the long term.' Van Camp argued that the acceptability of modifications should be assessed in terms of 'the continuing dialogue within a particular artform for how best to promote its potential and the usefulness of the work as evidence of the artistic skill of the artist'. The debate on colourisation has ebbed and flowed since the 1980s. As authors, we have previously acknowledged the views of scholars who disagree with the technology and process, but we believe the benefits and impact of these images outweigh these concerns. We see this book and the *Old Ireland in Colour Project* as part of the democratisation of history, a tool to develop empathy and a connection with the past while the original photograph remains intact. We hope and believe that it will encourage people of all ages to dig deeper, to explore and to engage, and while we respect the healthy debate that has occurred, it must also be acknowledged that there are different interpretations, views and theories on the subject.

John Breslin & Sarah-Anne Buckley

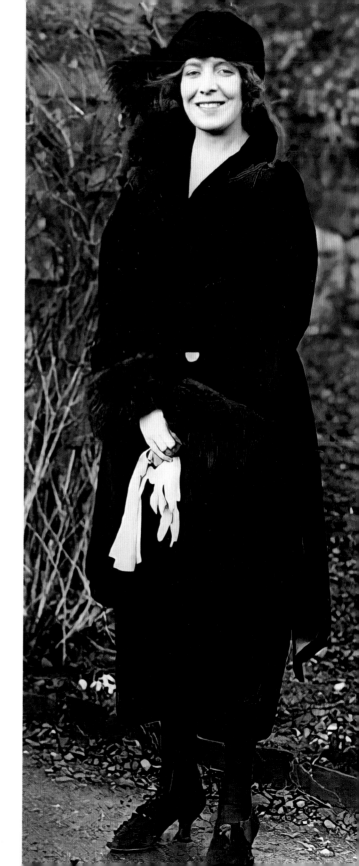

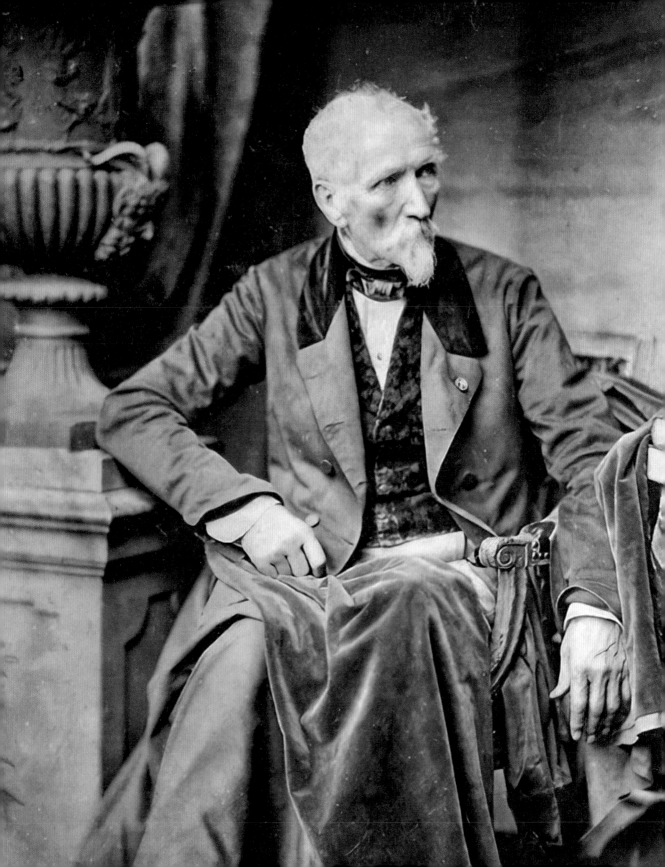

POLITICS AND REVOLUTION

A 1798 REBEL

1859, France

Miles Byrne (1780–1862) was born in Ballylusk, Co. Wexford, and at the age of 18 he became a unit commander in the 1798 Irish Rebellion. The rebellion, launched by the underground republican society the United Irishmen, aimed to sever the connection with Great Britain and establish an Irish Republic. The military uprising was put down with great bloodshed in the summer of 1798, and some of its leaders, notably Theobald Wolfe Tone, were killed or died in imprisonment, while many others were exiled. Byrne was a trusted lieutenant of Robert Emmet in the 1803 Rebellion and later fought for Napoleon. He is buried in Montmartre, Paris. As a result of the 1798 Rebellion, the Irish Parliament, which had existed since the thirteenth century, was abolished and, under the Acts of Union (1800), Ireland was ruled directly from London until January 1922.

THOMAS FRANCIS MEAGHER (1823–1867)

*c.*1862, USA

Meagher was an Irish nationalist and leader of the Young Irelanders during the 1848 Rebellion. He was initially sentenced to death after being convicted of sedition, but this was commuted to transportation for life to Van Diemen's Land (in modern-day Tasmania). Meagher was born in Waterford City, where his father was twice elected Mayor. In 1848, Meagher and William Smith O'Brien travelled to France to understand the revolution there, and returned with the new flag of Ireland, a tricolour of green, white and orange made and given to them by French women sympathetic to the Irish cause. Following his escape from Tasmania and arrival in New York, Meagher emerged as a national leader of Irish-America. During the US Civil War, he recruited and led the 'Irish Brigade', which was one of the Union Army's most celebrated units. He is seen here in the uniform of a Union Brigadier General. Meagher died in mysterious circumstances while serving as Montana's acting territorial governor.

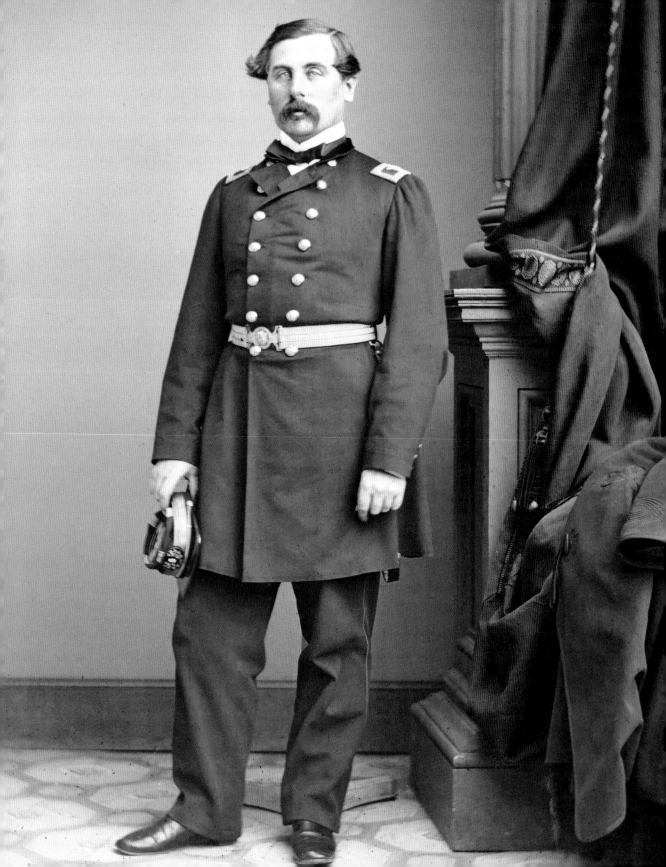

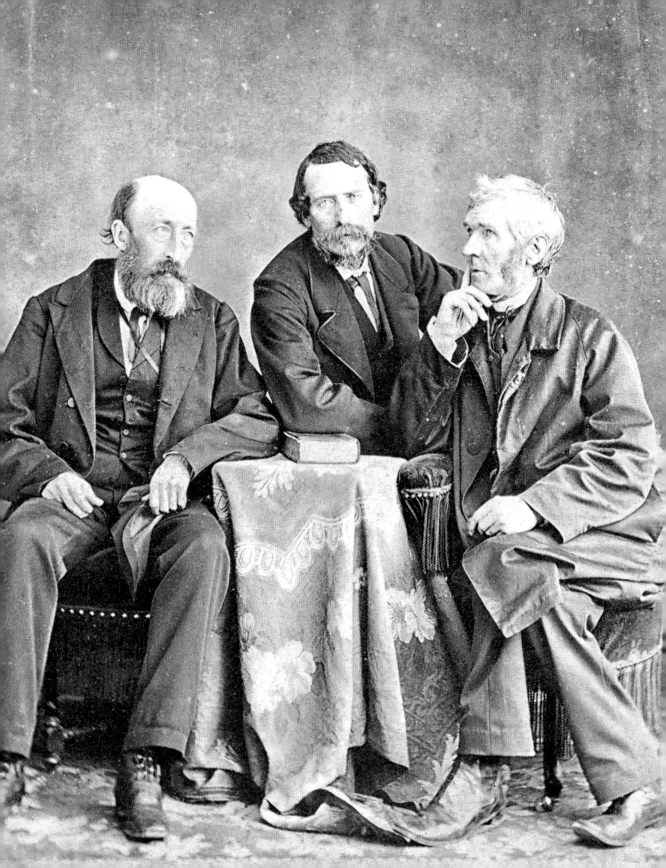

JOHN MITCHEL (CENTRE) WITH JOHN MARTIN AND FATHER JOHN KENYON (DETAIL)

1866, Dublin

This image depicts John Mitchel (1815–1875), John Martin (left, 1812–1875) and Father John Kenyon (right, 1812–1869). Mitchel was one of the most influential Irish nationalists of the nineteenth century, as well as being a publisher and journalist. In May 1848, he was found guilty of treason and sentenced to fourteen years' transportation, arriving in Hobart, Tasmania, in April 1850. There he resided with his fellow Young Irelanders leader and friend John Martin, who'd been transported for treason in 1849. In 1853, Martin escaped by disguising himself as a priest and sneaking aboard a ship to Sydney, before making his way to San Francisco. Pardoned in 1858, he returned to Ireland and was elected to parliament in 1871. Mitchel became a vocal supporter of the Confederacy in the American Civil War, and lost two sons who served in the Confederate Army. Martin died in March 1875, having contracted bronchitis while attending Mitchel's funeral. Father John Kenyon was a controversial and outspoken priest whose opinions on physical force and opposition to Daniel O'Connell led to him being suspended twice from clerical duties. He was a member of both the Young Ireland movement and the Irish Confederation.

JEREMIAH O'DONOVAN ROSSA (1831–1915)

*c.*November 1866, Mountjoy Prison

O'Donovan Rossa was born in Reenascreena, Co. Cork. In 1856 he co-founded the Phoenix National and Literary Society in Skibbereen, which later amalgamated with the Irish Republican Brotherhood (IRB). In 1865, he was arrested, tried on a charge of conspiracy, and given a life sentence. While imprisoned, he suffered greatly at the hands of his jailers. After an inquiry into the treatment of Fenian prisoners, he was given an amnesty in 1871, emigrated to the US and became involved in republican circles there.

JOHN DEVOY (1848–1928)

*c.*1866, Mountjoy Prison

Born near Kill, Co. Kildare, Devoy would go on to become a man described by *The Times* in London as 'the most dangerous enemy of this country [Britain] Ireland has produced since Wolfe Tone'. Sworn into the IRB in 1861, he was tried for treason in 1866 and endured a severe regime in Irish and English jails. In 1871 he was exiled to the US, where he became instrumental in forming Clan na Gael, the American wing of the IRB. Over the next half century, he was the most prominent leader of the Irish-American nationalist movement.

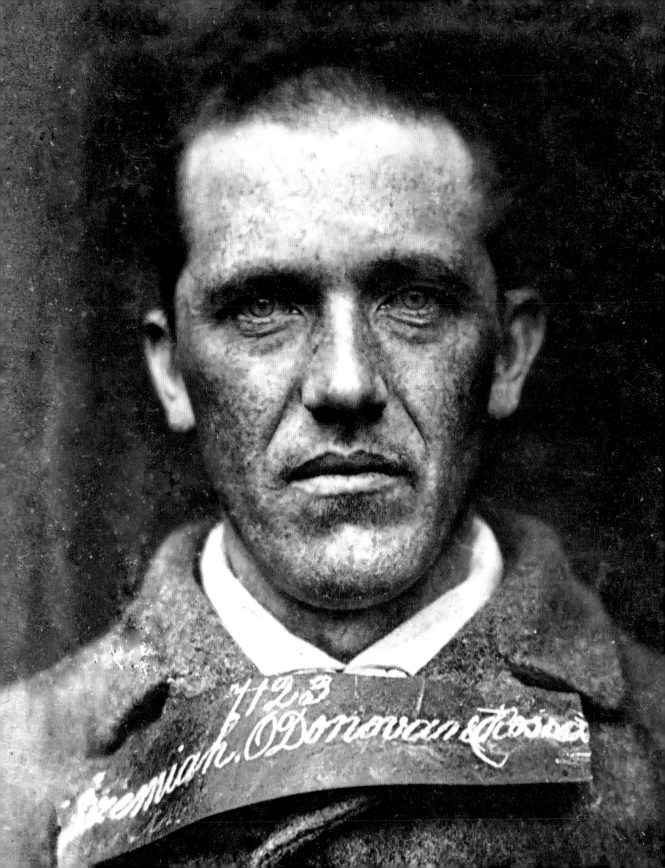

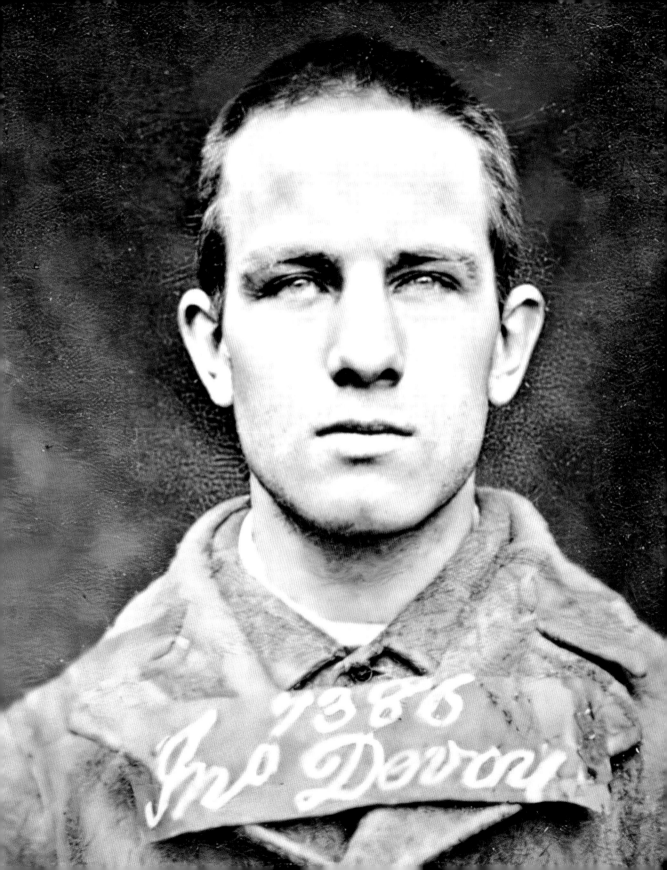

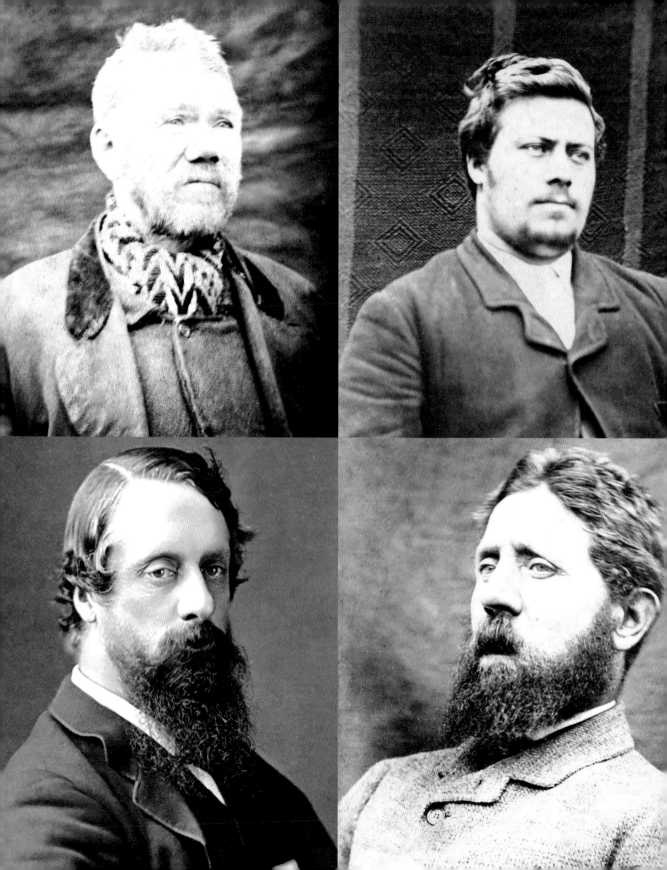

THE INVINCIBLES

*c.*1867–1882, Dublin and London

On 6 May 1882, Frederick Cavendish, the newly appointed chief secretary, arrived in Dublin. As he and Undersecretary Thomas Henry Burke walked through the Phoenix Park that day, they were targeted by seven Invincibles, a militant group within the IRB. The two officials were brutally stabbed to death – the highest-ranking British officials ever assassinated in Ireland. Clockwise from top left are James Fitzharris, Joe Brady, James Carey and Lord Frederick Charles Cavendish.

CARDINAL PAUL CULLEN (1803-1878)

*c.*1860–1870

The influence of the Kildare-born Cardinal Paul Cullen on Irish society and culture from the mid-nineteenth century cannot be overestimated. His belief in obedience and discipline, and fear of liberalism and modernity, had an enormous impact on Irish Catholicism, nationalism and the political establishment. In 1849, Pope Pius IX tasked Cullen with bringing the Irish Church into line with Roman canon law and usage. Until his death, he directed his activities to this end.

ANTI-HOME RULE RALLY

*c.*1911–1913, Belfast

Sir Edward Carson addresses 50,000 men from unionist clubs and Orange Lodges at a huge demonstration organised by James Craig. Carson told the men to be prepared, on the morning Home Rule passed, 'to become responsible for the government of the Protestant Province of Ulster'. Home Rule was the demand that the governance of Ireland be returned from Westminster to a domestic parliament in Ireland. In 1912 the Irish Parliamentary Party introduced the Third Home Rule Bill in the House of Commons. It passed in 1914, despite unionist opposition, only to be suspended on the outbreak of the First World War.

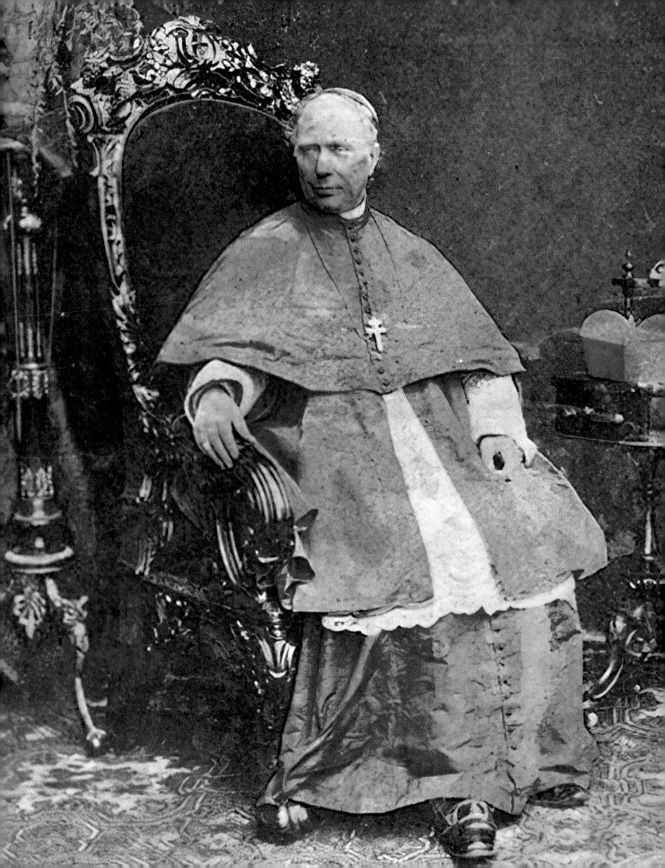

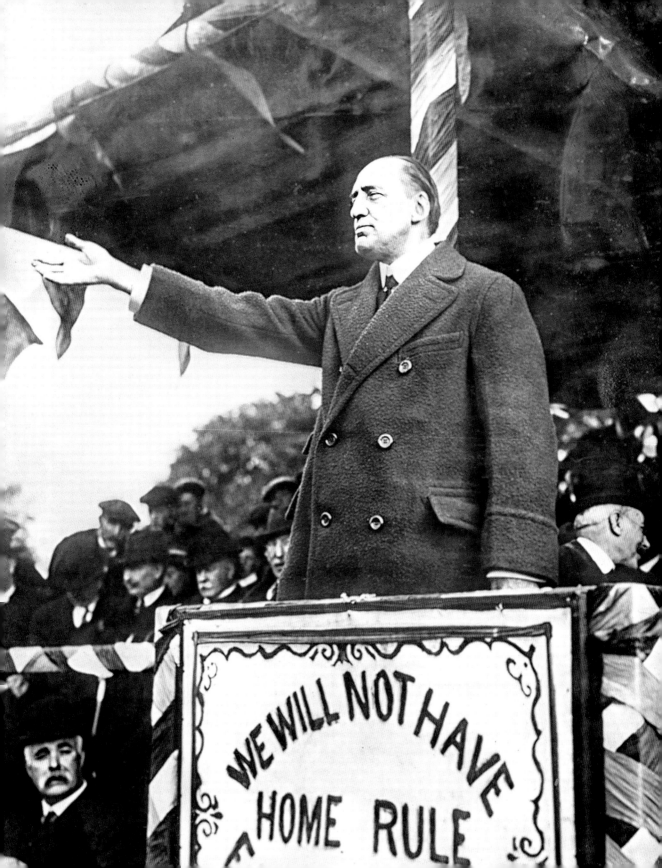

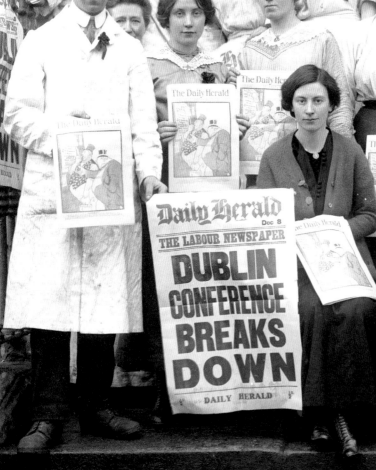

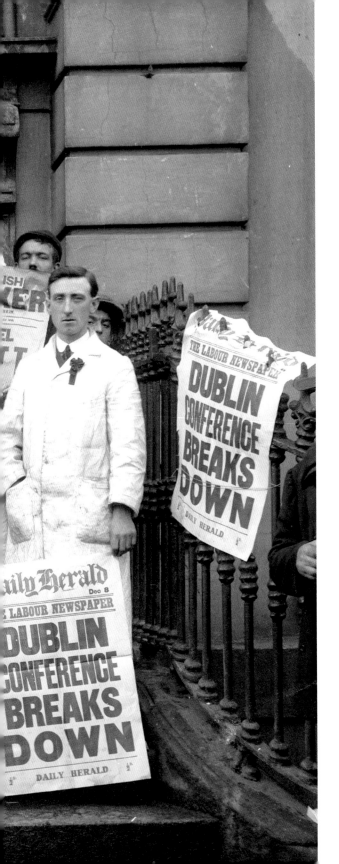

THE 1913 DUBLIN PEACE CONFERENCE

7 December 1913, Dublin

Workers holding news posters announcing the failure of the Dublin Peace Conference. Delia Larkin (centre) is holding *The Irish Worker*. The conference was established to resolve the long-running industrial deadlock in the city, and saw exhaustive negotiations between unions and employers. The negotiations broke down on the workers' requirement for complete reinstatement of former employees, which the employers wouldn't concede.

FUNERAL OF O'DONOVAN ROSSA

1 August 1915, Glasnevin Cemetery

The funeral of Cork Fenian Jeremiah O'Donovan Rossa was one of the largest and most significant in modern Irish history. All seven signatories of the Proclamation were listed as members of the committee that organised transfer of his body from Staten Island to Dublin. It would be the first of a number of very large 'political' funerals and a significant feature was that his body was received with full religious ceremonials and many prominent clergy were present. Prominent republicans featured in this image include Patrick Pearse, Tom Clarke, Cathal Brugha and Thomas MacDonagh.

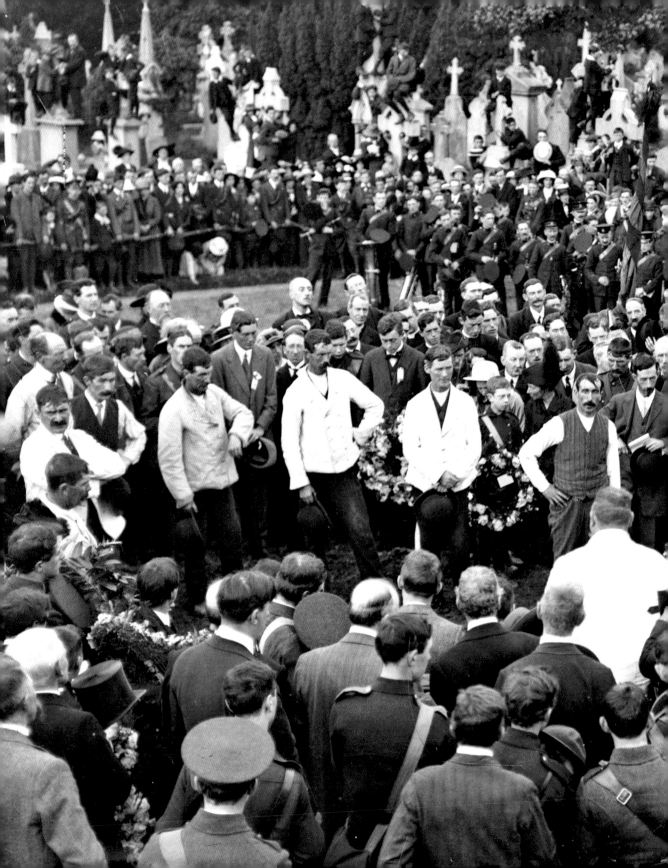

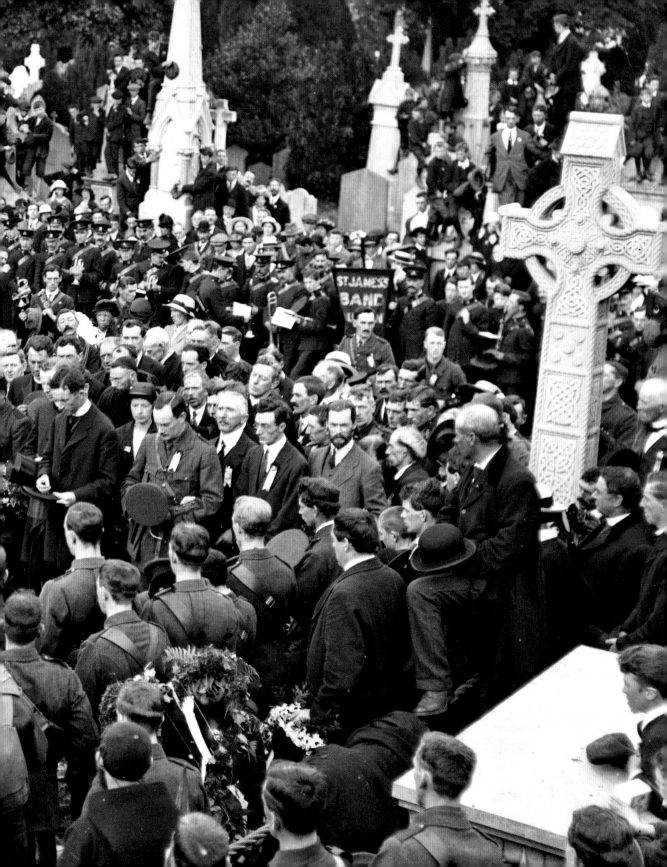

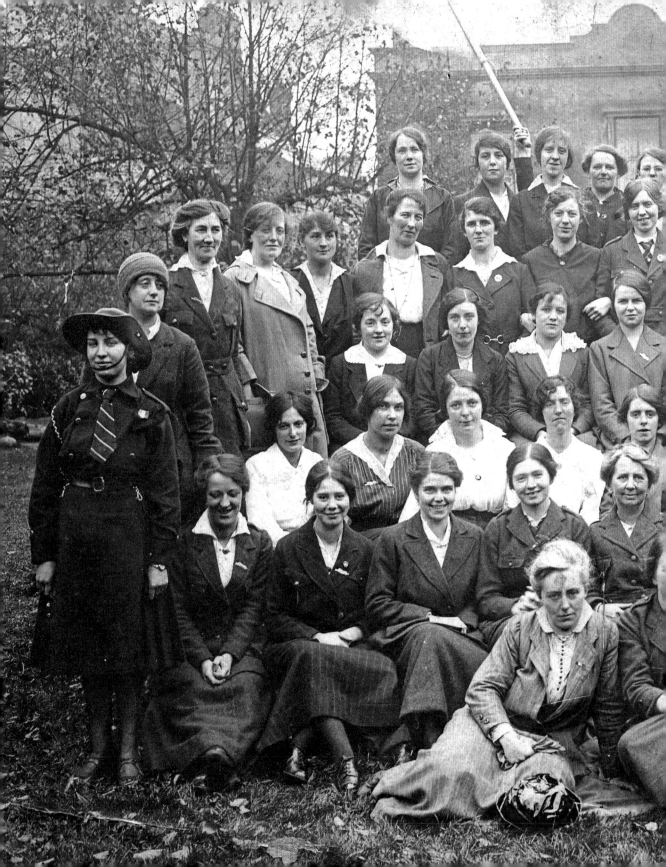

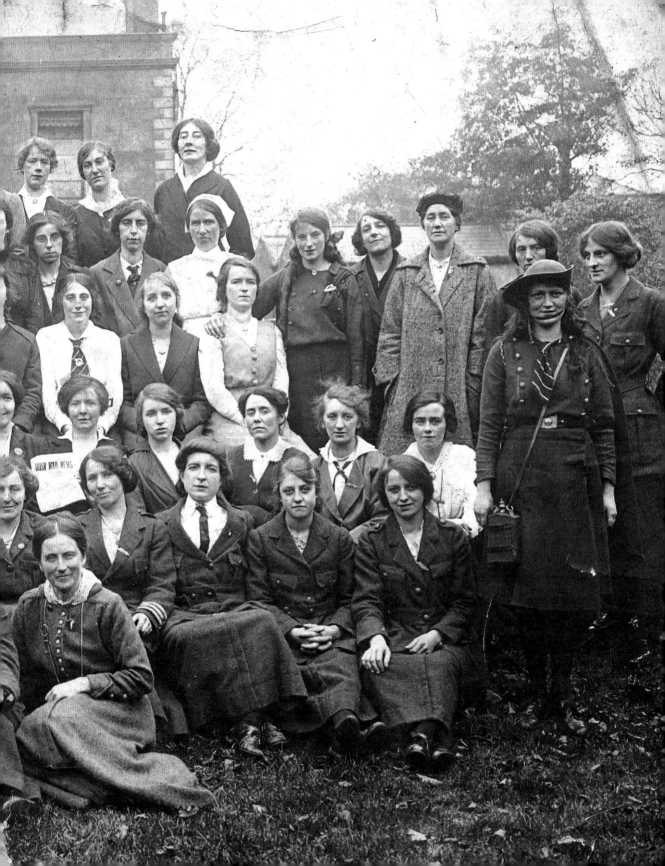

WOMEN OF THE REVOLUTION

1916, Dublin

Several hundred women took part in the 1916 Rising. Most belonged to organisations like Inghinidhe na hÉireann, Cumann na mBan and the Irish Citizen Army. This photograph depicts sixty of those women. They were based in a variety of locations, including the General Post Office, Jacob's Biscuit Factory, Marrowbone Lane, the South Dublin Union and the College of Surgeons. The National Museum of Ireland states that the photograph was most likely taken at a meeting of the Irish National Aid Association and Volunteer Dependents' Fund, which was held in Mr and Mrs Ely O'Carroll's house in Peter's Place, Dublin, in the summer of 1916.

PEAKY POLITICIANS

1919, Dublin

This photograph was taken at the office of *The Freeman's Journal*. The paper was published from 1763 to 1924 and was the leading nationalist newspaper in nineteenth-century Ireland. The image contains various Sinn Féin politicians from Cork. In the front row (left to right) are Tadhg Barry, Tomás MacCurtain and Pat Higgins. In the back row are David Cotter, Seán Murphy, Donal Barrett, Terence MacSwiney and Pat Trahey.

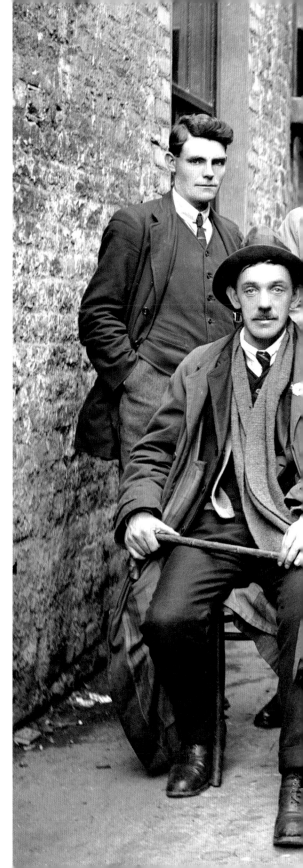

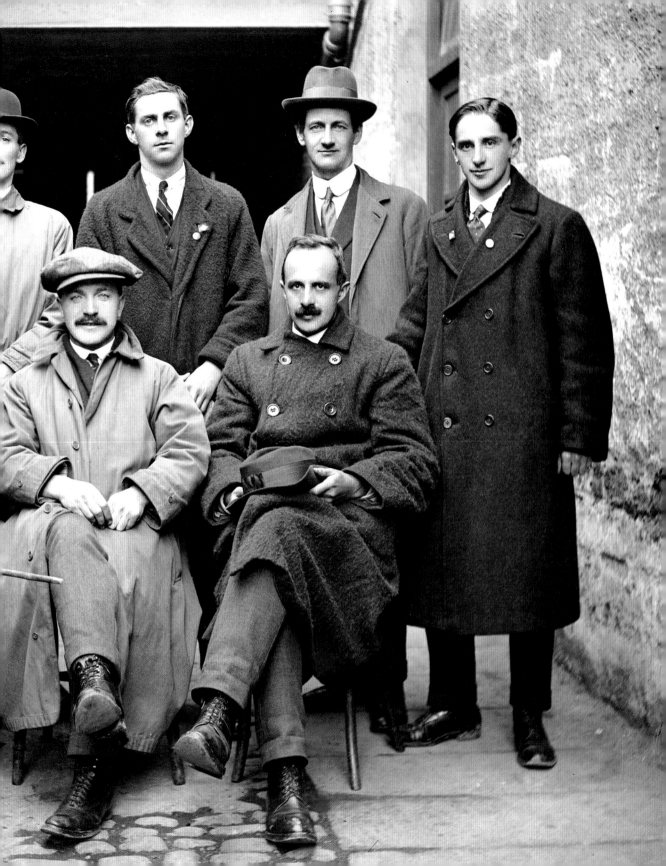

TERENCE MacSWINEY
(1879–1920)

30 May 1920, Rochestown Friary, Cork

Pictured here with Capuchin Fathers Bonaventure, Coleman, Berchmans and Francis, MacSwiney is most often remembered as the Cork republican martyr who died on hunger strike in Brixton Prison, London, after seventy-four days without food. In December 1918 MacSwiney was elected an MP, and following the assassination of Tomás MacCurtain, succeeded him as Lord Mayor and commandant of the Cork No. 1 Brigade. On 12 August 1920, City Hall was raided and MacSwiney was arrested. At his court martial in Dublin, he received a two-year sentence and was transferred to Brixton. He immediately began a hunger strike, and on 25 October was declared dead.

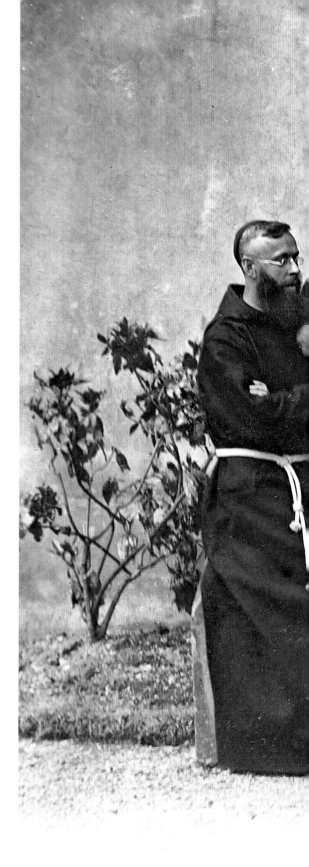

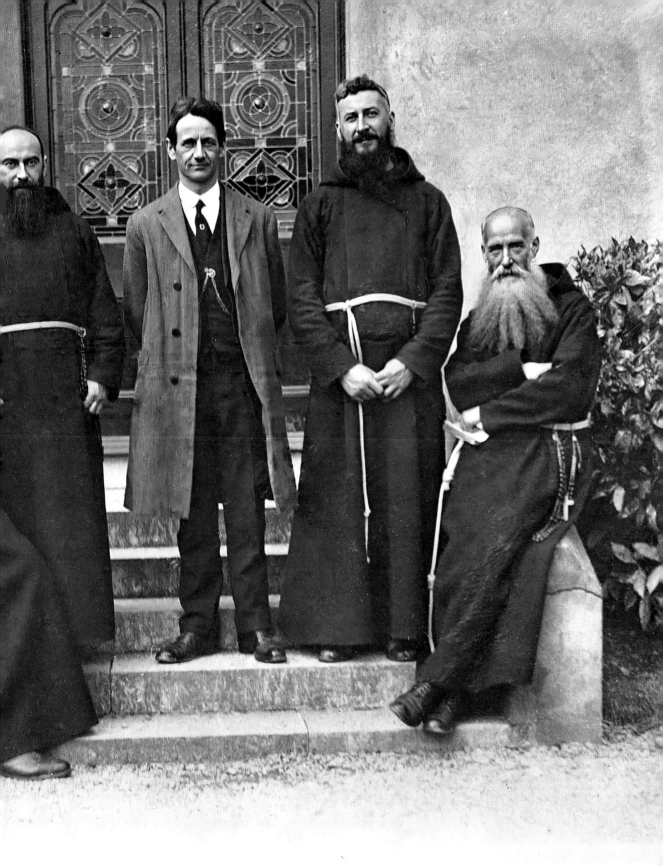

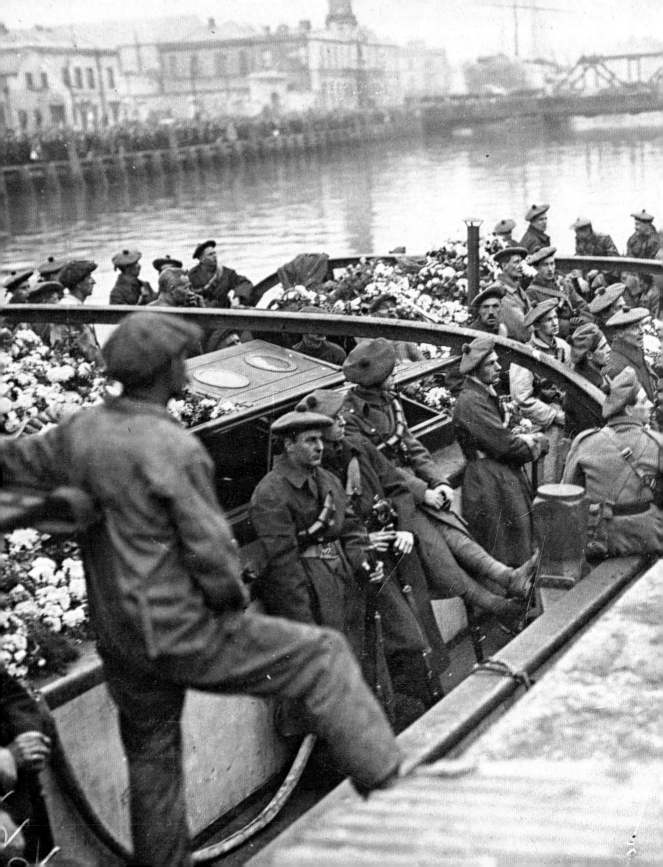

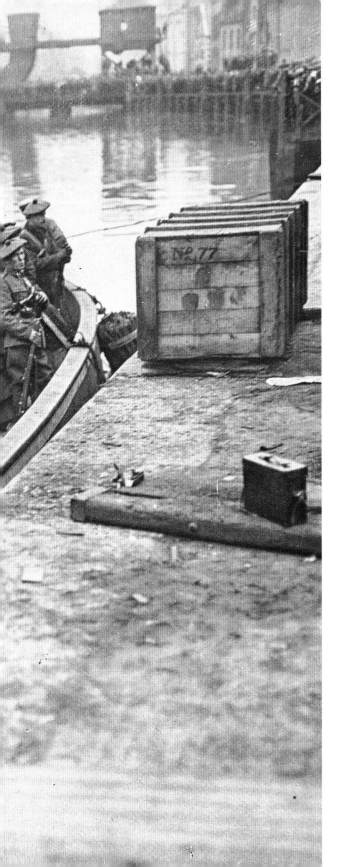

JOURNEY'S END

29 October 1920, Custom House Quay, Cork

While Cork would be his final resting place, Terence MacSwiney had three funerals following his death: the first in Southwark, London, the next in Dublin, and the final one in Cork. The British authorities attempted to suppress the funeral in Dublin by sending his coffin directly to Cork, but one was held anyway, without the body. In Cork, his family accepted the body and a guard of Irish Volunteers marched in formation to deposit the coffin at Cork City Hall. MacSwiney was buried at the republican plot in St Finbarr's Cemetery, with Arthur Griffith delivering the graveside oration.

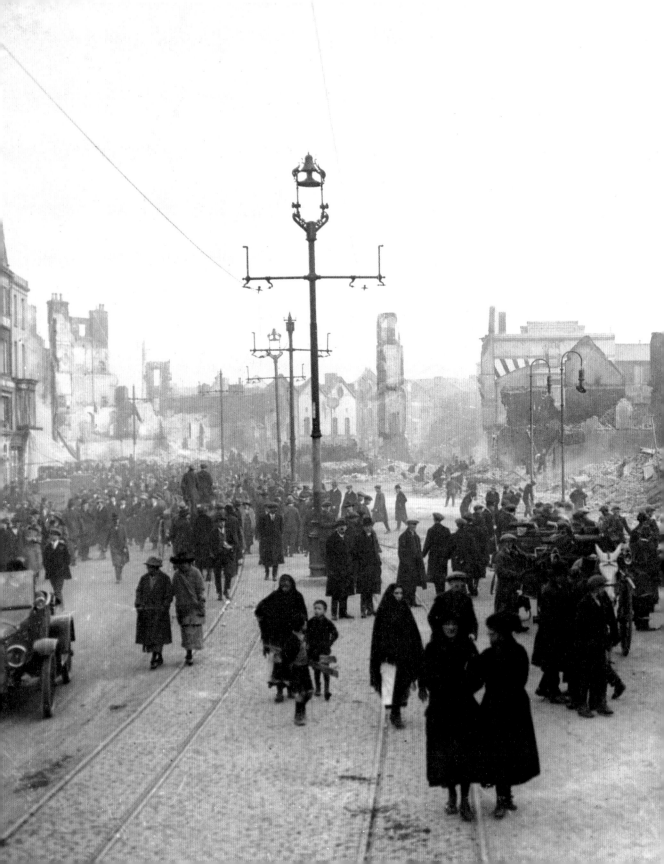

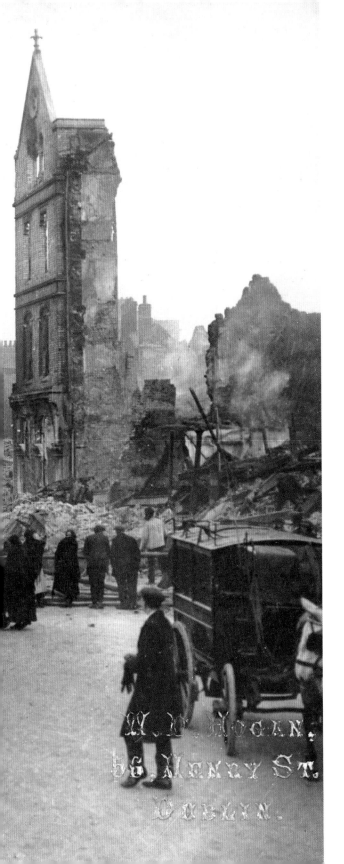

THE BURNING OF CORK

13 December 1920, Cork

A photograph taken just after Cork was burned by British forces, showing part of St Patrick's Street. More than 2,000 people lost their jobs due to the destruction wreaked on the city centre. The wave of arson that began on the night of 11 December 1920 followed an IRA ambush of an RIC Auxiliary patrol at Dillon's Cross, on the outskirts of the city, but was the result of a month of increasing tension. The *Atlas of the Irish Revolution* states fifty-seven premises were destroyed by the fire, twenty were badly damaged and twelve were ravaged by looters. Five acres of property were destroyed, and the damage and repairs cost £2,500,000. The initial official British response to the burning of Cork was to try to blame Sinn Féin. It would take until the mid-1930s before Cork City was renovated and rebuilt.

IN SOLIDARITY

1920, Dublin

This photograph shows a line of women protesting outside Mountjoy Prison in support of the 1920 hunger strikes. On Easter Monday, 5 April 1920, thirty-six Irish Volunteer prisoners in Mountjoy pledged not to eat food or drink anything except water until all had been given prisoner-of-war treatment or were released. The *Irish Independent* reported that by 10 April the number participating had climbed to 101 – the largest scale on which this form of protest had ever been attempted. Protests involving republican women had become a key feature of the War of Independence and often involved prayer recitations and dignified, silent protests. Their military formation suggests they were members of the republican womens' organisation Cumann na mBan.

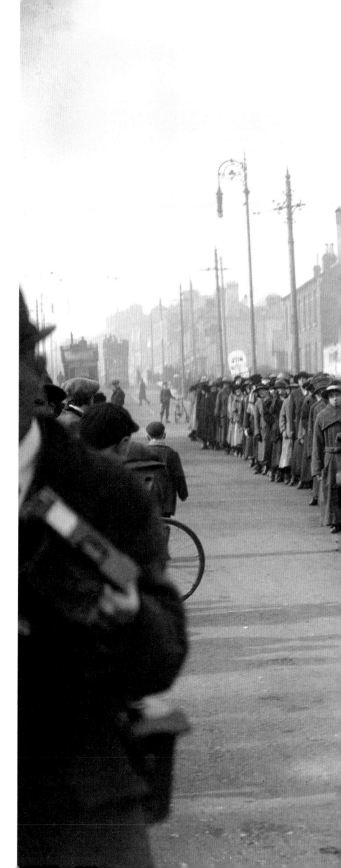

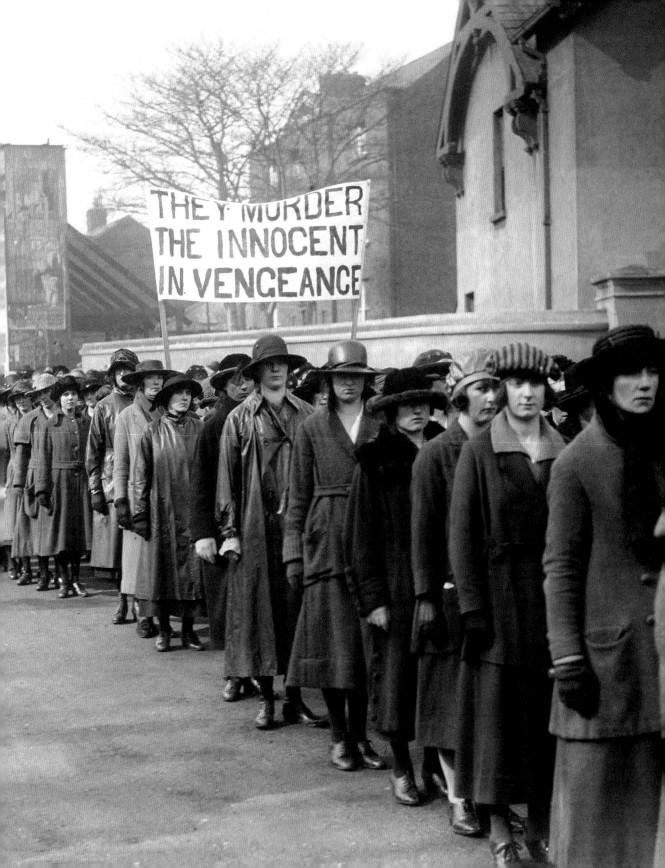

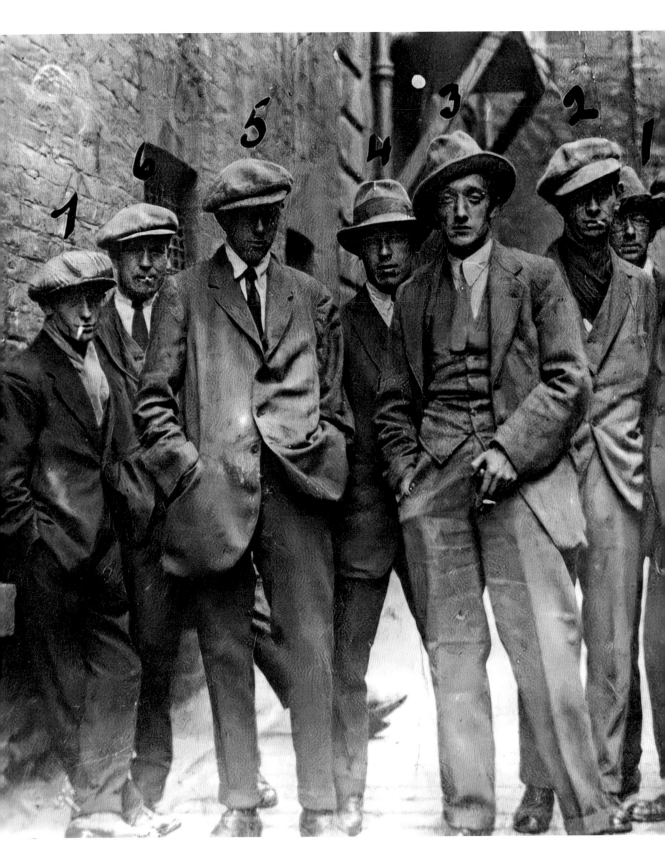

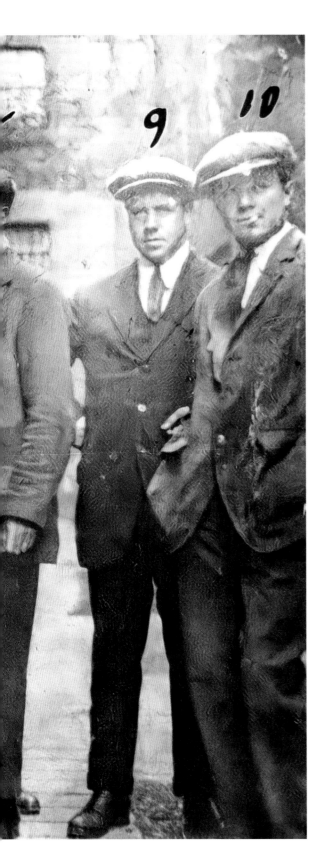

THE CAIRO GANG

1920, Dublin

An iconic photo from the War of Independence of the 'Special Gang', as named by IRA intelligence. During the War of Independence, Dublin was inhabited by a shadowy world of spies and agents working for the Crown Forces. Although associated with the Bloody Sunday attacks on British secret service agents in Dublin, this photograph remains something of a mystery, as those killed by the IRA on that day do not appear. While the image seems to be of British agents, and was studied by the IRA for intelligence purposes, the men's exact identities are unknown.

CHARGE!

November 1920, Dublin

Civilians on Dublin's Sackville (O'Connell) Street scatter in confusion during a British Army raid. Rolls Royce armoured cars were deployed to Ireland during the War of Independence, and were used by the National Army during the Civil War and afterwards. A Vickers machine gun is visible extending from its turret.

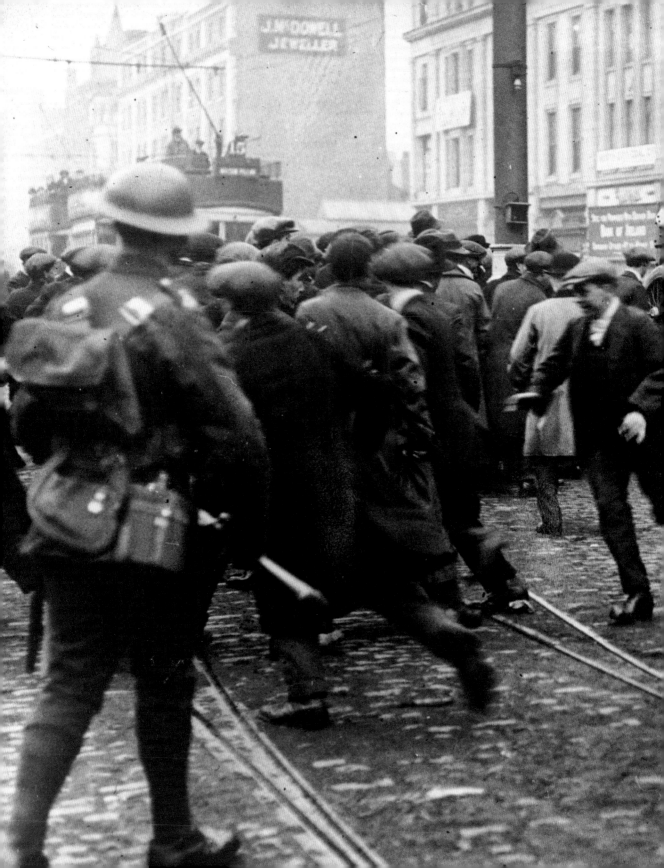

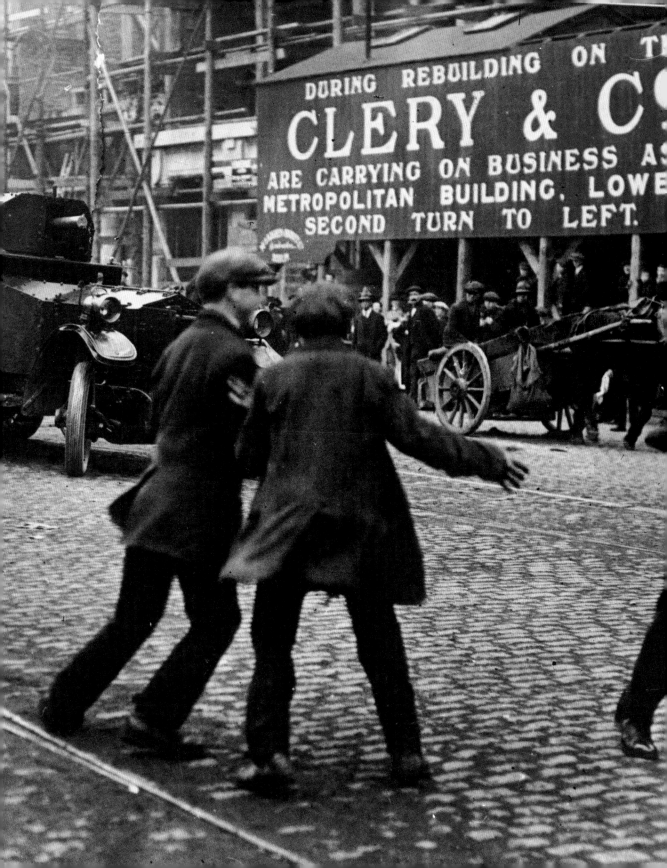

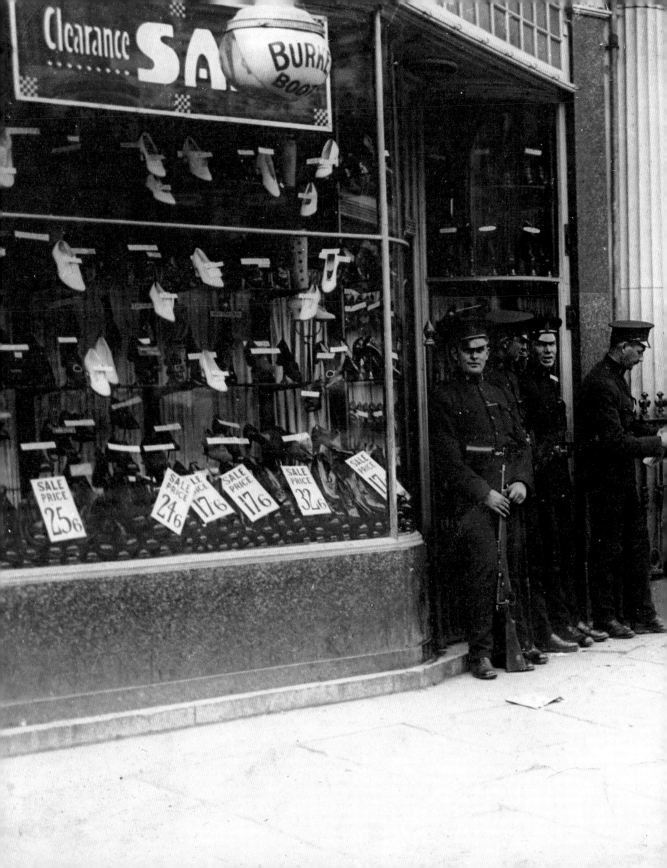

ARMED RIC MEN IN CORK CITY

1921, St Patrick's Street

This image shows armed RIC members outside a shoe shop on St Patrick's Street. Formed by the Irish Constabulary Act in 1836, the RIC was awarded the prefix Royal in 1867 following its actions in putting down the Fenian uprising. While its senior officers were predominantly Protestant, the majority of the rank-and-file constables were Catholic. Although Dublin maintained its own separate police force, the Dublin Metropolitan Police (DMP), the RIC was essentially the key policing organ of the British administration in Ireland until 1922. In 1914, there were 1,400 RIC barracks across Ireland and in 1920 the force numbered about 9,500 men. As the republican campaign escalated in late 1919, many retired or resigned, so the British government began a recruiting campaign in Britain, leading to the arrival in Ireland of the infamous Black and Tans and the Auxiliary Division to bolster police numbers.

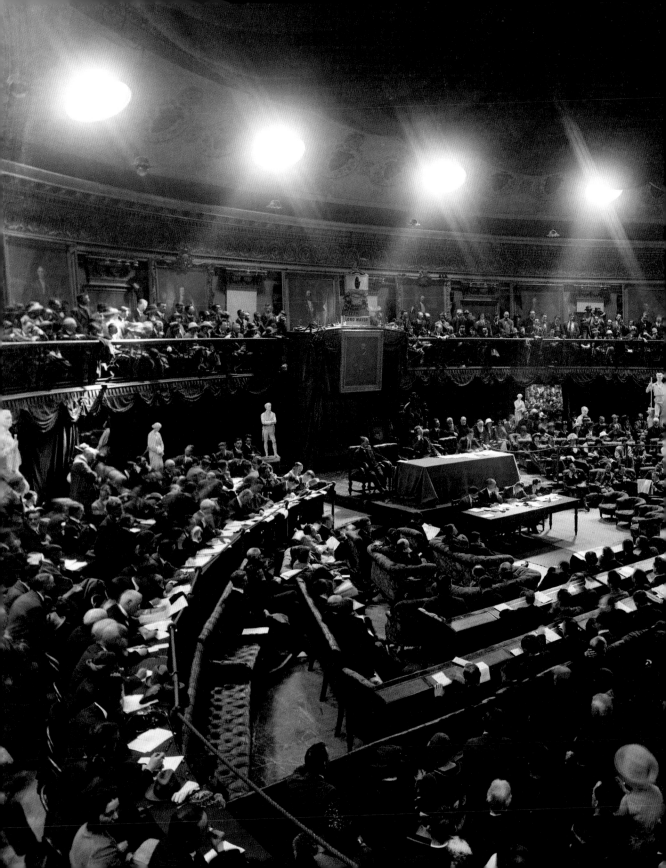

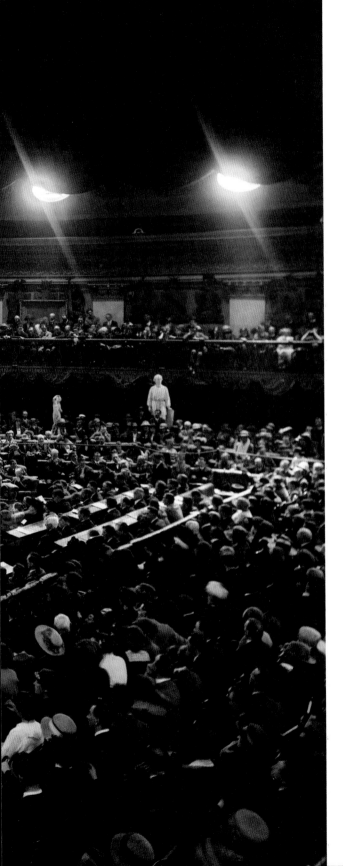

THE SECOND DÁIL ÉIREANN

August 1921, Mansion House, Dublin

Under the Government of Ireland Act, 1920, Ireland was partitioned into two 'Home Rule' areas in 1920–1921 and elections were held for the two devolved parliaments. Of the 125 successful Sinn Féin candidates, 112 had served time in prison, forty-seven were currently in jail and a further fifty-two were wanted by the police. In the elections for the 'Southern Ireland parliament', all seats were uncontested, with Sinn Féin winning 124 of the 128 seats, and Independent Unionists winning the four seats representing the University of Dublin. In the election for the 'Northern Ireland parliament', the Ulster Unionist Party won forty of the fifty-two seats, with Sinn Féin and the Nationalist Party winning six seats each. Of the seats won by Sinn Féin in Northern Ireland, five were held by people who had also won seats in Southern Ireland. The Second Dáil responded favourably to the Truce, which came into effect from noon on 11 July 1921. This allowed the Dáil to meet openly and without fear of arrest for the first time since September 1919, when it had been banned and driven underground. Éamon de Valera, Arthur Griffith and Michael Collins are seated at the front near the table.

TAKING OVER THE BARRACKS

25 February 1922, Athlone,
Co. Westmeath

National Army troops taking over
the Custume Barracks in Athlone
from British forces. As a result of the
ratification of the 1921 Anglo-Irish
Treaty, the British Army withdrew their
forces from Ireland throughout 1922.
The barracks were originally built as
temporary accommodation for cavalry
and infantry units in 1691 and named
after Sergeant Custume, who defended
the bridge from the forces of King
William III during the 1690 Siege of
Athlone. After the takeover by the army
of the Irish Free State, they served as the
headquarters of 4th Western Brigade
until the brigade was disbanded.

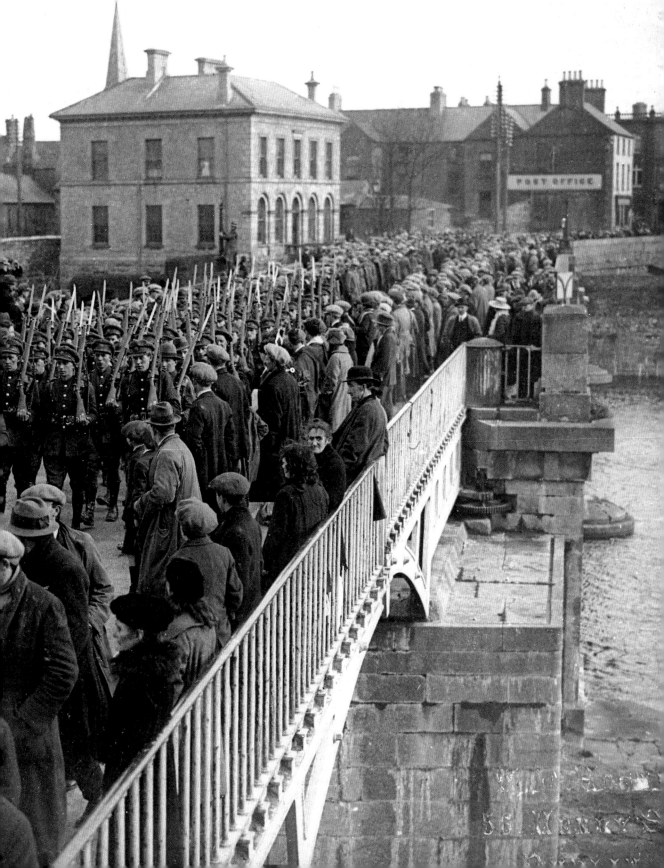

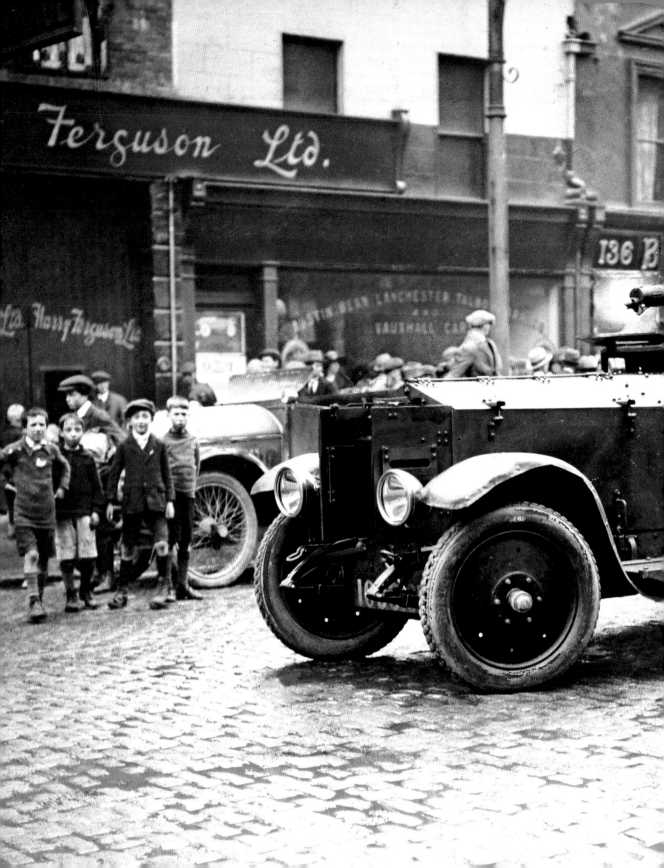

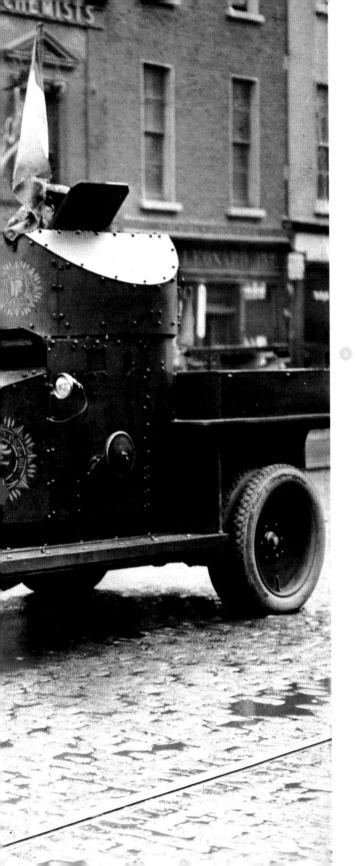

'THE BIG FELLA'

29 June 1922, Dublin

One of thirteen armoured cars given to the National Army by the British government, 'The Big Fella' is seen here outside Messrs H. Ferguson Ltd. During a raid on the premises by anti-Treaty soldiers, they were surrounded by Free State troops and Commandant Leo Henderson was captured.

THE BURNING OF THE FOUR COURTS

30 June 1922, Dublin

The destruction of the Four Courts on 30 June 1922 marked an end to the three-day siege of the building. The explosion sent a cloud of smoke high above Dublin and debris littered the city. The Free State Army was attempting to retake the Four Courts from anti-Treaty republicans, who had occupied the complex since April 1922. The detonation took place inside the Public Records Office block of the Four Courts, which the IRA garrison used to store munitions. At the time, the destruction of the irreplaceable records and manuscripts was described by the pro-Treaty press as an act of cultural vandalism. The loss of these archives had and continues to have an enormous effect on Ireland's history.

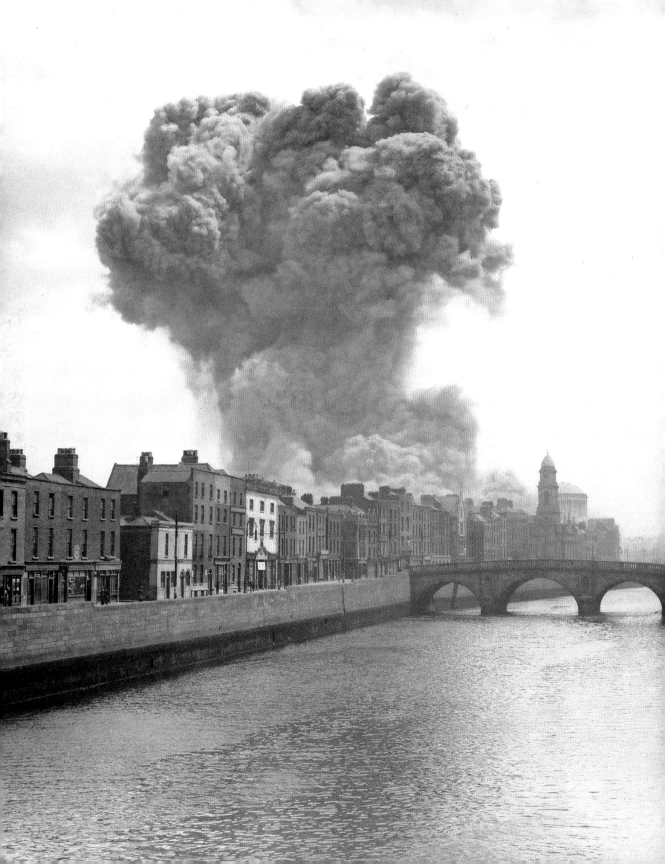

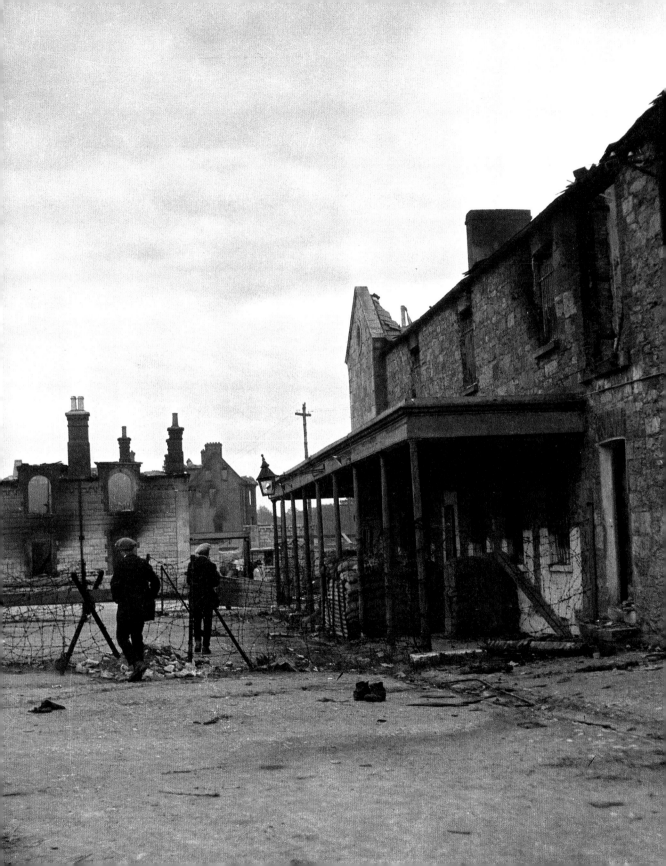

FERMOY BARRACKS

August 1922, Co. Cork

The East Barracks were designed and built by Abraham Hargrave on a site provided by John Anderson between 1801 and 1806. The West Barracks and military hospital were added to the complex in 1809. The British Army left Fermoy in spring 1922. In August, in the midst of the Civil War, the barracks were burnt to the ground by retreating anti-Treaty IRA forces. Afterwards, a member of the Urban District Council complained that the local authority lost £3,400 in rates and an additional £450 in special water rates. The financial loss devastated the town, especially in the first economically depressed decades of the new state.

COMRADES IN ARMS

25 July 1922, Co. Limerick

A wounded soldier being treated by medics at Kilmallock. Fighting between anti-Treaty and Free State forces took place in the area from 21 July to 5 August 1922 as part of the Civil War. At least thirteen soldiers were killed, as well as a member of Cumann na mBan.

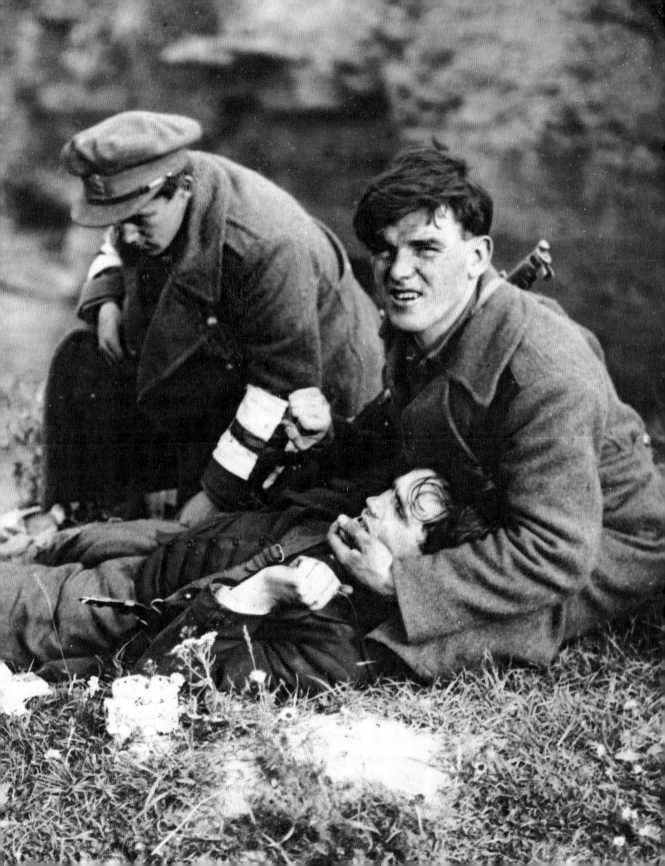

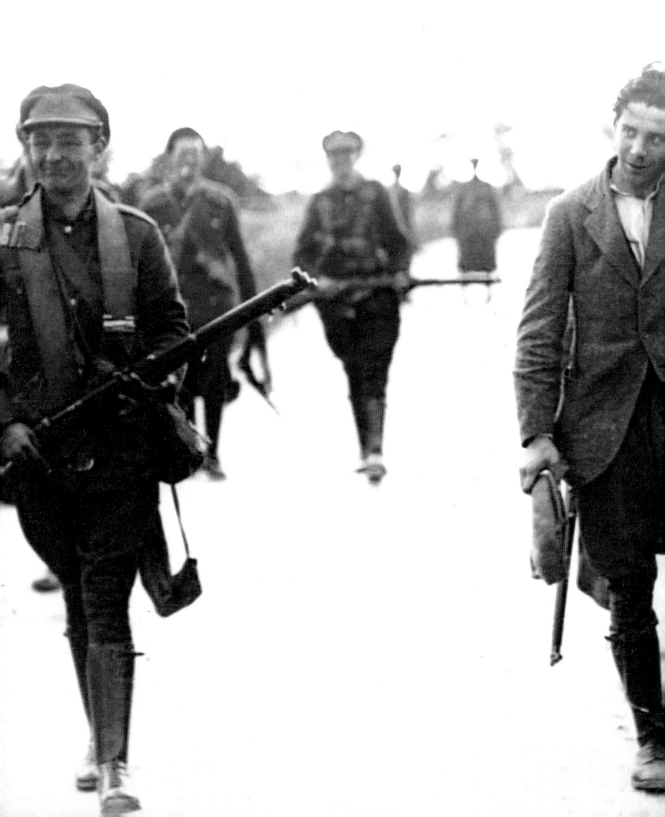

PRISONER UNDER ESCORT

July 1922, Co. Limerick

An anti-Treaty IRA prisoner under escort after being captured by the Free State army during the battle for Kilmallock, which ended in the government's forces taking the town on 5 August. On the far right of the image we can see a man holding a camera.

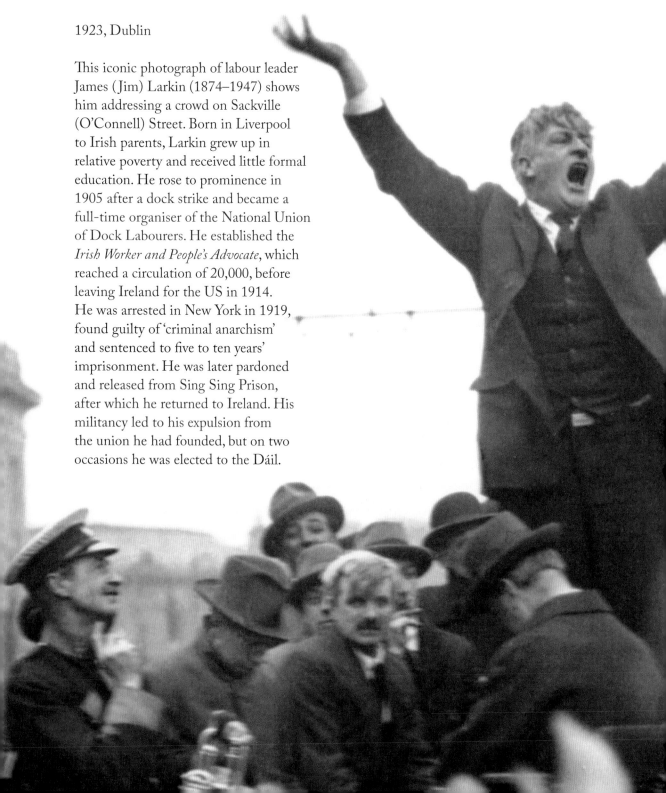

LARKIN

1923, Dublin

This iconic photograph of labour leader James (Jim) Larkin (1874–1947) shows him addressing a crowd on Sackville (O'Connell) Street. Born in Liverpool to Irish parents, Larkin grew up in relative poverty and received little formal education. He rose to prominence in 1905 after a dock strike and became a full-time organiser of the National Union of Dock Labourers. He established the *Irish Worker and People's Advocate*, which reached a circulation of 20,000, before leaving Ireland for the US in 1914. He was arrested in New York in 1919, found guilty of 'criminal anarchism' and sentenced to five to ten years' imprisonment. He was later pardoned and released from Sing Sing Prison, after which he returned to Ireland. His militancy led to his expulsion from the union he had founded, but on two occasions he was elected to the Dáil.

MARCH OF THE CARDINALS

June 1932, Dublin

This image was taken just outside the Pro-Cathedral on Marlborough Street during the 31st Eucharistic Congress. Cardinal Dougherty of Philadelphia is front left, with Papal Legate Cardinal Lorenzo Lauri and other Church dignitaries, including Cardinal MacRory, also in attendance. The Congress was one of the most remarkable public events to take place in twentieth-century Ireland. Huge crowds, good weather and the sheer scale of it brought thousands of people onto the streets and to events. The Men's Mass, held in the 'Fifteen Acres' of the Phoenix Park on 23 June in front of a giant altar flanked by colonnades, was attended by a congregation of approximately 250,000 people, while the Women's Mass on 24 June was attended by some 200,000 spectators. The Children's Mass on the following day saw approximately 100,000 children gather in the Park. The main pontifical High Mass on 26 June was attended by an estimated one million people. Dublin was chosen as the venue to mark the 1,500th anniversary of St Patrick's 'mission' to Ireland.

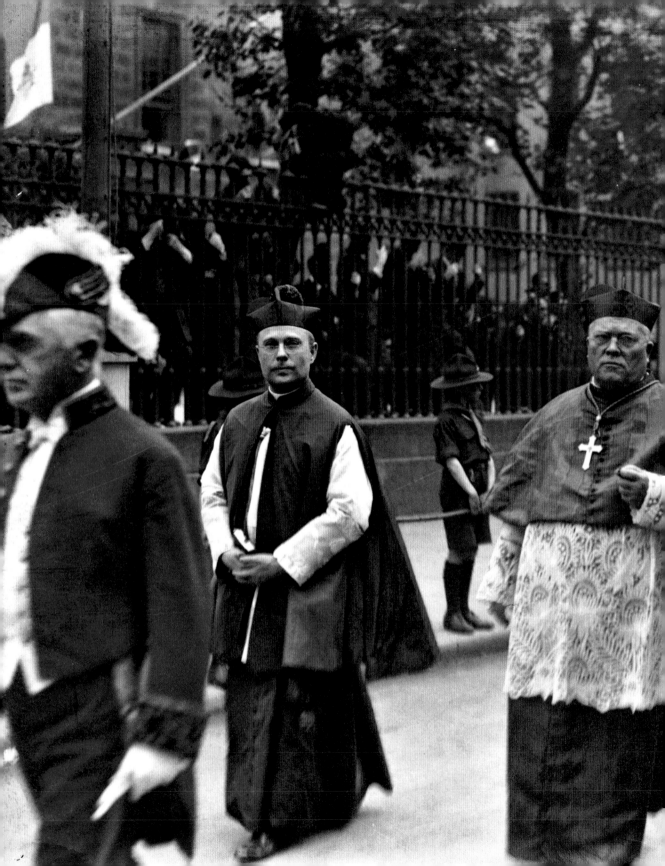

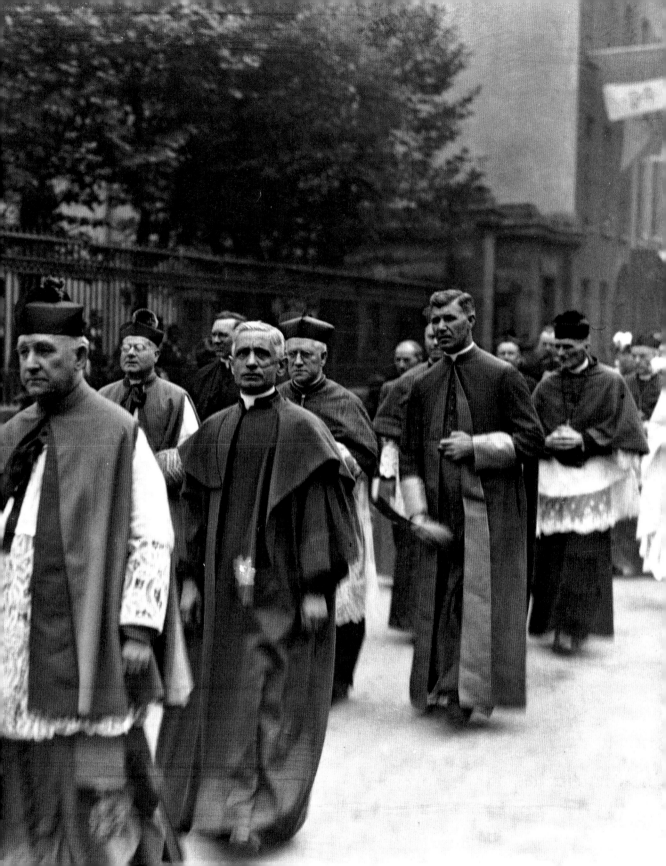

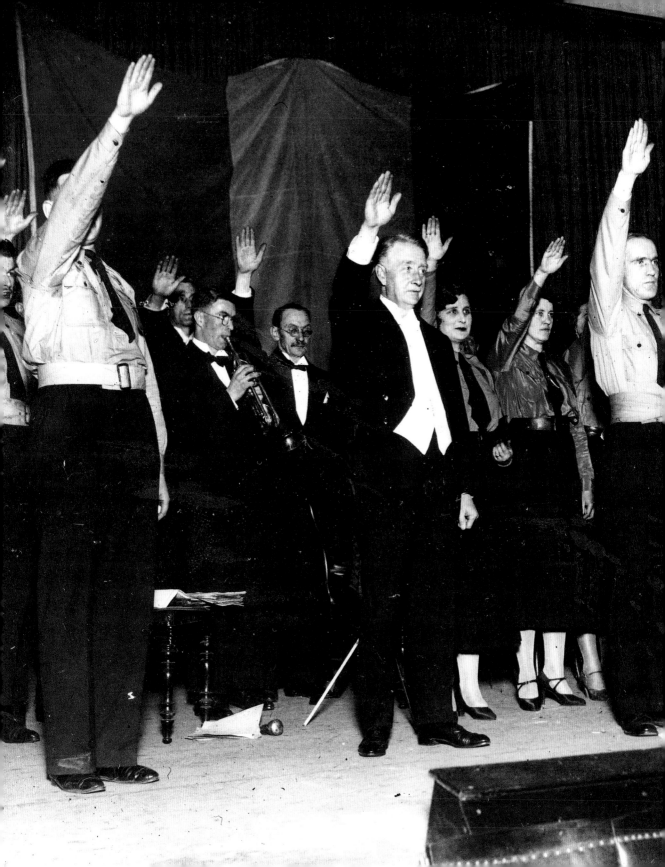

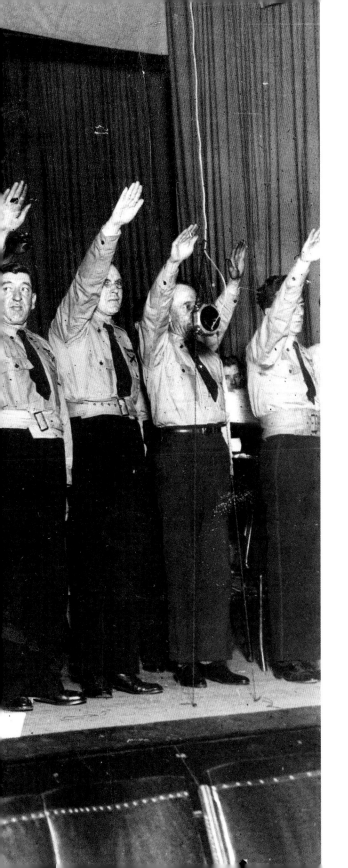

BLUESHIRTS

29 November 1934, Mansion House, Dublin

The moment of the Roman salute while the hymn of the Blueshirts movement plays, at a ball in the Mansion House organised on the occasion of the release of Colonel Jerry Ryan. Visible, among others, are William Thomas Cosgrave, Colonel Ned Cronin, Colonel Jerry Ryan and Ernest Blythe. Following Cumann na nGaedheal's defeat in the 1933 election, a section of pro-Treatyites, formed the Army Comrades Association, which later became known as the Blueshirts. Led by former Garda commissioner Eoin O'Duffy, the group's aim was to protect the social order from possible 'republican terror'. A number of the Blueshirts' leadership, including O'Duffy, openly admired European fascism and were vocal opponents of democracy.

ST ULTAN'S HOSPITAL

1936, Dublin

Members of St Ultan's with Madeleine ffrench-Mullen and Kathleen Lynn pictured first and third from the left respectively, and Dorothy Stopford Price fourth from the right. Lynn was a committed socialist, politician, activist and medical doctor, as well as an active suffragist. She was an honorary vice-president of the Irish Women Workers' Union and denounced the poor working conditions of many women workers. In 1919, she founded St Ultan's Hospital for Infants on Charlemont Street with ffrench-Mullen. Lynn and ffrench-Mullen lived together for over thirty years, and it is now accepted by historians that they were in a relationship. Stopford Price worked in St Ultan's and in Baggot Street Hospital for most of her career. She studied the tuberculosis vaccination (BCG) on the continent and pioneered its use in St Ultan's in 1937, making it the first hospital in Ireland or Britain to use the BCG. She was nominated for the World Health Organisation Léon Bernard prize for her contribution to social medicine, and was chairman of the National BCG Centre, set up at St Ultan's in 1949.

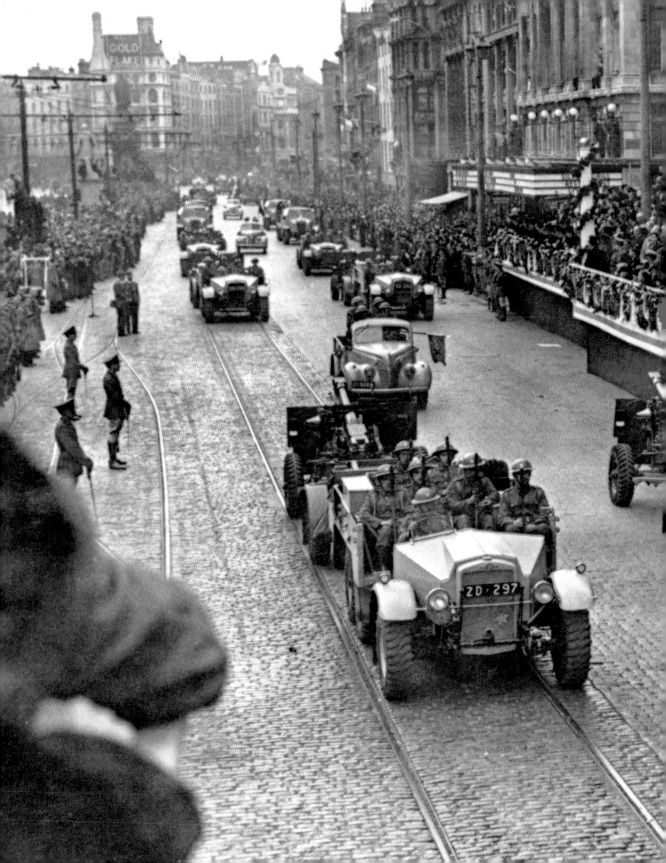

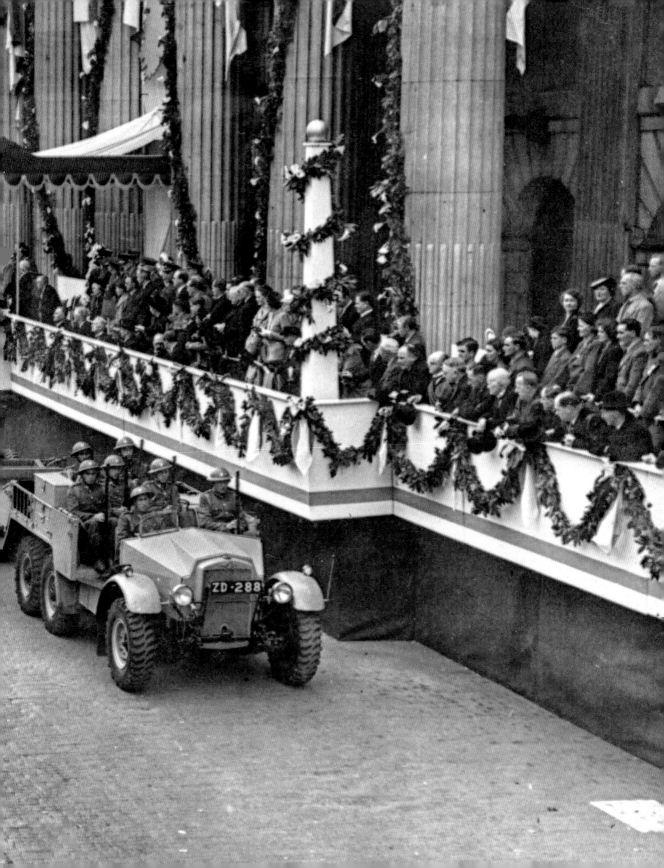

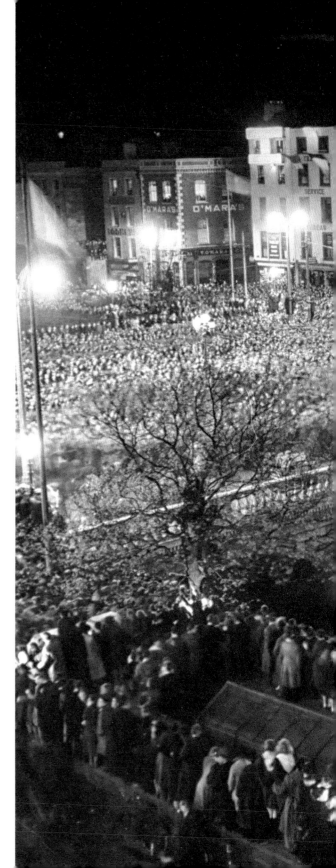

IRISH REPUBLIC DECLARED

18 April 1949, Dublin

The Republic of Ireland Act was signed into law on 21 December 1948 and came into force on 18 April 1949 – Easter Monday and the thirty-third anniversary of the beginning of the Easter Rising. This image shows the official celebration on O'Connell Street.

THE REPUBLIC CELEBRATES

18 April 1949, Dublin

Crowds gather on O'Connell Bridge, on the quays and even in the trees to celebrate the official creation of the Republic. Parades and events took place all over the country. Raidió Éireann marked the Republic's official birth at one minute past midnight: 'These are the first moments of Easter Monday, April 18th, 1949. Since midnight, for the first time in history, international recognition has been accorded to the Republic of Ireland.' This image shows the enormous reaction to the event and the party atmosphere.

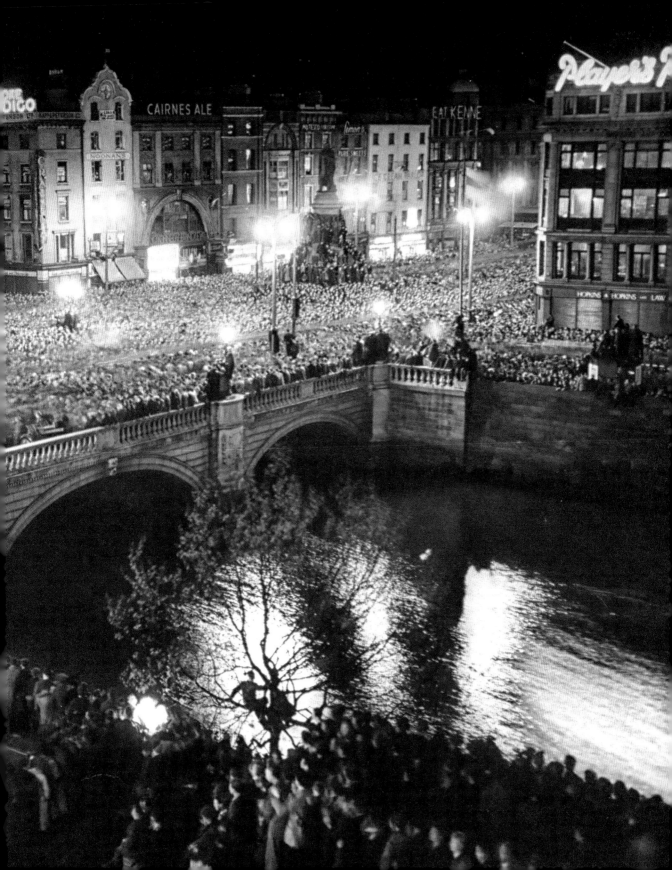

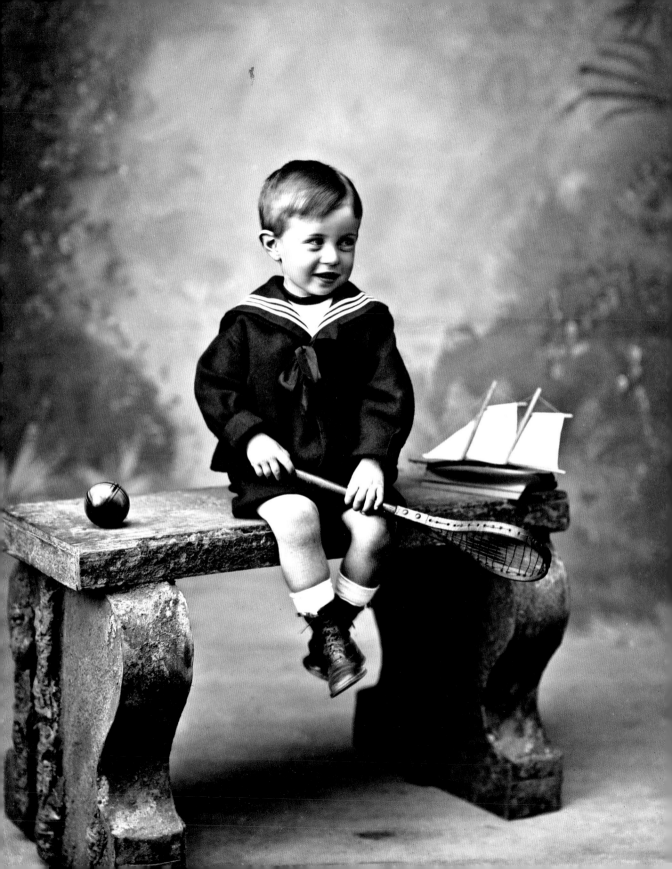

CHILDHOOD AND YOUTH

MASTER O'BRIEN

20 September 1910, Coolmore, Fermoy, Co. Cork

Two-year-old James Gerard O'Brien is pictured here with a racquet, ball and toy boat. The sailor outfit he is wearing became a hugely popular choice for young boys in the second half of the nineteenth century, particularly as Queen Victoria regularly dressed her sons and daughters in the outfit. In her study of middle-class childhood, Mary Hatfield notes that age rather than gender dictated dress, and younger girls and boys often required clothing that facilitated movement and toilet use.

FAMILY PORTRAIT

1860s, Cookstown, Co. Tyrone

A *carte de visite* was a photograph mounted on a piece of card the size of a formal visiting card – hence the name. The format was patented by the French photographer André-Adolphe-Eugène Disdéri in 1854 and was introduced to England in 1857. In May 1860, J.E. Mayall took *carte* portraits of Queen Victoria, Prince Albert and their children. These were published later that year and the popularity of *carte* portraits soared.

AFTER THE GREAT FAMINE

*c.*1854, Richmond Barracks, Templemore, Co. Tipperary

One of the earliest images in the book, this shows two young boys (or possibly a girl and a boy) just after the Great Famine (*an Gorta Mór*, 1845–1852). Two million people died during the Famine, a watershed moment in modern Irish history. It had profound effects on family life, migration, housing, politics, the Irish language and welfare. Before the Famine, the population of Ireland was eight million. The Famine also had a major impact on children and childhood, and this image raises questions surrounding poor relief, childhood mortality and the position of children in nineteenth-century Ireland.

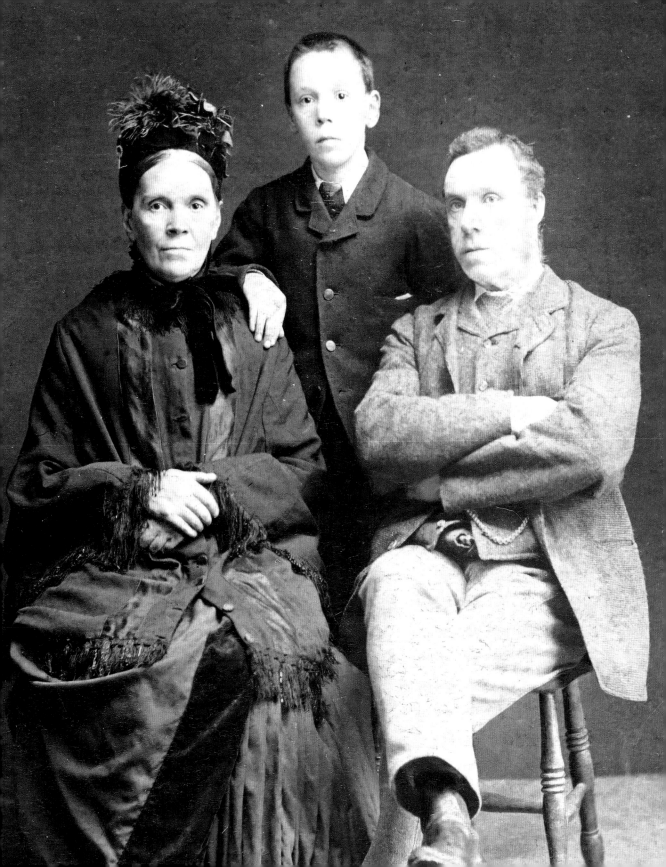

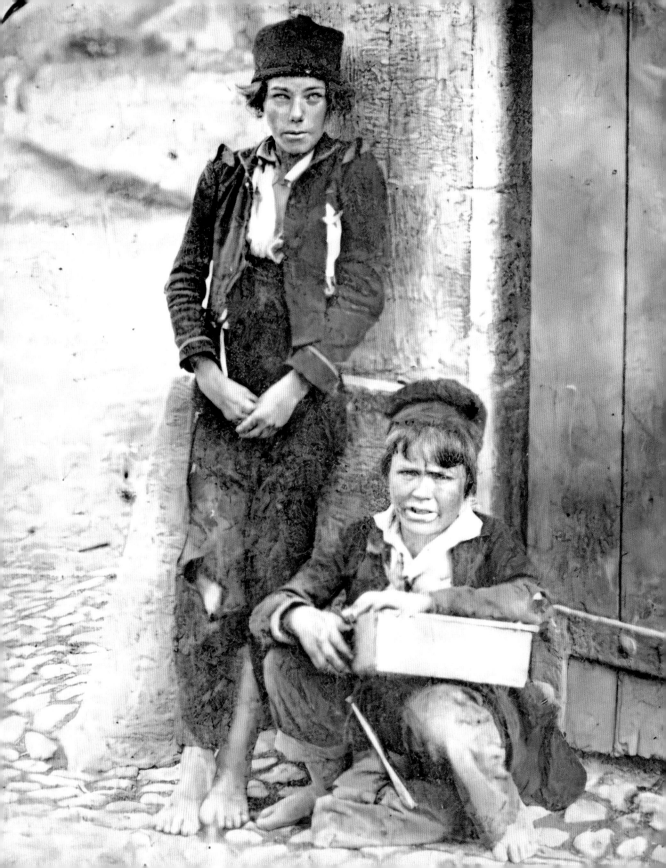

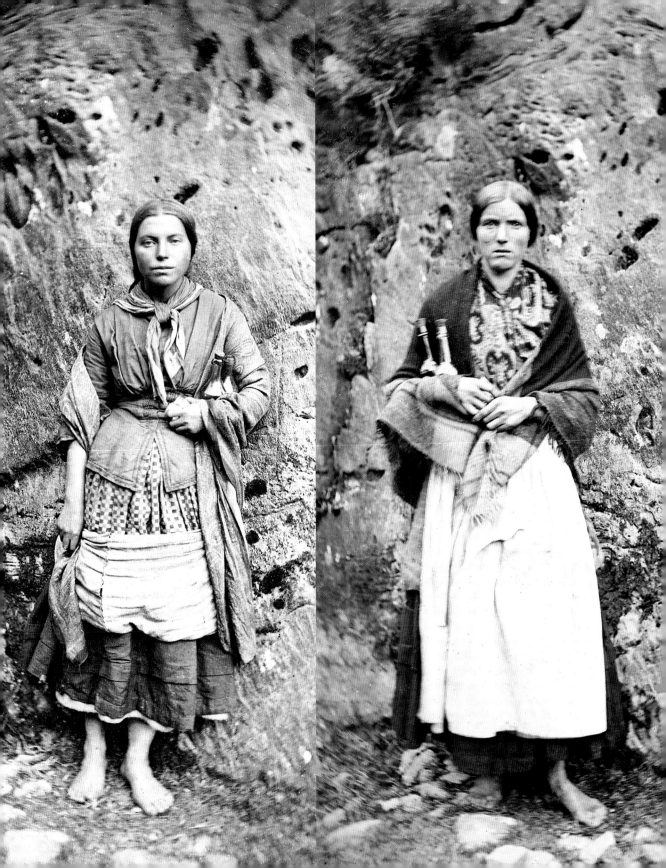

GAP GIRLS

1860–1883, Gap of Dunloe, Co. Kerry

These images are part of the Stereo Pairs Collection in the National Library of Ireland. The collection consisted of negatives acquired by William Lawrence. These images were created by Dublin photographers James Simonton and Frederick Holland Mares, and include a series of seven portraits of girls from the Gap of Dunloe. These particular images depict Joanna Keefe and Norah O'Connell, who were selling refreshments to visitors to the Gap. Both girls are wearing red petticoats, with petticoats made of drugget, a coarse woollen cloth outside them.

ST ANNE'S

c.1880s, Francis Street, Galway

This orphanage and industrial school was founded in 1869 by the Sisters of Mercy, one year after the Industrial Schools (Ireland) Act was passed. In 1870, an inspection report stated there were on average 57 girls resident and 704 external day pupils. In 1925, the school moved to Lenaboy Castle, Taylor's Hill Road, where grave concerns were expressed by Dr Anna McCabe, the inspector of industrial schools. She reported that many of the children looked 'emaciated' and two-thirds had scabies. 'Lenaboy', as it was known, remained open as a residential home and child psychiatric clinic until the 1990s. In 2017 the property was donated to Galway City Council.

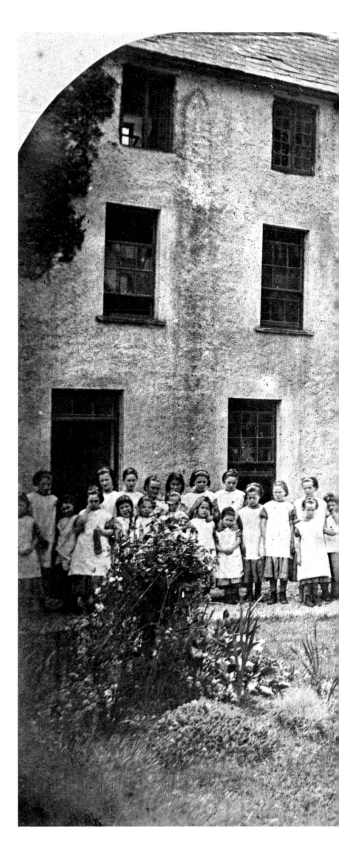

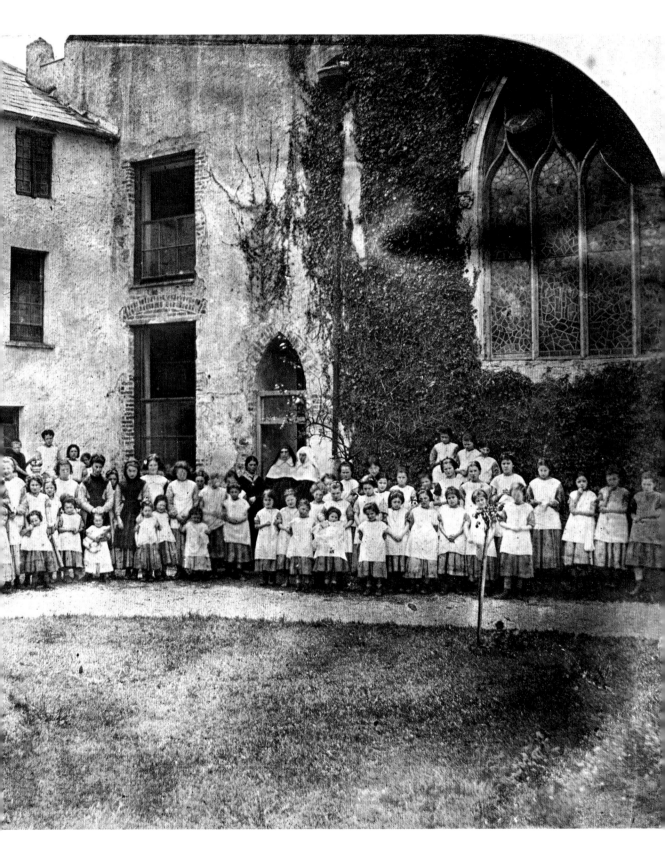

THE O'HALLORAN SISTERS

June 1887, Bodyke, Co. Clare

This image depicts the O'Halloran sisters – Annie, Honoria and Sarah – with a fourth unidentified girl. The sisters were living with their parents and their brothers, Patrick and Frank, as tenants of Colonel John O'Callaghan during the Land War. They became one of the families to participate in the Bodyke rent boycotts, and in June 1887 they resisted eviction from the land their family had lived and worked on for generations. O'Callaghan had been charging £31, which the court ordered be reduced to £22 10s, a sum the family maintained was still unfair. In his account of the resistance, Frank describes how his sisters threw cans of scalding water to ward off bailiffs, and Honoria even managed to grab the 'sword-bayonet' of one of the policemen, who was trying to come through a window.

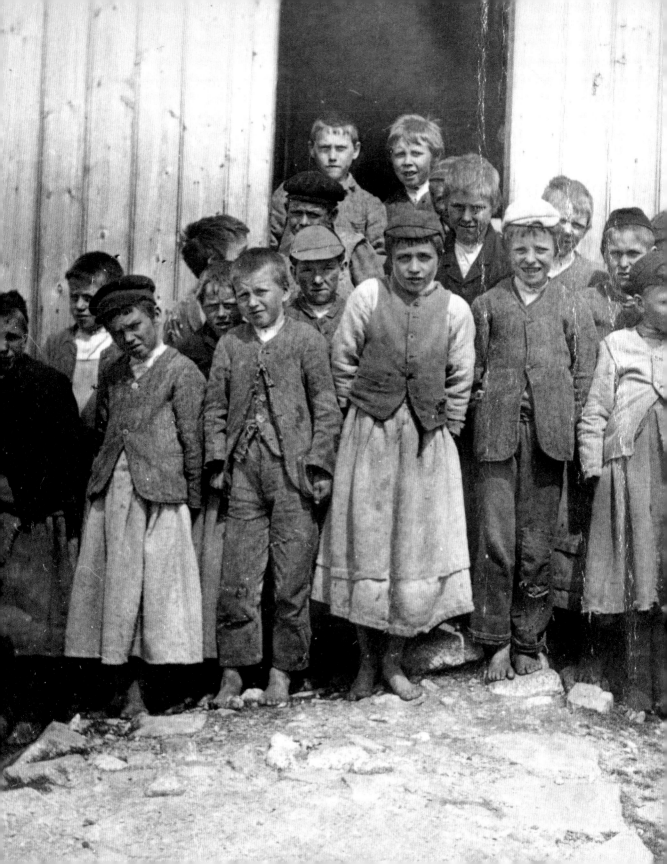

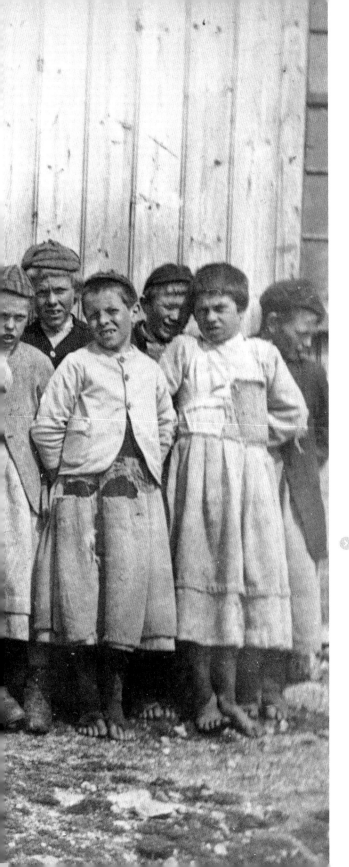

THE CONGESTED DISTRICTS BOARD

1892, Connemara, Co. Galway

The Congested Districts Board for Ireland was established in 1891 by A.J. Balfour, the Chief Secretary for Ireland, to alleviate poverty and congested living along the western seaboard from Donegal to West Cork. The board was dissolved in the Irish Free State in 1923. In this image, most of the boys are wearing skirts, as they were easier to make than trousers, and the children all have similar haircuts. In 1892, education was made compulsory for six- to fourteen-year-olds, although the legislation had several loopholes.

DRESSING UP

c.1890s, Co. Waterford

Second-hand clothes became very common and acceptable in the mid-to-late nineteenth century, and we know from Mairead Dunlevy's research that dye colours of the time include 'madder' red, indigo and various shades of blue, green, brown and grey. Green was not often worn by children due to its association with the fairies.

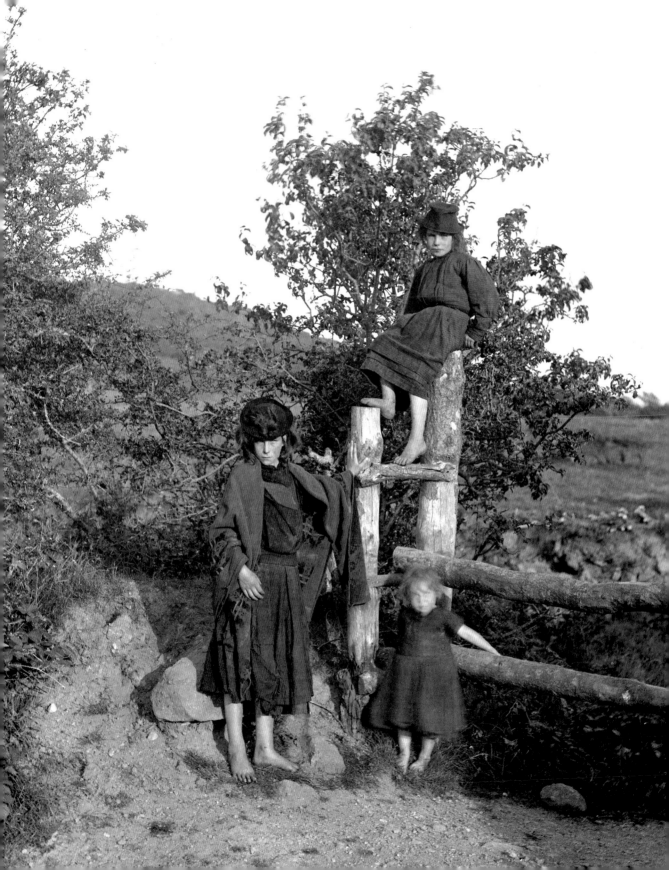

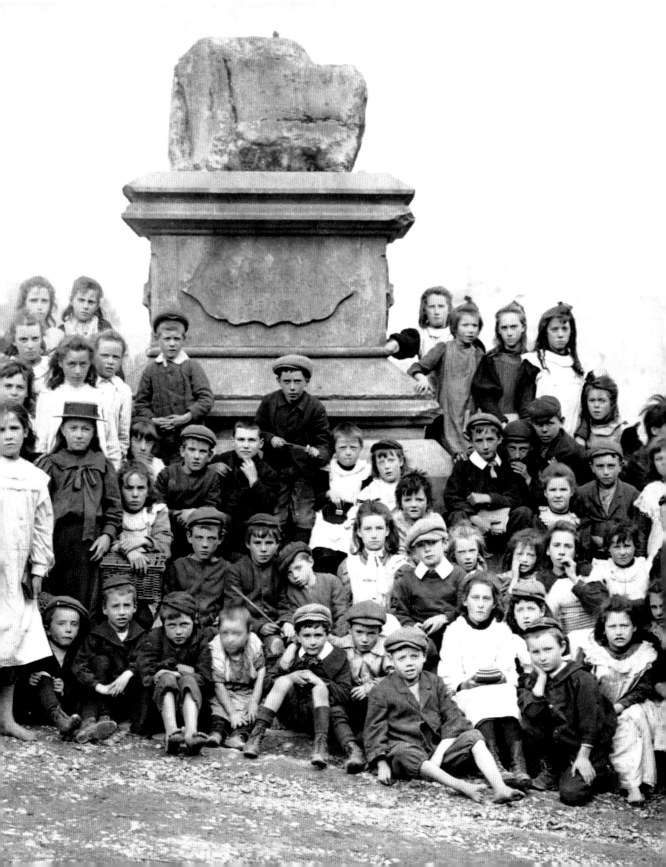

THE TREATY STONE

*c.*1903, Limerick

A group of children near the Treaty Stone, where the Treaty of Limerick was signed in 1691, marking the surrender of the city to William of Orange. Since May 1865, the stone has rested on a pedestal erected by John Richard Tinsley, Mayor of the city, at the north end of Thomond Bridge.

ADD AND SUBTRACT

*c.*1890s, Mount Sion School, Waterford

This image shows boys sitting around an adding machine and most likely studying book-keeping. The school was initially founded in 1803, and the earliest records indicate that the site belonged to the Knights Templar from 1250 to 1540. In 1803, the land was leased to Edmund Rice, the Catholic missionary and educationalist. Rice had started his first school in New Street in 1802. In 1889, a decision was made to provide a paying school for well-to-do children. It started in the Mount Sion Monastery in 1890 and then moved to its new building at Waterpark in 1912.

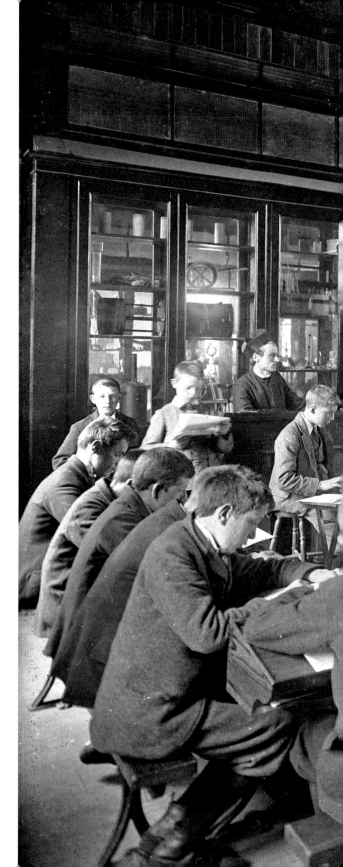

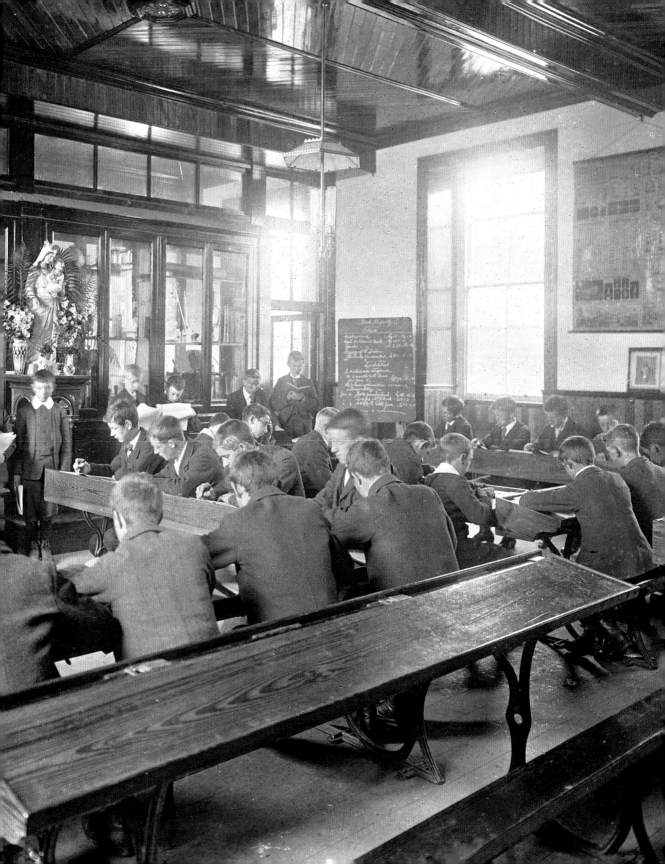

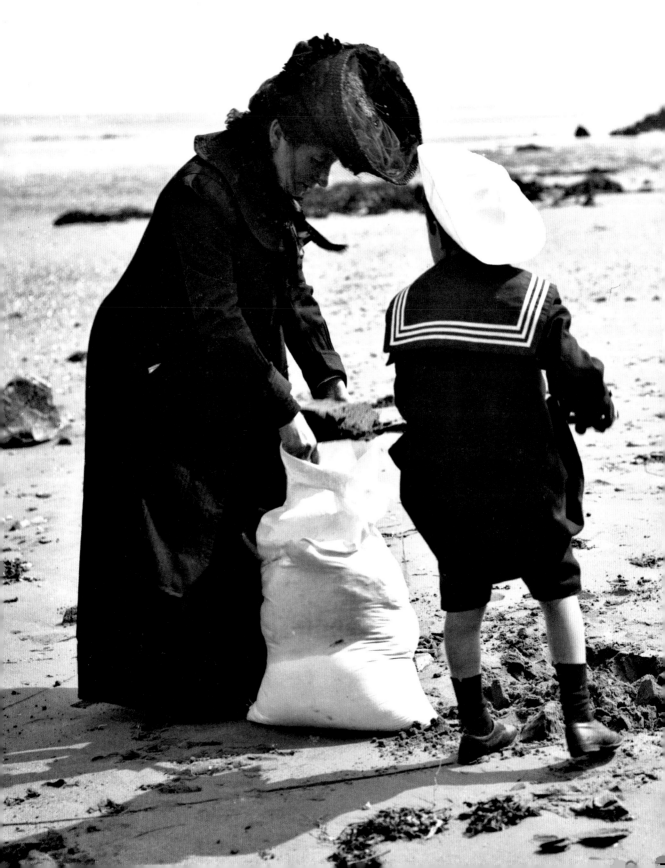

LIFE'S A BEACH

1904, Co. Louth

Jane Emily Tempest and her son Trevor filling a bag with sand on Blackrock Beach. The photo was taken by Jane's son Harry. Trevor would later participate as a lieutenant in the First World War. Blackrock Beach, with its promenade and beautiful surrounding areas, has been a popular seaside resort since Victorian times. It had developed as a fishing village in the early 1800s. By 1845, visitors were complaining about a lack of accommodation, so Thomas Fortescue, the local landlord, had a wall along the main beach and several hotels built.

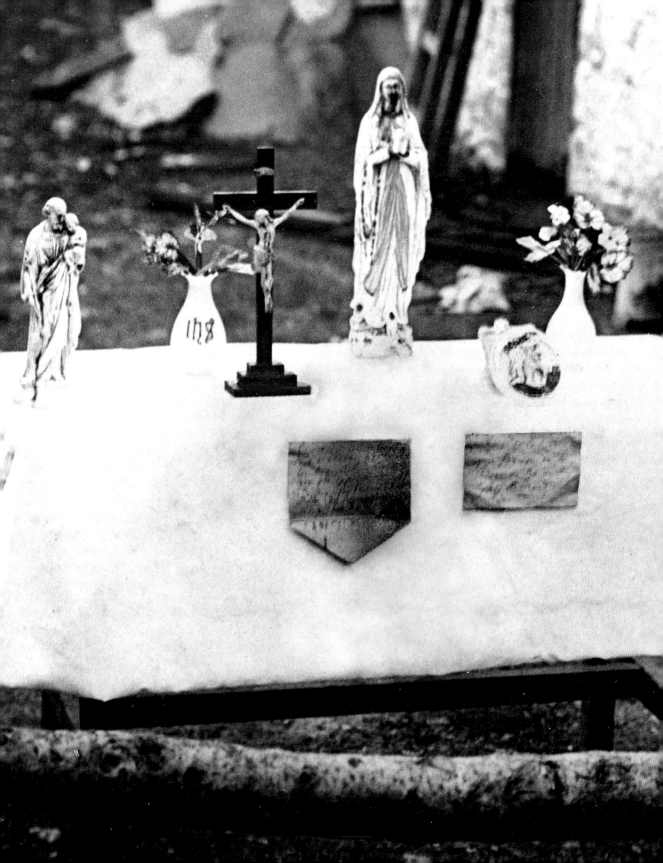

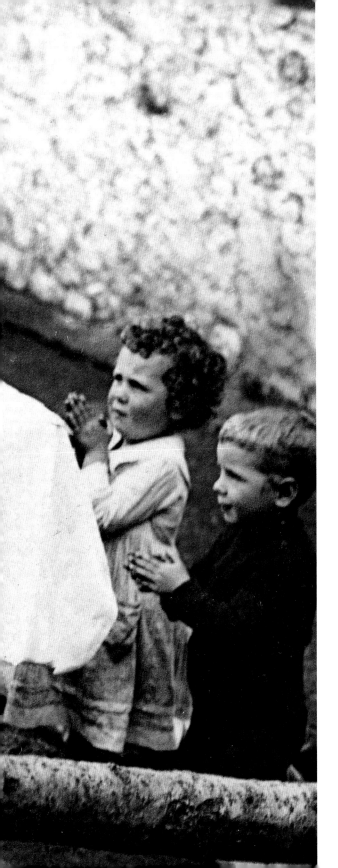

BLEEDING STATUES

22 August 1920, Co. Tipperary

During the War of Independence local people in Templemore believed a miracle had stopped the complete destruction of the town during British Army reprisals. Around 15,000 people a day came to pray at the 'bleeding statues' outside Dwan's shop, and reports of 'supernatural manifestations, accompanied by cures' reached IRA headquarters. After he had received information from the local Catholic clergy that IRA Volunteers had engineered statues that would bleed at specific times, Michael Collins sent a courier to Tipperary to acquire one of the statues. The internal mechanism of an alarm clock had been concealed inside the statue, connected to fountain pen inserts containing a mixture of sheep's blood and water. When the clock mechanism struck at certain times, it would send a spurt of blood through the statue, giving the impression that it was bleeding. According to an eyewitness, Collins, '… took hold of the statue and banged it off the side of the desk, and of course out fell the works of the alarm clock. "I knew it", he says. So that was the end of the bleeding statue.'

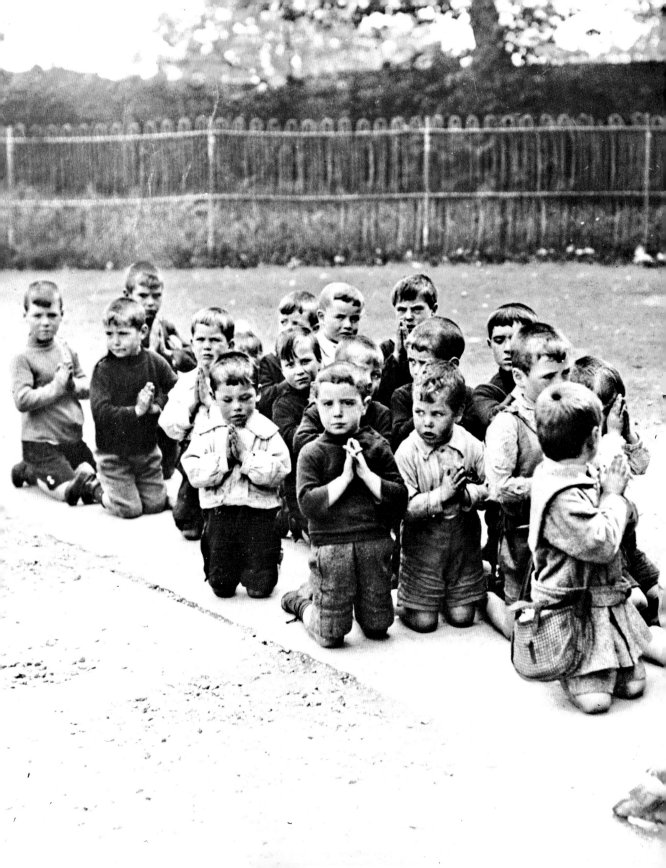

PRAYING FOR THE LORD MAYOR OF CORK

1920, Cork

In 1920, Cork City lost two Lord Mayors – Tómas MacCurtain and Terence MacSwiney. At regular intervals, masses of intercession were held with women and children to pray for their souls. Public prayers projected Catholic morality and respectability but were also a safe way to allow the public to peacefully display their political allegiances on the streets at a time when Crown Forces were liable to attack civilians at the slightest provocation.

THE DOLLS' HOSPITAL

15 May 1924, Ursuline Convent,
Waterford

The first pupils began their education in
the Ursuline Convent on 8 September
1816 at the foundation house, and the
Secondary Day School of St Anne's
opened in 1892. Founded in 1535 in
Brescia, Italy, by St Angela Merici, the
Ursulines have been involved in the work
of education since their foundation. It
was not unusual in the nineteenth and
early twentieth centuries for children to
dress up as adults and mimic their roles –
in this case a 'dolls' hospital'.

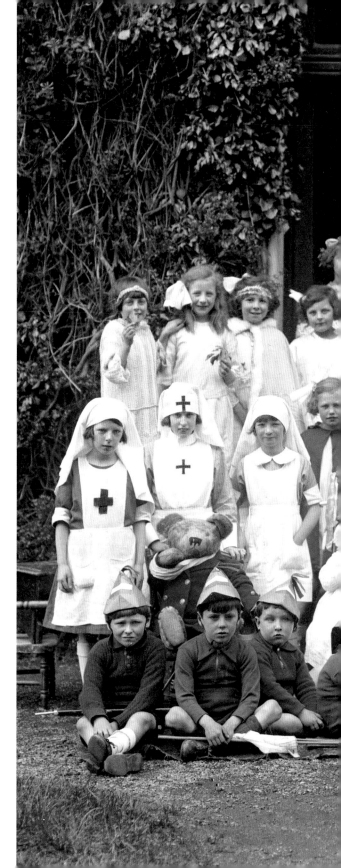

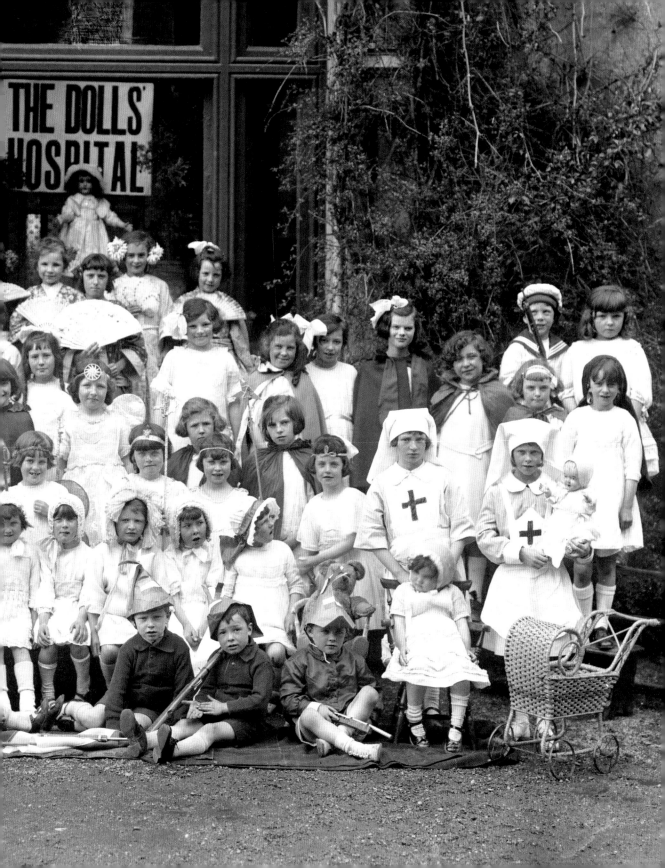

THE BIG SNOW

1947, Belturbet, Co. Cavan

'Worst blizzard for 25 years hits Ireland', was the front-page headline on *The Irish Times* of 26 February 1947. After weeks of extremely low temperatures, a 12-hour blizzard hit the country. A 25 per cent electricity reduction was imposed on businesses and private users who still had power, and emergency fuel consignments were ordered from Britain as supplies dwindled. The weather also affected food, with necessities like bread, milk and margarine in short supply. It was not until 8 March that the sky cleared and the 'big snow' thawed.

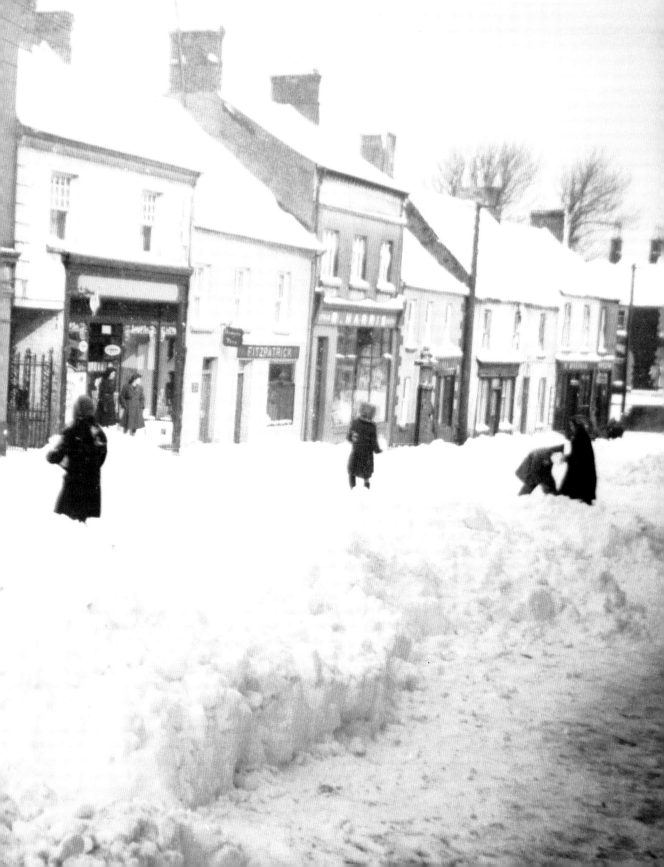

THROUGH THE GENERATIONS

1952, Inis Meáin, Aran Islands, Co. Galway

Part of the Fáilte Ireland Tourism Photographic Collection, this image shows Cata Bheag Ní Fhátharta with her grandchildren: Coilmín, Bríd, and Páraic the baby. Hardwearing, practical garments were an important feature of island life, with Connemara and West Cork being slow to change regarding fashion, and we can see this in the clothing of both the grandmother and the children. Although this photograph is from the twentieth century, we can see the family are wearing pampooties and we have assumed other traditional colours popular up to that point, including red/brown Galway shawls and petticoats.

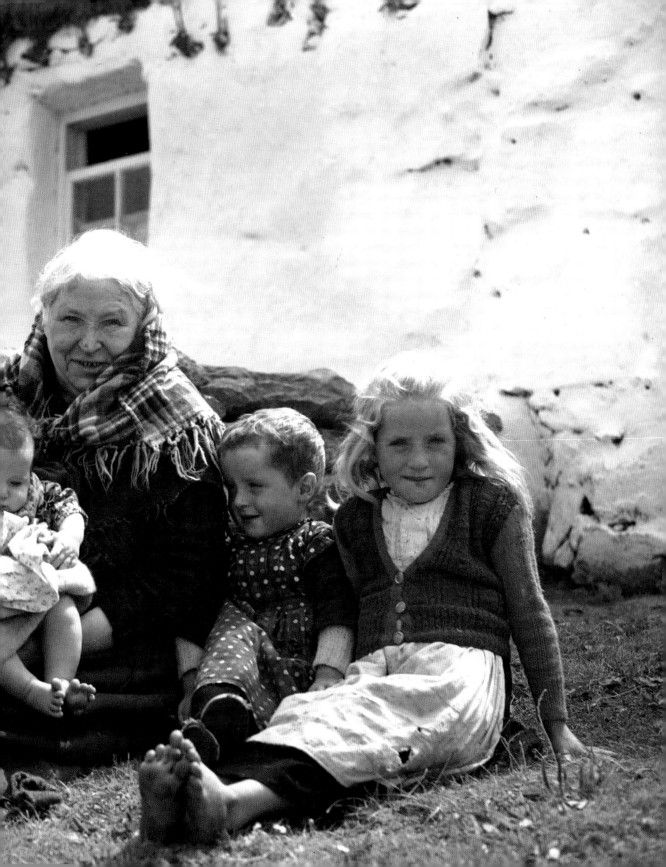

OFF TO THE HORSE FAIR

July 1954, Buttevant, Co. Cork

Women and children preparing for Cahirmee Horse Fair. The horse fair, thought to have its origins in prehistoric times, was originally held at the Fair Field of Cahirmee, three miles east of the town, but in 1921 it was transferred into the town. It is still held in July each year. Irish Travellers were ardent supporters of the fair, and crowds gathered to buy and sell horses, meet family and friends, and have weddings. There was also a famous 'parade of caravans', when highly polished and decorated barrel-top caravans were paraded through the town. The winner would receive a trophy. The woman to the front of the photo was identified by her granddaughter as Elizabeth 'Lizzie' Furey Hanafin. She was seventeen at the time and was the niece of late artist Ted Furey.

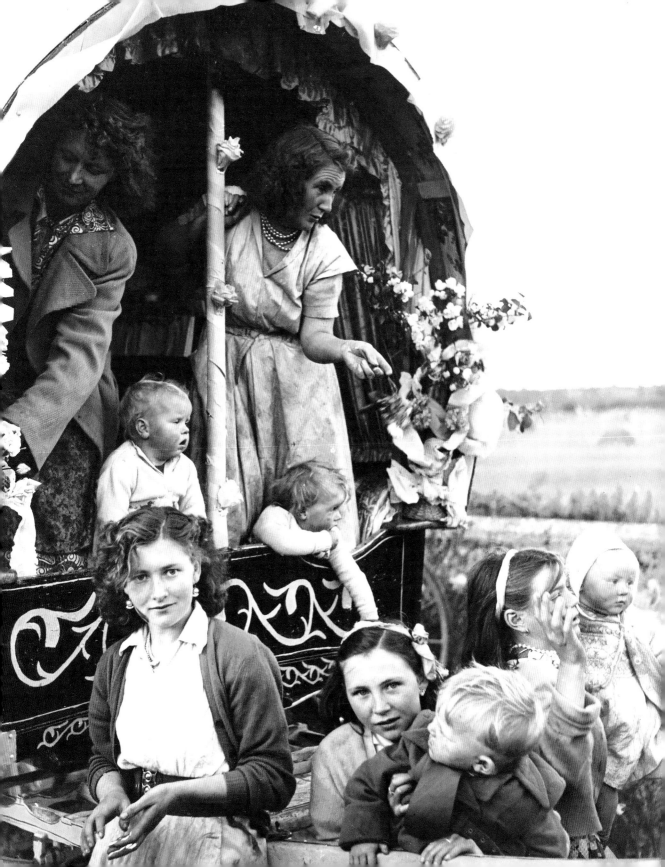

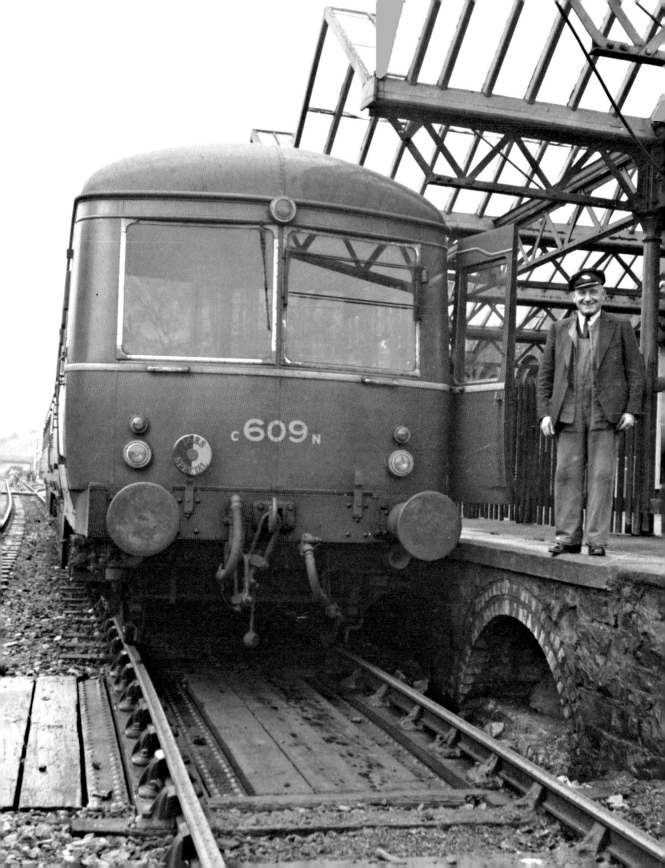

WORKING LIFE

DRIVER JOE

19 December 1959, Monaghan

This image shows 'Driver Joe' beside his train at Monaghan Railway Station. The railway to Monaghan closed on 31 December 1959 and this was the last passenger train to use it. It officially closed to passengers in 1957, but periodic specials, such as GAA trains, continued to operate. Monaghan railway station was part of the Ulster Railway designed by Sir John Macneill.

LEVIATHAN

1880s, Birr Castle, Co. Offaly

The Rosse six-foot telescope, known affectionately as the Leviathan of Parsonstown, was a reflecting telescope with a 72-inch (1.83m) aperture and 15m-long tube. It was the largest telescope in the world from 1845 until 1917, when the Hooker Telescope was built in California. The Leviathan was built by William Parsons, 3rd Earl of Rosse, on his Birr Castle estate at Parsonstown, and with it he was the first to discover that some nebulae had spiral forms.

LORD ROSS'S TELESCOPE . BIRR

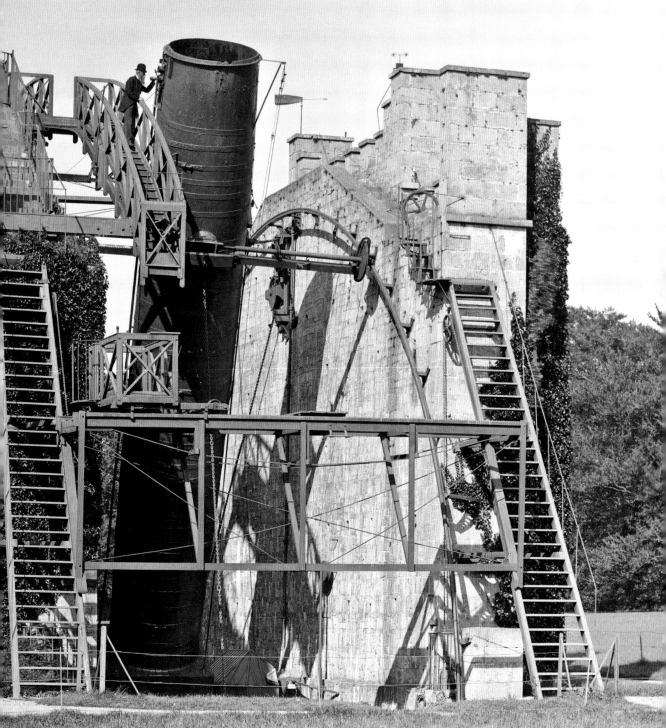

W.L.

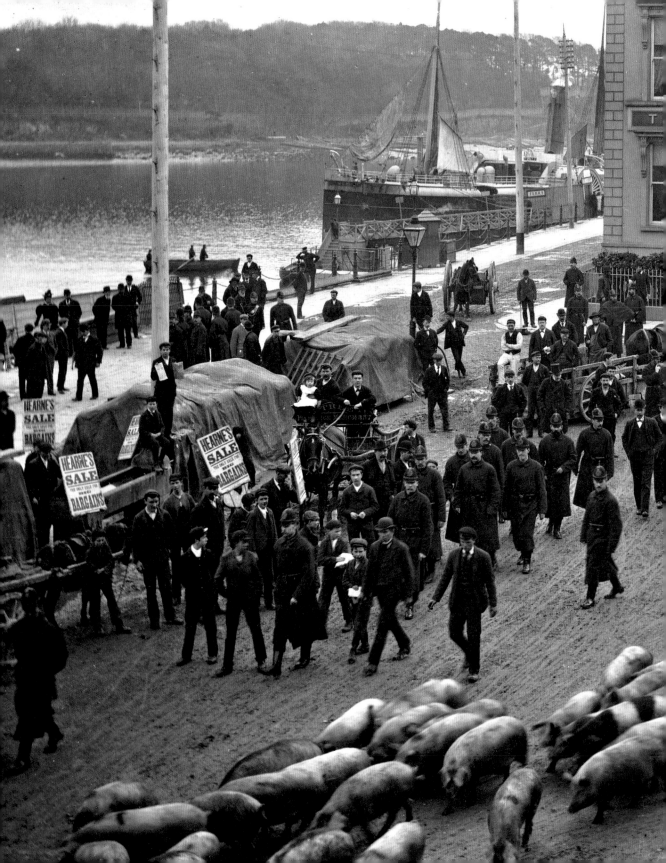

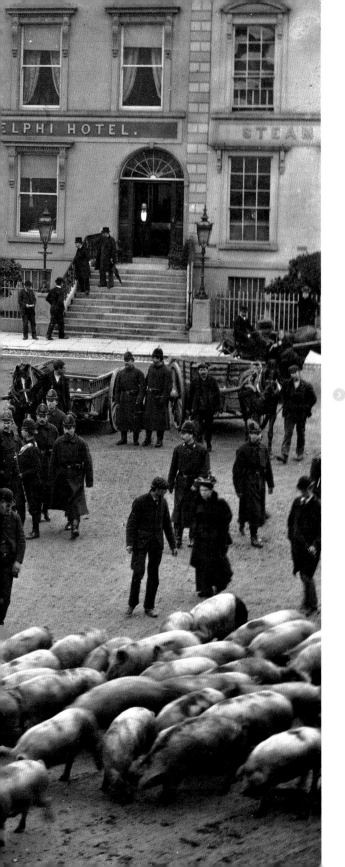

PIG STRIKE

1897, Waterford

Police escorting farmers and their pigs to a bacon factory in Waterford in January 1897. In 1892, the factories began to purchase pigs directly from farmers, bypassing professional pig buyers. The Waterford pig buyers had been campaigning to recover their role. In this image, they are attempting to buy all pigs entering the city. In the background is the historic Adelphi Hotel, which was demolished on 25 May 1970.

COCKLE PICKERS

Both images *c*.1890s, Woodstown Strand, Co. Waterford

In the late nineteenth and early twentieth centuries, many women in Waterford made their living picking, boiling and selling cockles on Michael and Peter Streets in Waterford City. They were often single or widowed, or women supplementing the family income. The practice came under pressure in the late 1930s, when several cases of typhoid were connected to contaminated shellfish. Under the new Public Health (Waterford Shellfish Laying) Regulations 1940, people were liable to prosecution and a fine of £100 if they wilfully sold or distributed cockles and other shellfish which had not been properly sterilised.

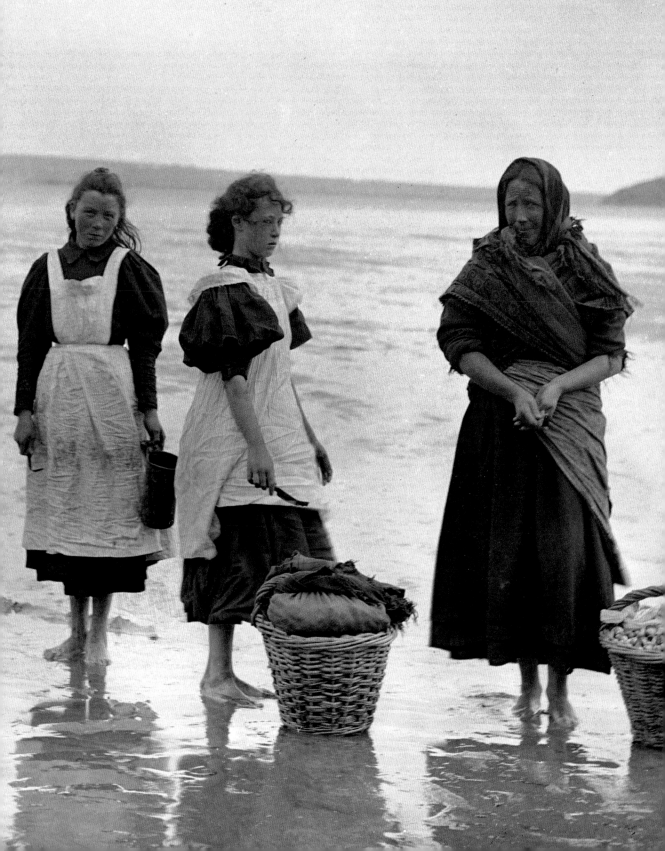

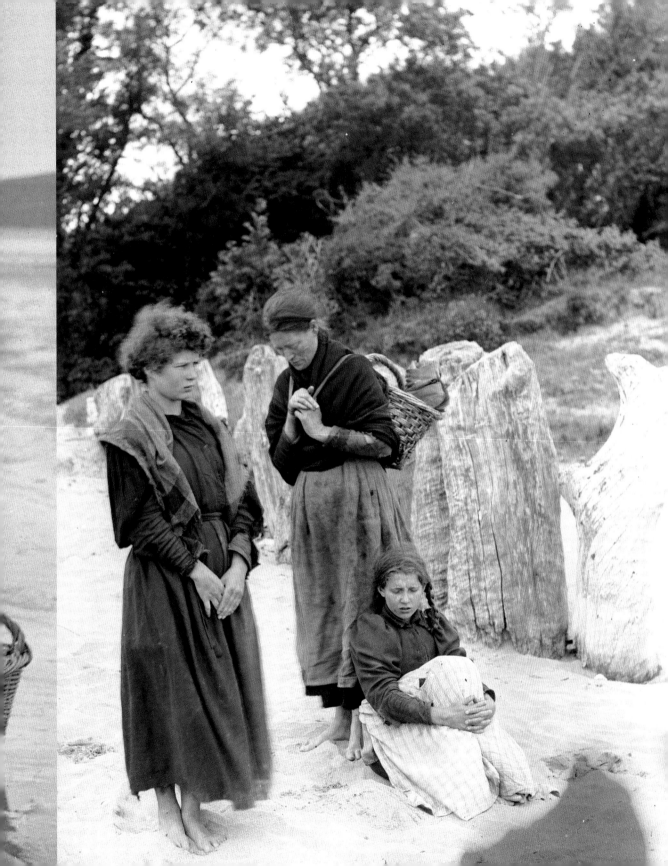

SAILORS IN THE CLADDAGH

*c.*1890, Galway

Royal Navy Reserve (RNR) sailors in the Claddagh, a traditional fishing village in Galway City. The RNR was founded in 1859 as a volunteer part-time civilian reserve force for the Royal Navy, to be used in times of crisis, such as during the two World Wars. The Claddagh fishing village would have been an obvious source for volunteers. The whitewashed cottages seen here were demolished by the 1930s due to their unsanitary living conditions. This photograph was likely taken by Robert French, the chief photographer responsible for photographing three-quarters of the Lawrence Collection.

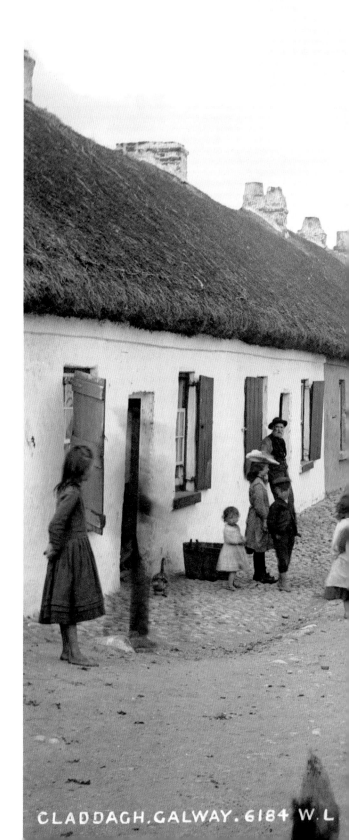

CLADDAGH.GALWAY. 6184 W. L

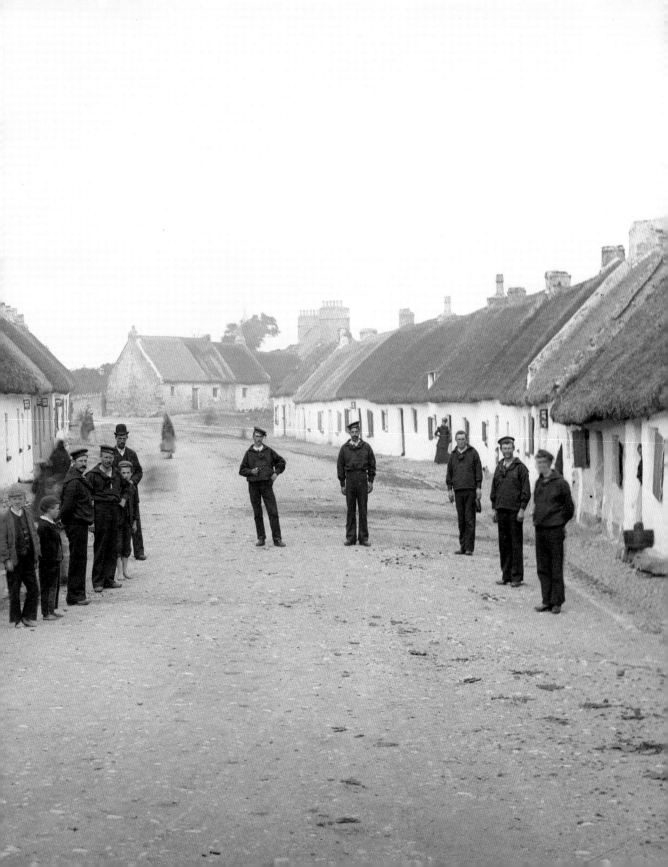

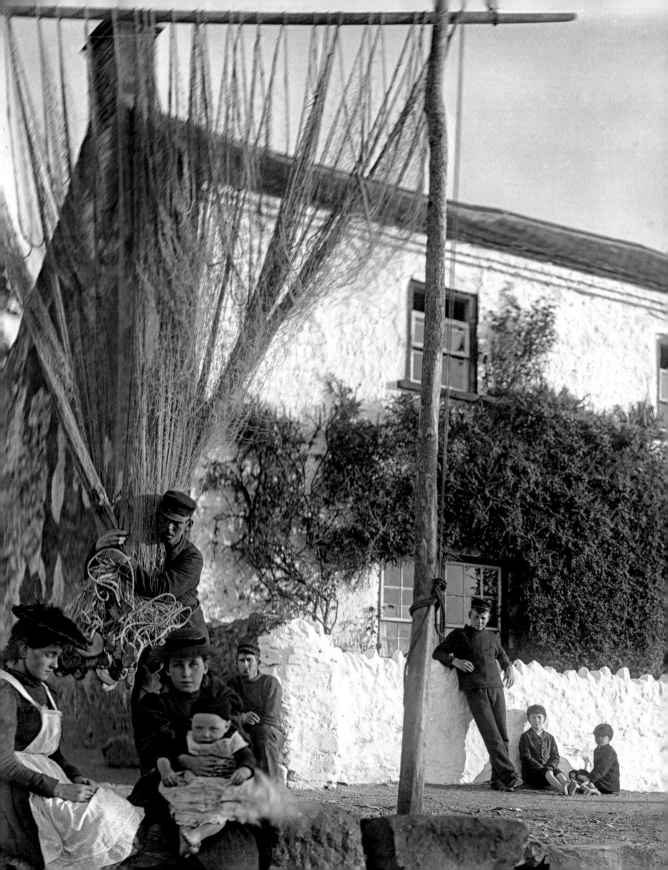

DOHERTY'S SHOP

*c.*1890s, Cheekpoint, Co. Waterford

This image from the Breslin Archive shows people from Cheekpoint fishing village sitting outside Doherty's shop. Michael 'Mick' Doherty is at the gate. Some fishing nets are hanging out to dry on the left-hand side of the photograph. From the nineteenth century, Cheekpoint was used as a fishing harbour and became known for a certain type of small fishing craft called the Cheekpoint Prong. The Prong was shaped like a half bottle and ideal for river fishing. It was used for long lining and salmon fishing with drift nets, snap nets and draft nets.

SILENCE IS REQUESTED!

*c.*1890–1900, Reading Room, National Library of Ireland, Dublin

The National Library of Ireland was established by the Dublin Science and Art Museum Act of 1877. At their first meeting on 21 February 1878, the Trustees appointed William Archer, librarian of the Royal Dublin Society, as the first librarian. The present building, which opened in September 1890, was designed by the architects Thomas N. Deane & Son. Thanks to staff at the NLI for their help with reference photos of how the Reading Room used to look. The paint scheme has gone through various incarnations from what we could see, with different combinations of aqua/light blue/cream used over time.

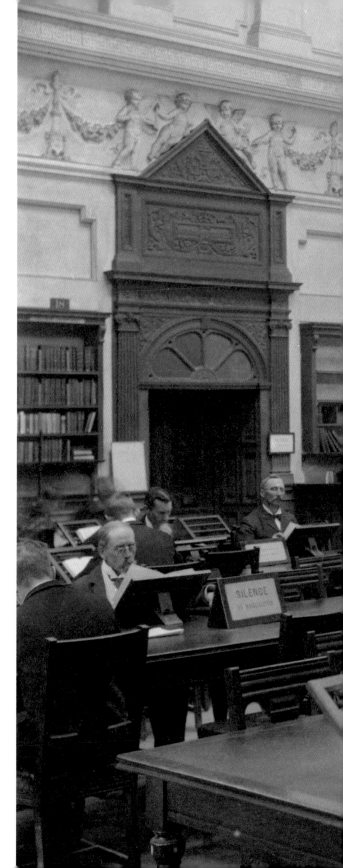

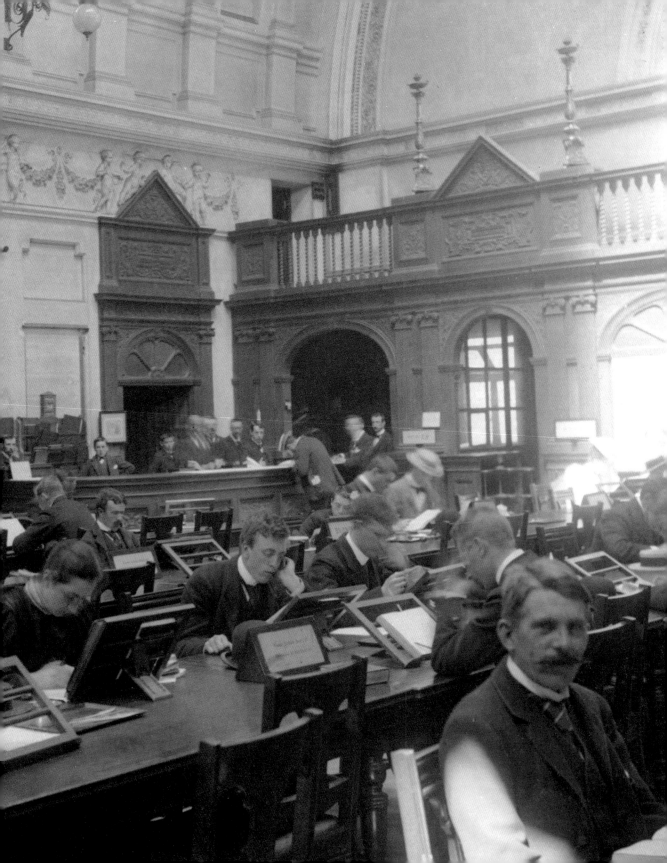

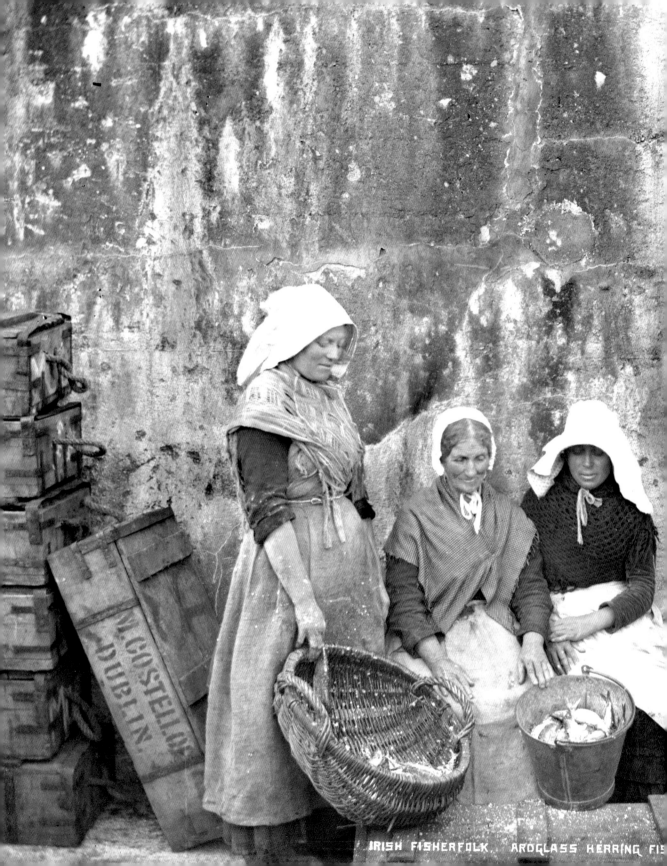

IRISH FISHERFOLK. ARDGLASS HERRING FIS

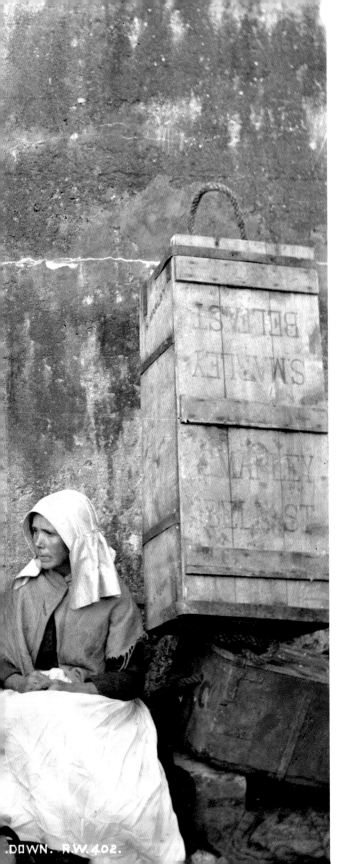

FISH HAWKERS

*c.*1900, Ardglass, Co. Down

Fish hawking, or fish selling, was popular in the nineteenth and twentieth centuries with women but was a seasonal venture. In the 1901 census for Co. Down, only four women refer to themselves as fish hawkers, while, in 1928, *The Irish Times* reported that seventy women identified as fish hawkers in the 1926 census. Ardglass is a coastal fishing village and townland that is still a relatively important fishing harbour.

BAZAAR

*c.*1899–1910, Dundalk, Co. Louth

The Casey family bazaar in Blackrock.
The term bazaar is a Persian one meaning
an enclosed market, often with different
stalls selling eclectic or exotic fair. Here,
we can see a range of products and
produce on offer – from penny periodicals
to wine, fruit, vegetables, bric-a-brac, toys
and signage – a range of treasures! Today,
the bazaar is a fruit and vegetable shop.

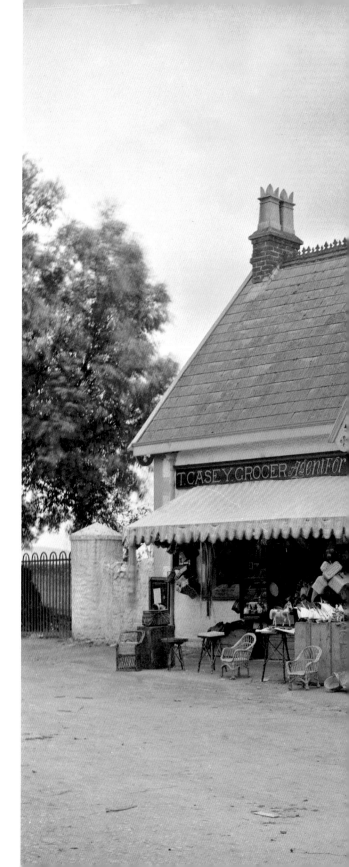

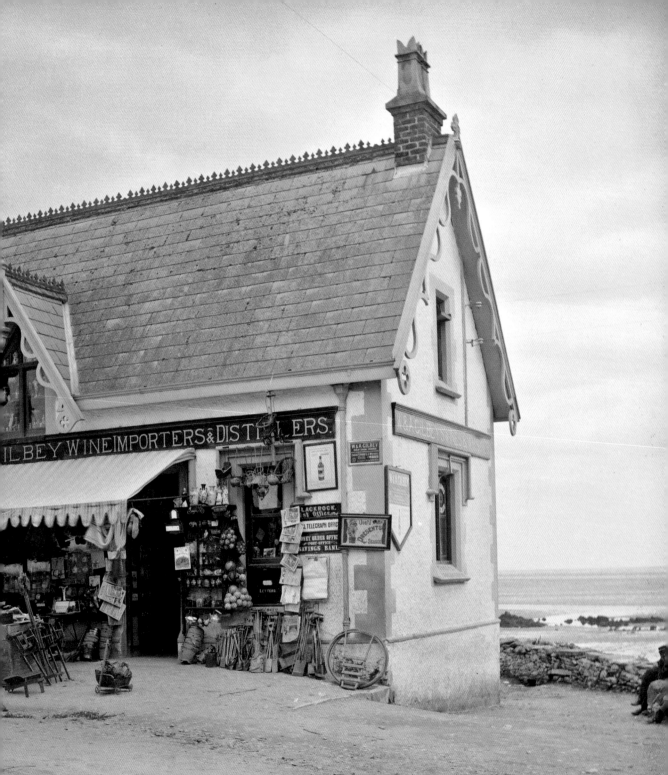

BLACKROCK BAZAAR. DUNDALK. 6 42. W.L

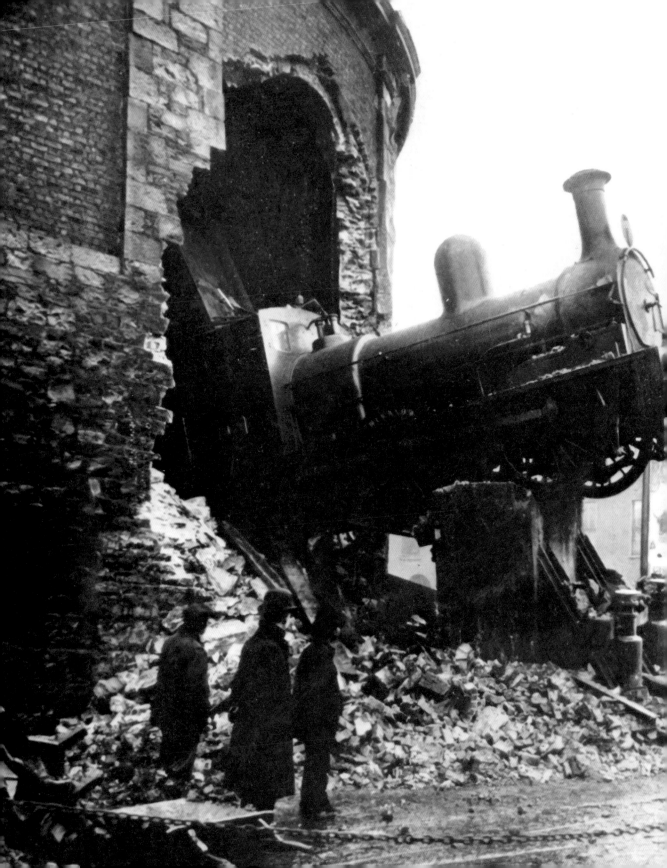

TRAIN CRASH

1900, Hatch Street, Dublin

Harcourt Street station opened in 1859 and served as the terminus of the line from Dublin to Bray. It closed in 1958, but the station is perhaps best remembered for the crash in 1900 that saw a cattle train from Enniscorthy crash through the end wall of the station, leaving the engine suspended over Hatch Street. Luckily nobody was killed, though the driver, William Hyland, had to have his right arm amputated. The engine had to be lowered down onto existing tram tracks, moved to Harcourt Road and then, on a temporary track, back to the station. In this image, we can see ads for Bovril, Pickapack Cigarettes, Manders Pale Ale, Quaker Oats, Zebra Grate Polish and TH White's Wafer Oats.

PEGGY IS EARNING WHAT PADDY IS BURNING

*c.*1900

This image depicts a typical 'third-class' house in rural Ireland at the turn of the twentieth century. According to the 1841 census, 40 per cent of rural houses were single-room mud cabins, which were associated with severe poverty. In this image, 'Peggy' is knitting; the couple's clothing is clearly in need of repair.

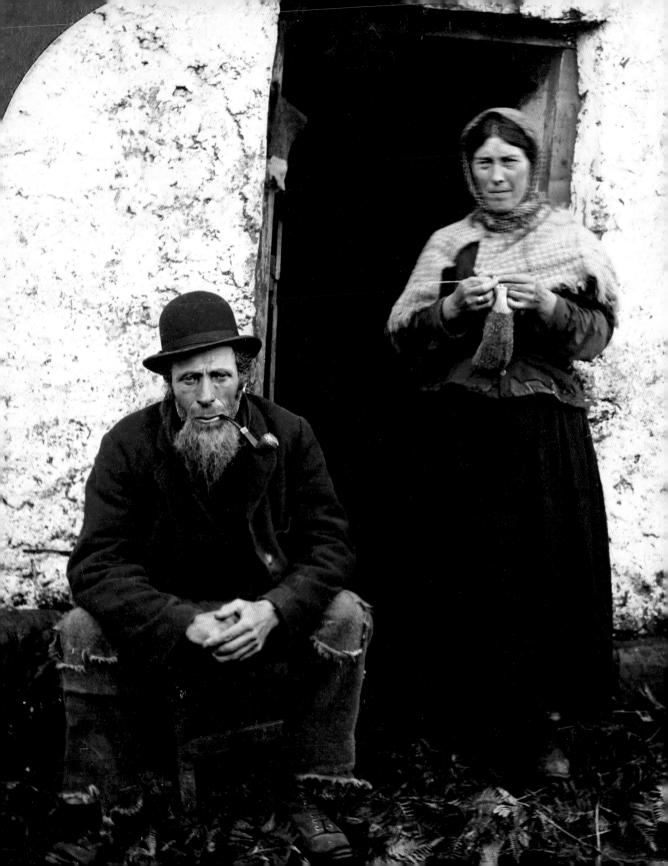

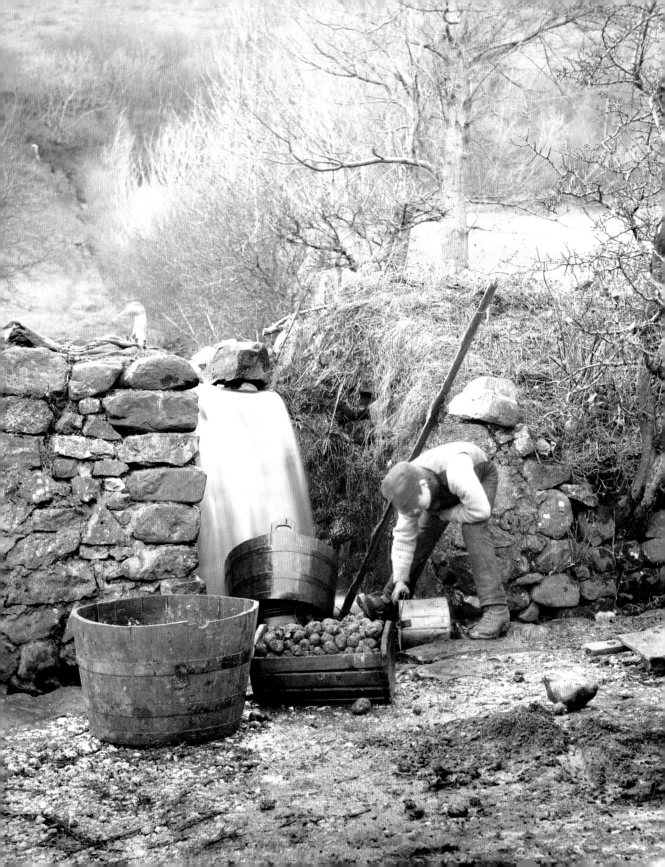

WALING SPUDS

*c.*1900, Glenariff, Co. Antrim

A boy 'waling spuds' at a waterfall. Welch noted on his original print: 'Note the curious "washer" the potatoes are in. I never saw this anywhere but in the Glens of Antrim, where "waling spuds" was till lately, and still is in places, the term for washing potatoes. The bigger tub is only a barrel cut in two.' While it is often argued that Sir Walter Raleigh introduced the potato to Ireland, it is far more likely that it was introduced by Sir Francis Drake from Spain.

FISHING SHOOT

*c.*1900, Ardara, Co. Donegal

Men, women and children fishing for commercial purposes in Ardara. The name Ard a' Ratha means 'high hill of the fort', a nod to the earthen ringfort on the hill to the northeast. In this image we can see the type of baskets used to collect fish, as well as the traditional dress of the area. Ardara had a longstanding association with tweed and knitwear – from the 1870s this became a cottage industry that produced homespun and hand-dyed woollen and tweed garments. Today it is one of five designated heritage towns in Donegal and is still known for its salmon and trout fishing.

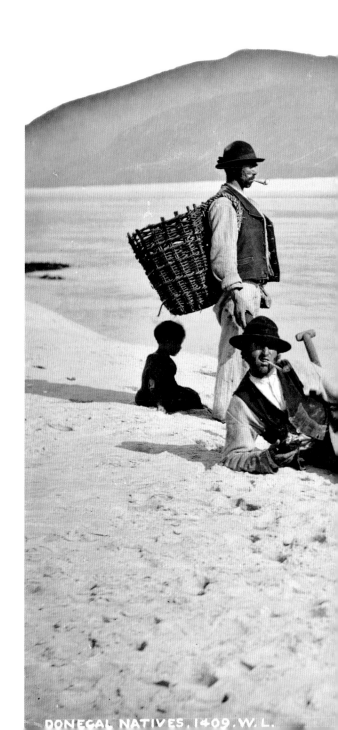

DONEGAL NATIVES, 1409. W.L.

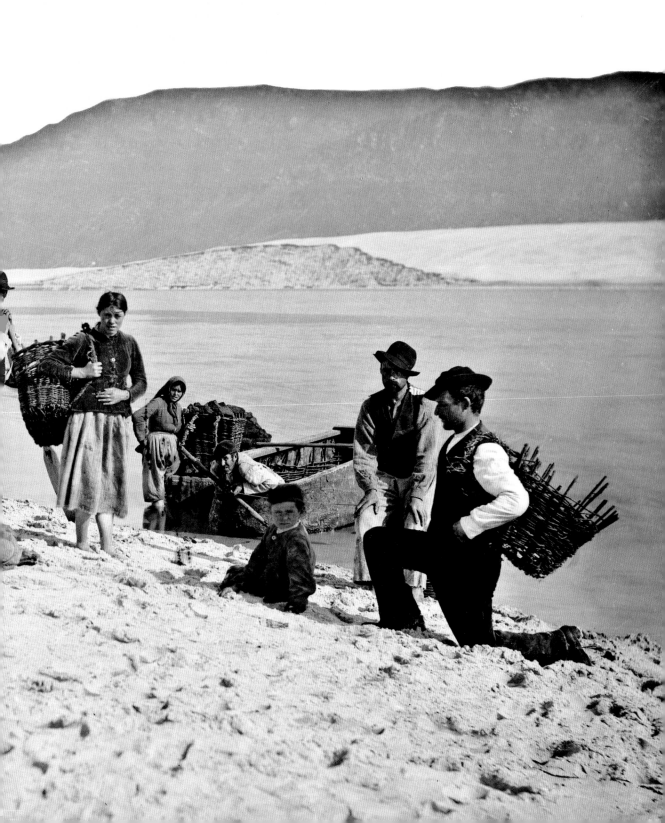

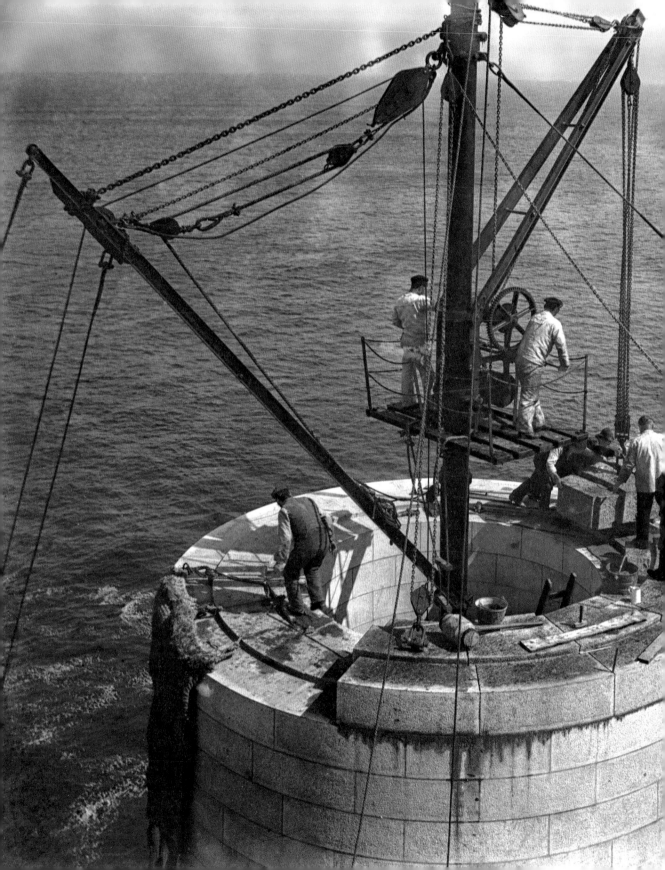

BUILDING FASTNET LIGHTHOUSE

*c.*1900, Fastnet Rock, Co. Cork

Fastnet light was established on 1 January 1854, replacing the lighthouse at Cape Clear. An external cast-iron casing was completed in 1868, but 1891 saw the decision to replace the cast-iron tower with a sturdier granite one. Designed by William Douglass, Engineer to the Commissioners of Irish Lights, this took five years to complete. Finished in 1904, it remains the tallest and widest rock lighthouse tower in Ireland and Great Britain. The new light was established on 27 June 1904. On 10 May 1969 it was converted from vaporised paraffin to electric, with a range of 28 nautical miles and the power of 2,500,000 candelas.

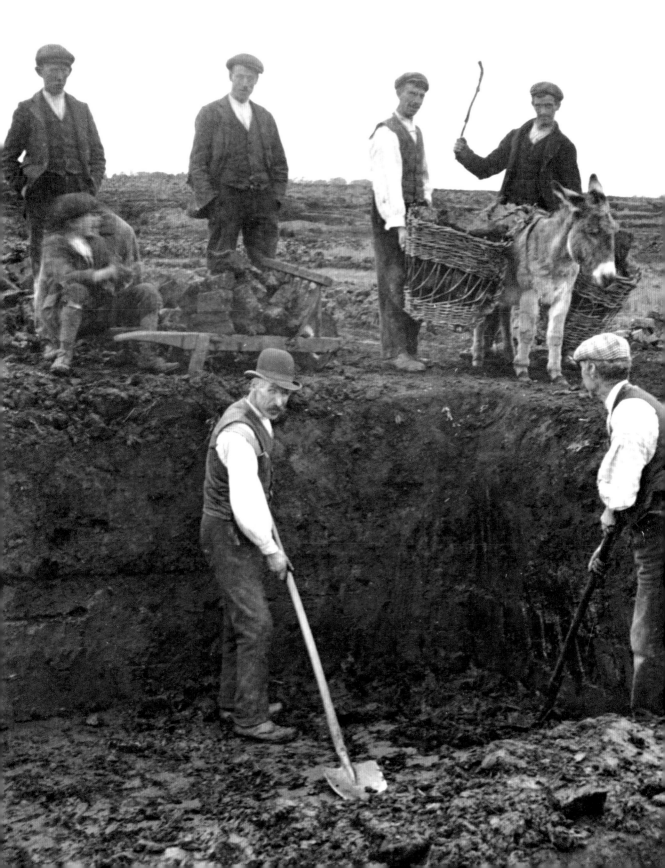

CUTTING AND CARTING TURF

1903, Kiltoom, Co. Roscommon

This image depicts two men with spades digging in a pit for turf while a group of four men look on. Peatlands in Ireland were traditionally viewed as wastelands and sources of poverty, but near the end of the nineteenth century became more popular due to a fuel crisis in coal. Measures were taken to improve the quality in the early twentieth century and in 1934 the Turf Development Board (TDB) was formed 'to develop and improve the Turf Industry …'

NURSING IN ARRANMORE

c.1906, Co. Donegal

A nurse visiting the McCauley family of Cloughcor on Arranmore Island. The baby's name is Sarah, and Fannie is the child nearest the father. District nurses were an important part of rural and island life in the nineteenth and twentieth centuries and performed a range of duties. They balanced medical and scientific developments with folk medicine and local traditions. Their role was especially important in tackling infant and maternal mortality through education and connecting families with other social services. This photograph is part of the Congested Districts Board Photographic Collection at the National Library of Ireland.

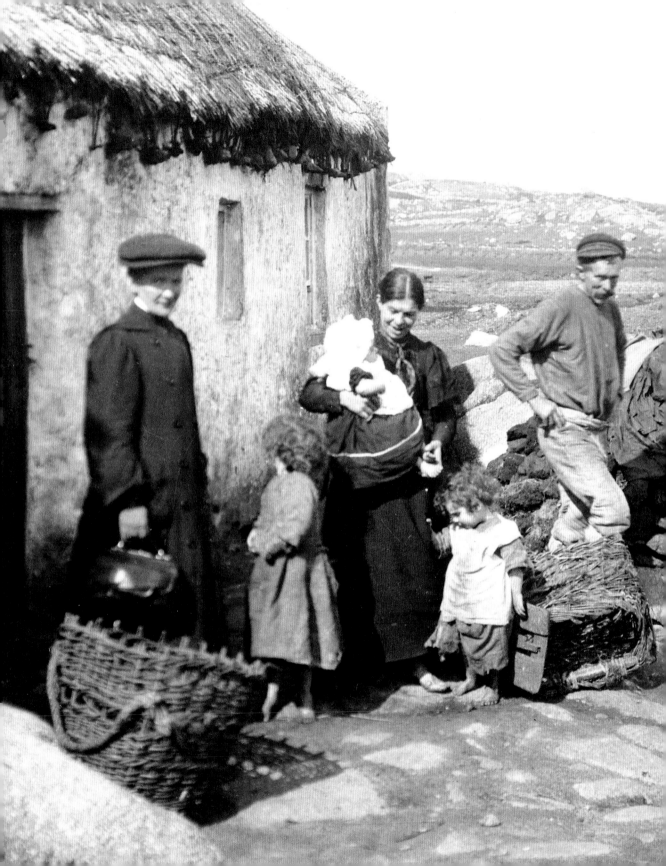

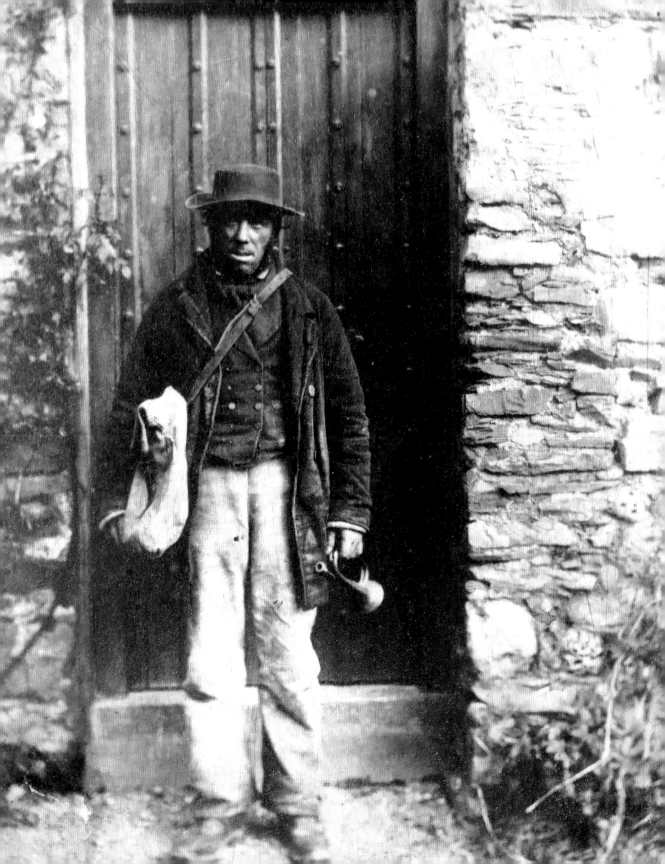

THE POST IS HERE

1910, Strangford, Co. Down

'Old Macartan' with bugle in hand. The postal system emerged in Ireland in the sixteenth century, with regular posts set up from Dublin to a few major towns in Ireland. Originally letters were delivered by 'post boys', and, before there were postboxes, bellmen in the streets would ring a bell to attract attention and collect letters. Mail coaches began to operate in 1789, speeding up delivery, while the introduction of the world's first adhesive postage stamp, the Penny Black, made the postal service affordable. The arrival of the railways made mail transport more efficient, and in 1855, the Post Office started to use special sorting carriages on trains.

OUTSIDE FLYNN AND YOUNG'S

c.1907, Conduit Lane, Waterford

Flynn and Young's was a well-known fishmongers in Waterford City, which also sold poultry. In this image we can see a number of turkeys. Employment in Waterford at the turn of the century revolved around farming and the sea – both of which were encompassed in the business.

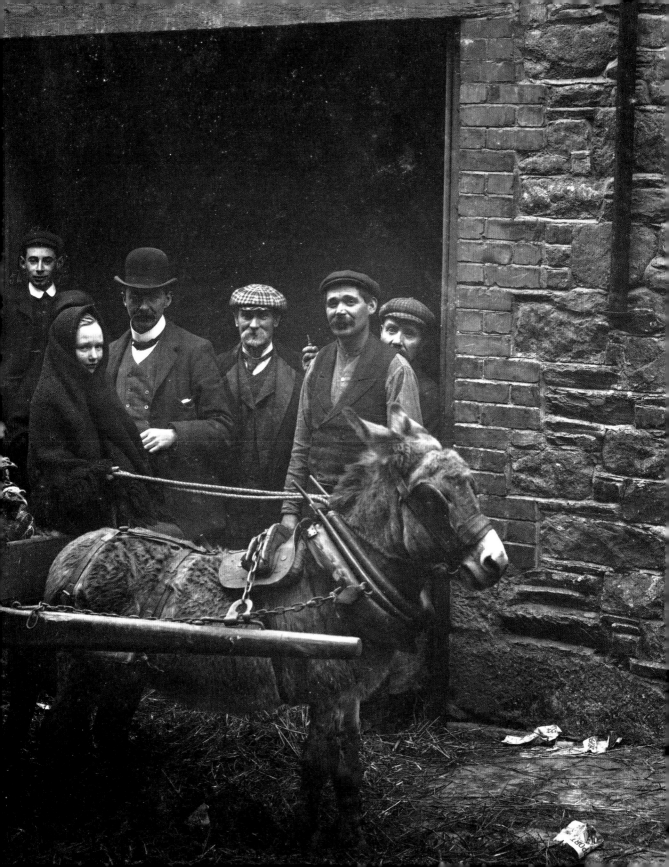

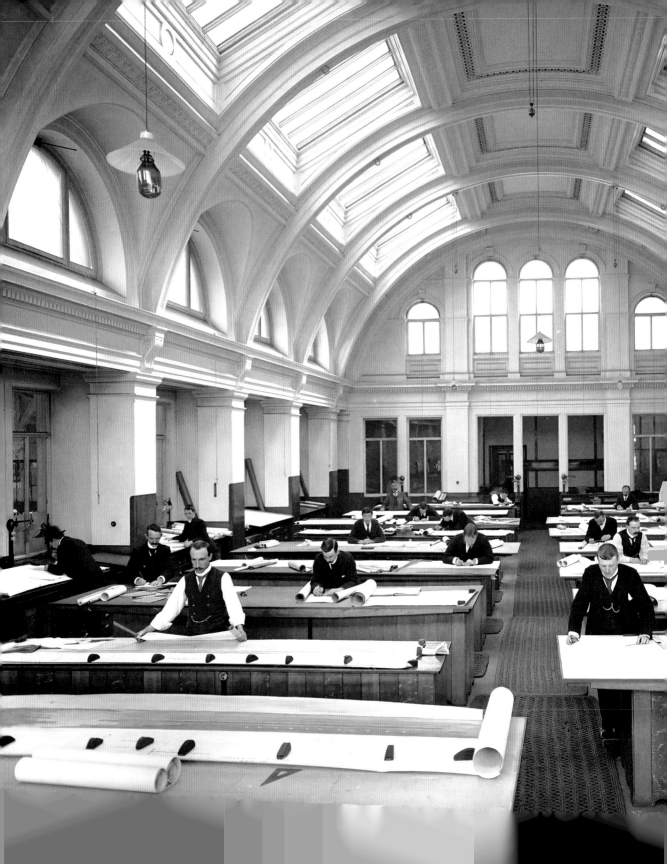

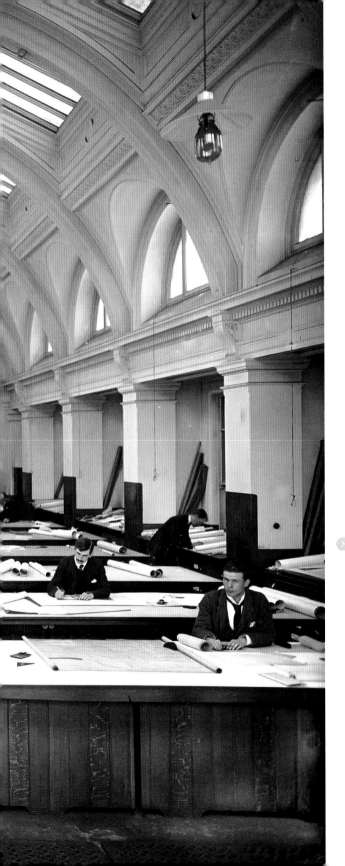

HARLAND & WOLFF

*c.*1908, Belfast

A drawing office in the draughting department of Harland & Wolff, where the *Olympic*, *Titanic* and *Britannic* liners were designed and built during the 1909 to 1914 time period. The drawing offices were built in the late 1880s when the company was emerging as one of the world's leading shipbuilders. In 1910, a three-storey building housing the administrative office was built to the south of Drawing Office One. The next year the old one-storey entrance block was demolished and replaced by the three-storey one we see today on Queen's Road. The room depicted is now part of the Titanic Hotel in Belfast.

FAIR DAY

*c.*1910, Glenties, Co. Donegal

A busy fair day scene, with sheep, dealers and onlookers on the Main Street in Glenties. O'Donnell's Hotel can be seen, as well as stalls and traders. In 1910, the *Ulster Towns Directory* states that Glenties had a population of 450, its chief industry was 'woollen and hosiery' and market day was on a Monday. Fair Day was on the twelfth of every month.

O' DONNELL'S HOTEL

FAIR DAY. GLENTIES. Co. DONEGAL. 9763. W.L.

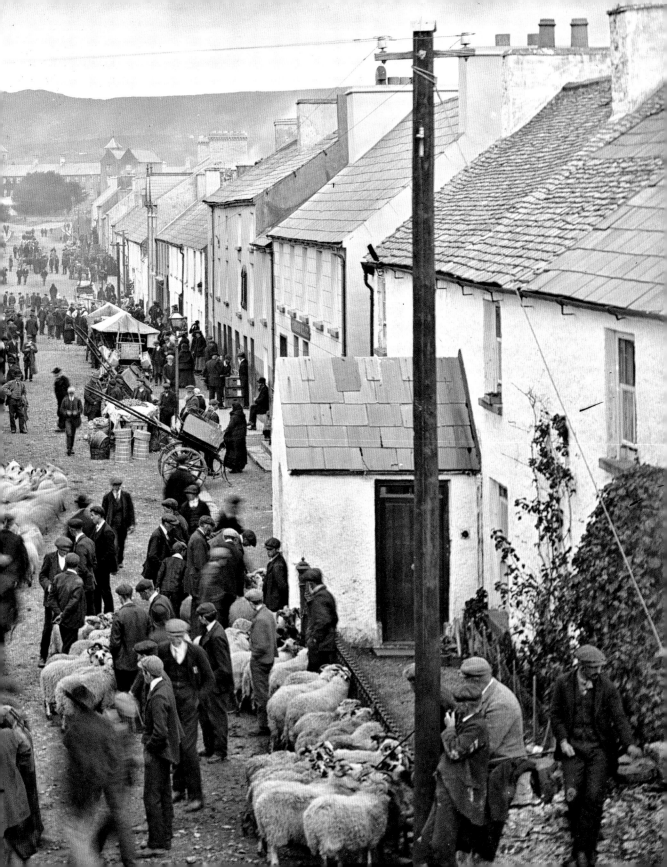

CATTLE FAIR

1865–1914, Eyre Square, Galway,

Eyre Square was the location of many of Galway's fairs and markets in the nineteenth and early twentieth centuries. The cattle fair, which was originally held at Fairhill, was an important affair and often spilled out of the square onto Forster, Williamsgate and Eglinton Streets. Pig fairs did not take up so much space, and usually took place in the area in front of where the Imperial Hotel is today. Hay was an essential commodity, so the Haymarket was a major event in the days when people travelled on horseback or in horse-drawn carriages.

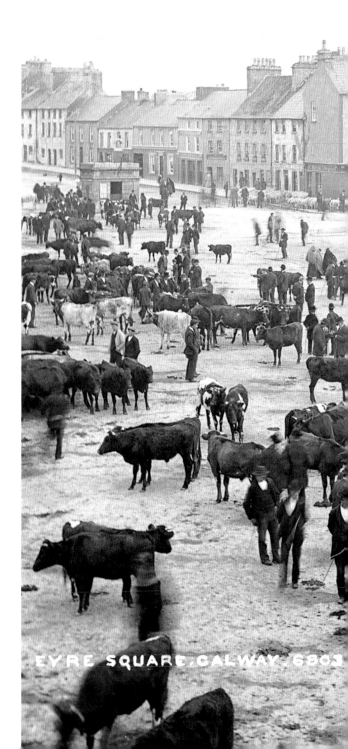

EYRE SQUARE, GALWAY. 6803

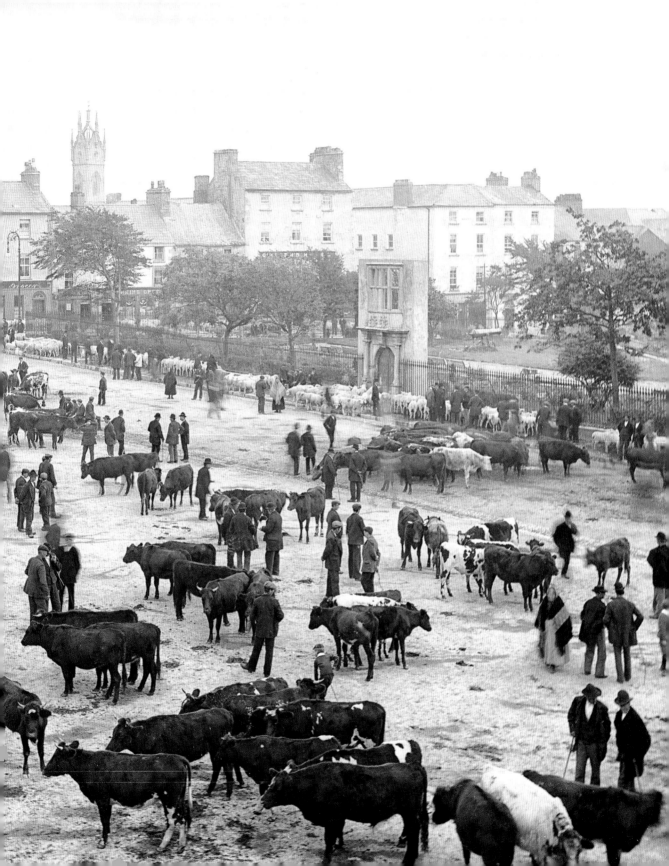

THE RMS *OLYMPIC*

*c.*1911, Belfast

Built in Belfast, the RMS *Olympic* was the lead ship of the White Star Line's trio of Olympic-class liners. Unlike *Titanic* and *Britannic*, *Olympic* had a mostly successful career spanning twenty-four years from 1911 to 1935. Under Captain Haddock, she rescued hundreds from the *Audacious* near Lough Swilly in 1914, after the battleship struck a mine. Nicknamed 'Old Reliable' for her service in World War I, *Olympic* transported around 201,000 troops and other personnel, burning 347,000 tons of coal, and travelled 296,000km. She also rammed and disabled a U-boat in 1918. The *Olympic* continued to operate until 1934, after which she was scrapped.

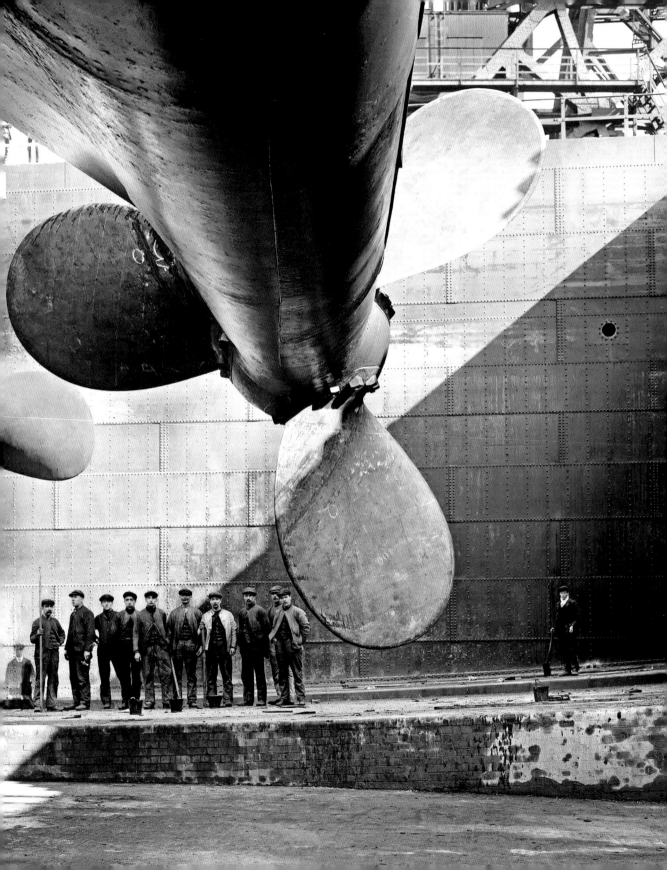

THE *JOHN STEPHENS* CREW

24 February 1914, Co. Wexford

A striking image, pictured here are the crew from the Wexford lifeboat *John Stephens*. On 22 February 1914, the Norwegian ship *Mexico* ran aground on the Kerragh Rock, approximately five miles from Fethard. The Fethard lifeboat launched for a rescue attempt but sank due to heavy seas. Nine crew died, along with one of the *Mexico*'s crew, an event that became known as the Fethard Lifeboat Disaster. The survivors were eventually brought ashore by the *John Stevens* crew and other lifeboats. The image emphasises the key role the Royal National Lifeboat Institution played and continues to play in communities.

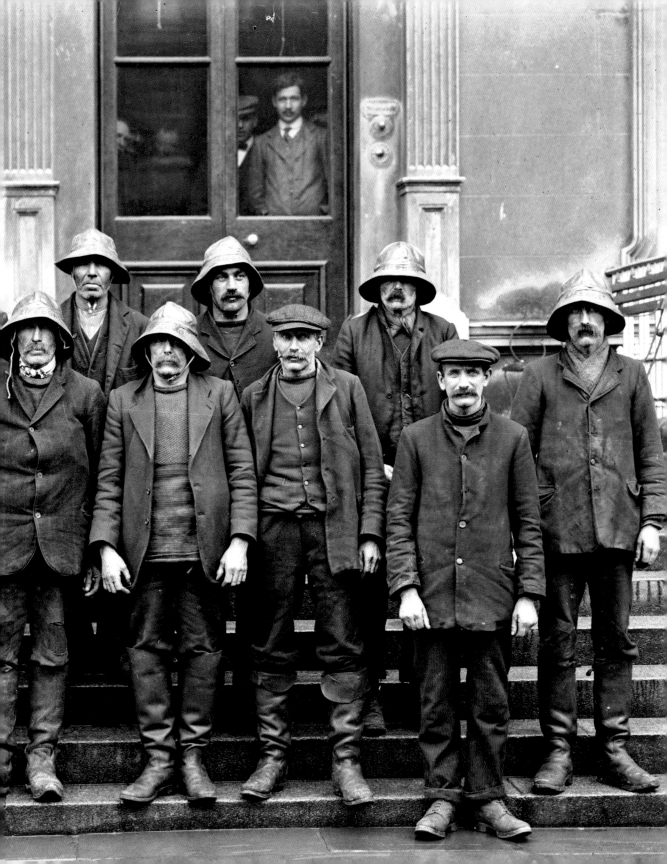

GROCER A.J. MORTI[...]

SPECIAL
BLEND OF
Tea
Per lb. 2/6

SPECIAL
BLEND OF
Tea
Per lb. 2/6

SPLENDID
QUALITY
Per lb. 2/4

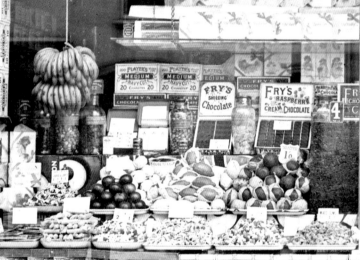

PLAYER'S
MEDIUM
NAVY CUT
20 CIGARETTES 20

PLAYER'S
MEDIUM
NAVY CUT
20 CIGARETTES 20

PLAYER'S
MEDIUM

FRY'S
CHOCOLATE

FRY'S
SHILLING
Chocolate

FRY'S
RASPBERRY
CREAM CHOCOLATE

FRY'S
CHOCOLATE
CREAM

FRY'S
NUT-MILK
Chocolate

LOZENGES

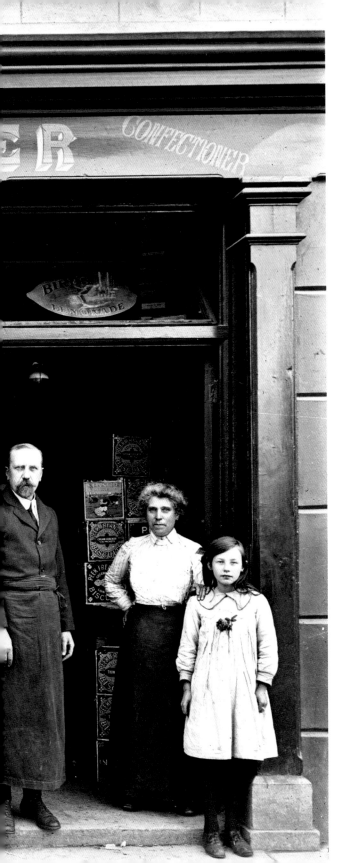

SWEET TREATS

24 June 1916, Co. Waterford

Mortimer's Shop was located at No. 2 Bridge Street and, as we can see from this image, there was a huge array of goodies in the store. Family businesses, often passed down through the generations, were a huge part of twentieth-century Ireland's economic landscape. Husband-and-wife teams were at the core of many of these. In smaller family businesses, the availability of low-cost (or free) labour could mean the difference between success and failure, so children were also a key part of the workforce.

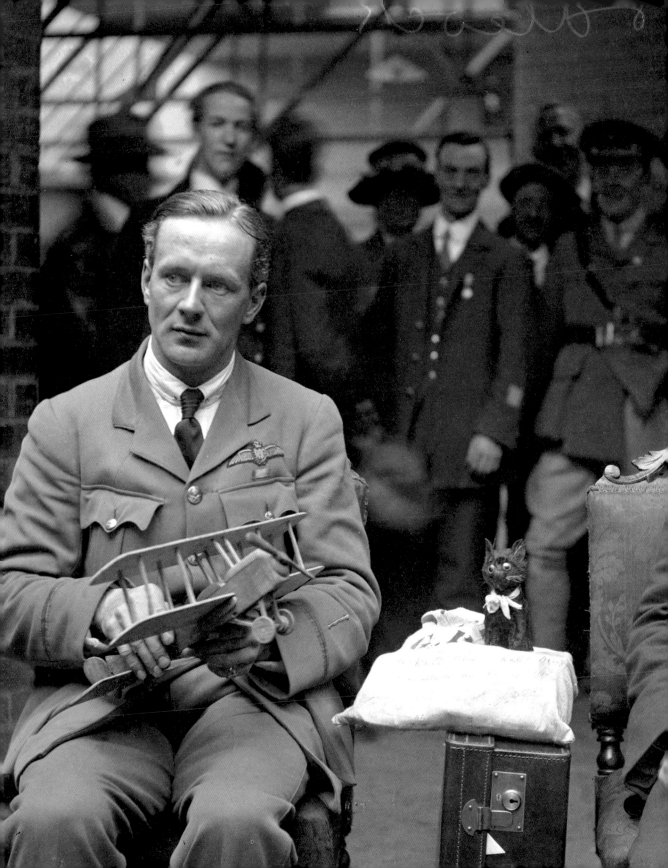

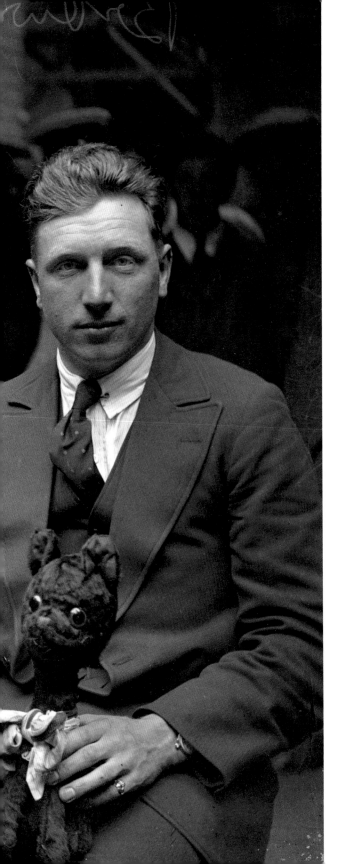

ALCOCK AND BROWN

16 June 1919, Dublin

Captain John ('Jack') Alcock (holding a model plane) and his navigator, Lieutenant Arthur ('Teddie') Whitten Brown, at the Automobile Club in Dawson Street, Dublin. They had just flown the first non-stop transatlantic flight, from Newfoundland to Derrigimlagh Bog, Connemara. The flight took slightly over 16 hours to complete. At just after 9 a.m. on 15 June, the signal operator at the Marconi Station in Clifden was surprised to hear they would be landing their 'heavier than air' plane locally. After asking for an autograph, the operator obliged the pair's request for a bath and a shave before news of the flight travelled across the island. The next day, they travelled to Dublin, where they were warmly greeted. In this picture Brown is holding Lucky Jim, Alcock's toy mascot cat, and sitting between the pilots is Twinkletoes, Brown's toy mascot cat, both of whom accompanied them on the flight for luck.

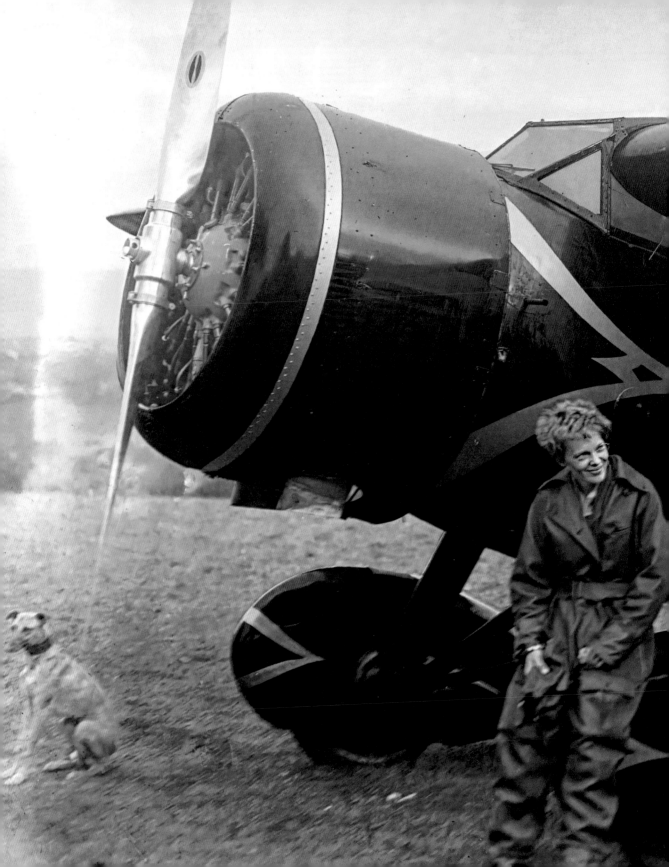

'LADY LINDY'

21 May 1932, Co. Derry

This image shows Amelia Earhart (also known as 'Lady Lindy'), who, in 1932, flew her Lockheed Vega from Newfoundland to Ballyarnett, where it 'limped' over the Irish coast. This flight broke several records: Earhart was the first woman to fly the Atlantic solo, and this was the longest non-stop distance flown by a woman. Shortly after leaving Newfoundland the altimeter failed and she completed the journey entirely by estimation of her height above sea level. Earhart surprised the Gallagher family when she landed in their field instead of in Paris, as planned.

SUGAR BEET FACTORY

1935, Co. Carlow

By the middle of the eighteenth century, sugar was Ireland's most valuable import. Sugar was refined in Carlow from 1926 and this factory became a vital part of the local economy, providing jobs and a regular income for farmers of sugar beet. In 1933 the Irish government set up Comhlucht Siúicre Éireann, which took over the Carlow plant, as well as establishing factories in Mallow, Thurles and Tuam.

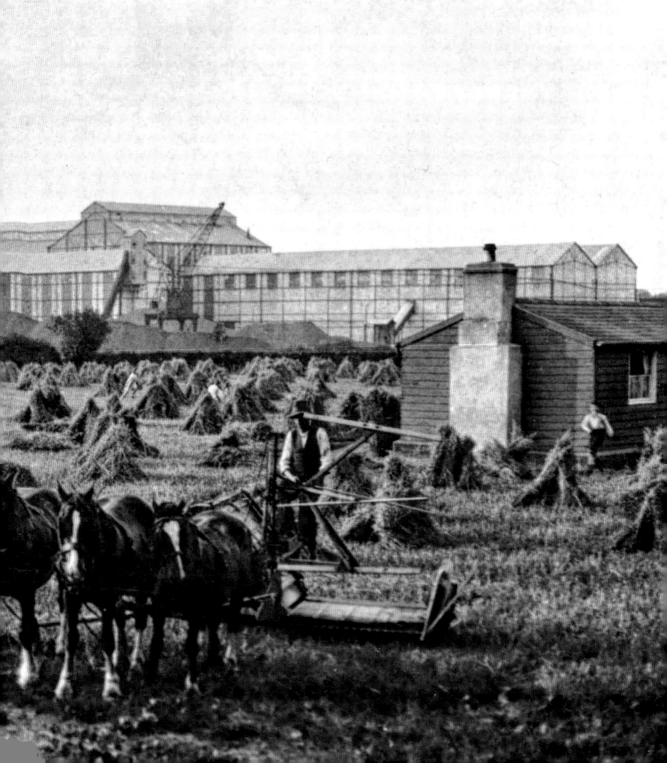

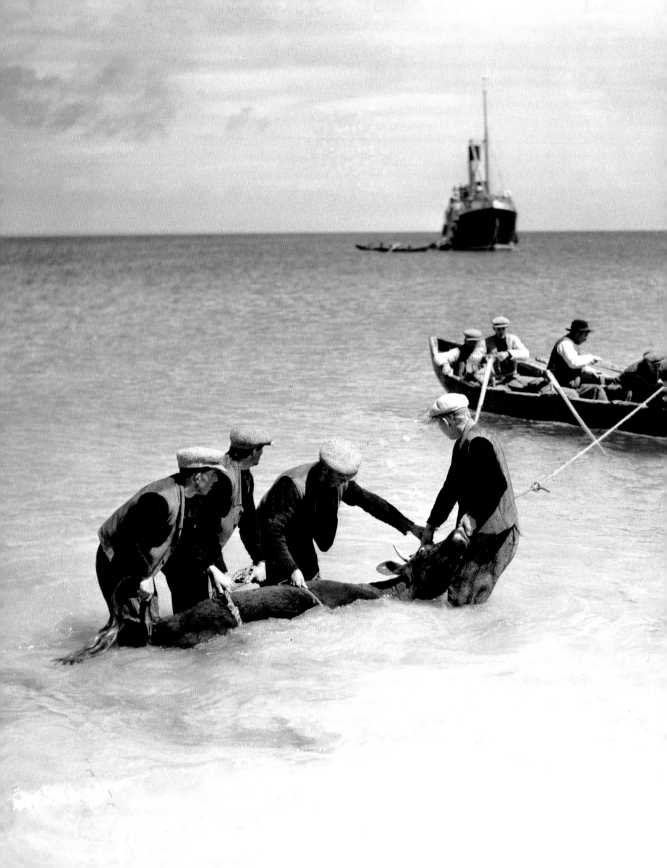

BULLOCK AT ARAN

31 May 1939, Inis Oírr, Aran Islands,
Co. Galway

From left to right in the photograph are
(holding the animal) Tomás Ó Conghaile
(Peter Mhéiní), Padraic Ó Conghaile
(Paitsín Mhéiní), unknown, Michael Póil,
and (in the currach) unknown, possibly
Padraic Ó Gríofa (Mhacanaí), Peter Ó
Conghaile (Mhéiní), John Francis Keane,
and Seosamh Ó Coistealbha (Joe Tom
Beag). These names were given to us
by Ann Mhaidhcí whose grandfather
is in the currach. Between 1921 and
1958, the Dublin-built *Dun Aengus*
carried passengers, livestock and freight
between Galway and the Aran islands.
On Inis Mór she was able to dock,
but at the other two islands she had to
offload into currachs. This image depicts
a bullock being taken from Inis Oírr
to the steamship. The clothing colours
were taken from a sketch on the Dúchas
website. The man on the far right is
wearing a *crios* – a traditional woven belt.

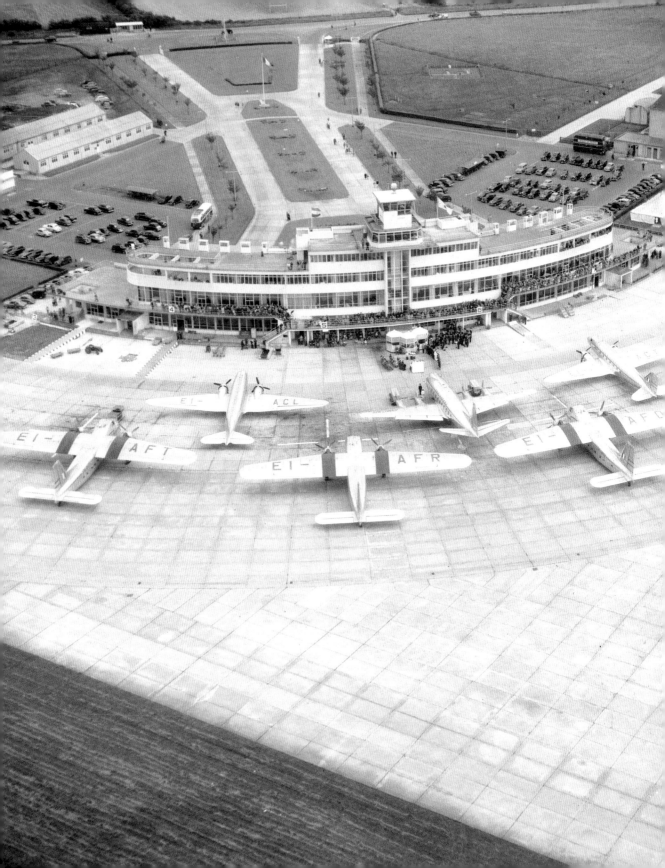

AER LINGUS BLESSING

13 June 1954, Dublin Airport

The annual blessing of the Aer Lingus fleet at Dublin Airport. This image shows four Bristol Wayfarers, two Douglas DC-3s and a Vickers Viscount. The registration numbers were issued by the Department of Industry and Commerce with EI being designated to the Republic of Ireland. *The Irish Times* recorded 'hundreds of people went to see the blessing … as the blessing was performed by Rev L.F. Kelly, P.P. Swords, the crowd sang hymns and recited prayers'. Each plane was blessed separately and afterwards the airport was 'thrown open' to the public.

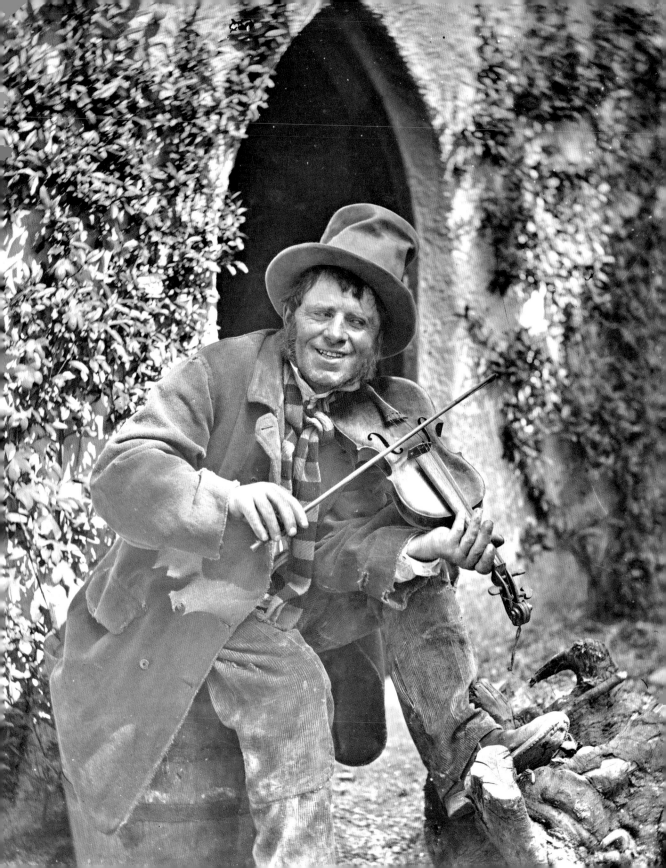

SPORT AND LEISURE

'FIDDLER'

*c.*1860–1883

While this looks at first sight to be a traditional fiddler playing, and would be one of the earliest images of such a thing, the fiddle only has three strings! What is very interesting is the costume he is wearing – a heavy frieze coat, which was virtually waterproof, corduroy trousers and strong nailed boots. The image is part of the collection of stereo negatives in the National Library of Ireland.

COUNTRYMAN

*c.*1860–1883

Another image from the stereo negatives – this one depicting a countryman sitting on a rock with a bottle in hand. He's wearing what were known as 'footless stockings' (*troighthíni*), or what more properly might be called soleless stockings. They were common throughout the country with people who did not wear or could not afford shoes.

SALMON TAKE

*c.*1890s, Killarney, Co. Kerry

Two anglers appraise their catch, as a boy idles in the background. Angling as a sport was very popular from the 1830s onwards in Ireland, particularly for salmon, and there are references to it in literature from the sixteenth century. The first publication devoted entirely to Irish angling was J. Coad's *The Angling Excursions …* published in 1824 under the name Gregory Greendrake. The men pictured in this image are suitably well dressed, as is the boy.

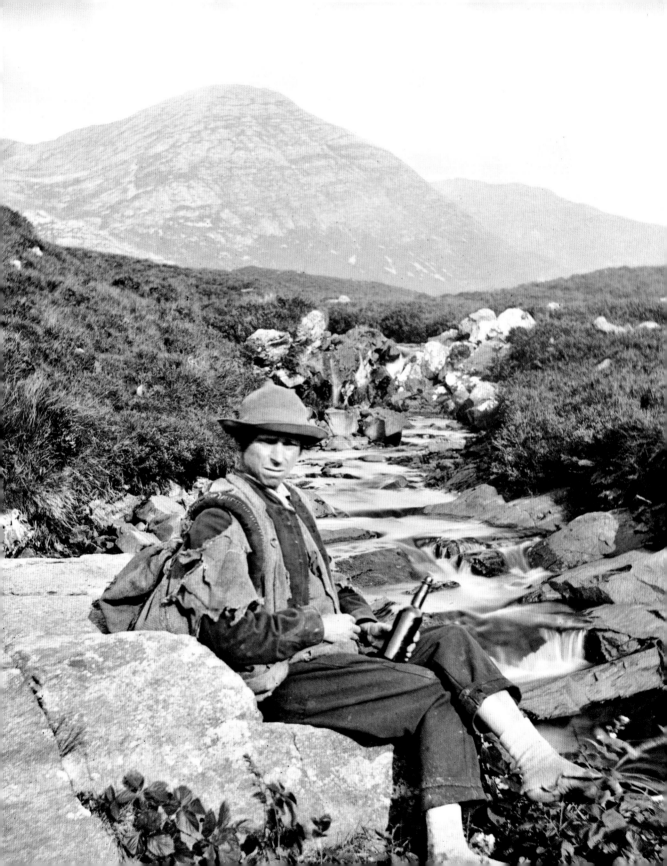

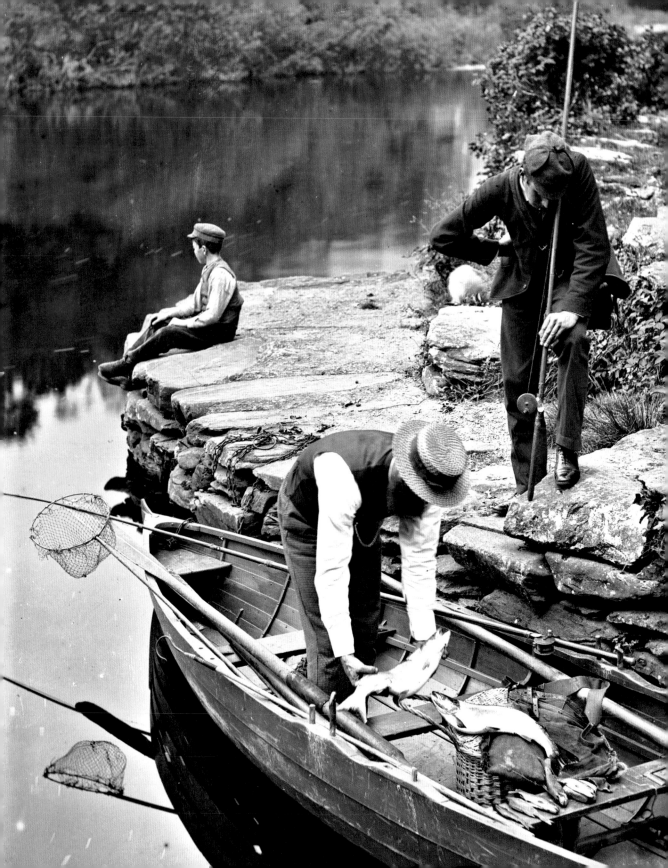

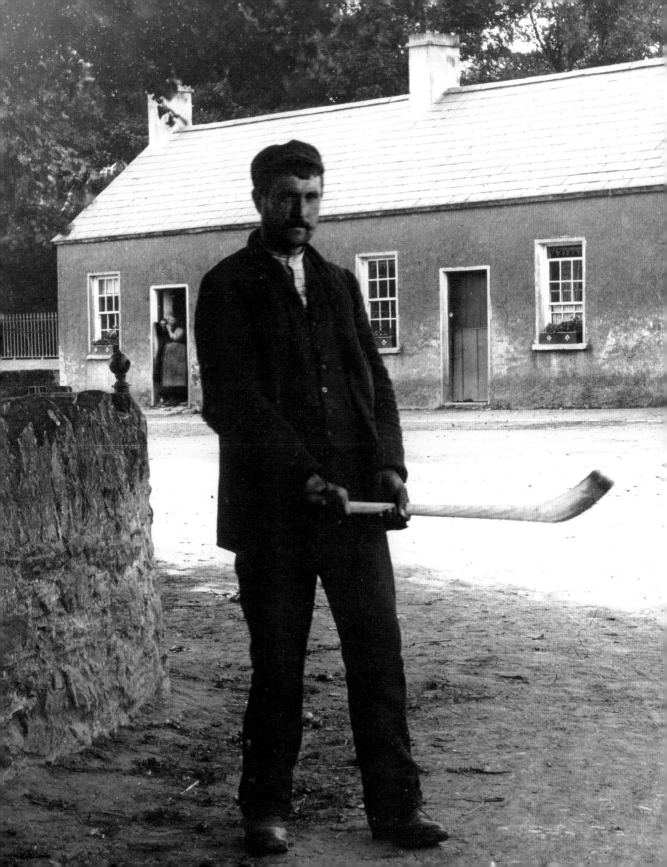

ON THE HURL

*c.*1880–91, Blarney, Co. Cork

Hurling is one of the oldest field games in the world and was popular 'for at least 3,000 years in Ireland, with the first literary reference dating back to 1272 BC'. How it has been played, and the forms of the stick and ball used, has varied but since the foundation of the GAA in 1884 and the introduction of a formal set of rules, the game of hurling has evolved into the sport we see today.

SALOON

*c.*1890s, McNeill's Hotel, Larne, Co. Antrim

Henry McNeill was an early pioneer in attracting tourists to the Antrim coastline. The hotel would have had numerous coaches waiting outside, dropping and collecting people for tours in their horse-drawn transportation. It is very possible that those photographed in this image are waiting for just that, and also possible that the saloon did not serve alcohol! What is particularly fascinating in this image is that you can see the camera reflected in the mirror and the presence of the self-playing barrel organ to the left at the back of the room.

SALOON. McNEILL'S HO

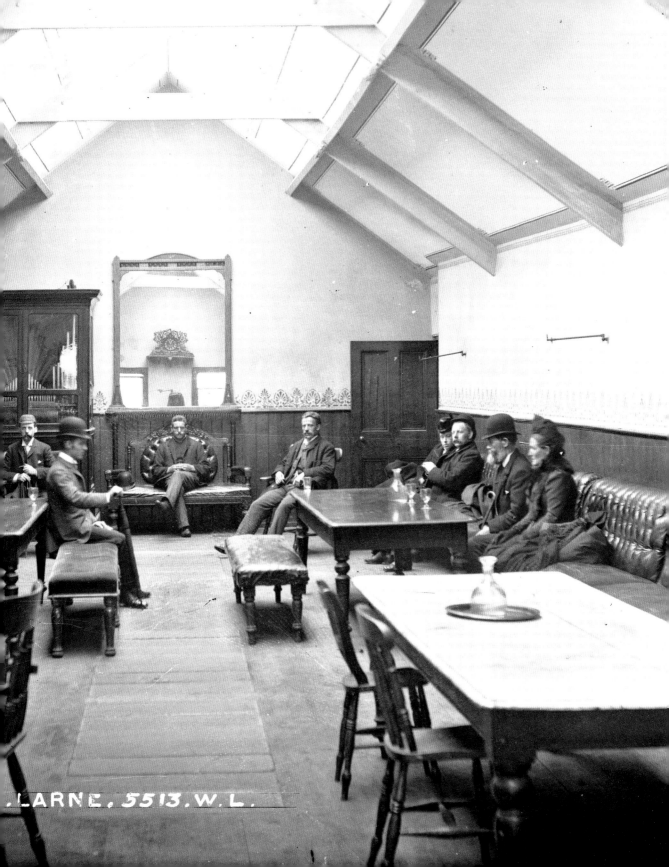

LARNE. 5513. W. L.

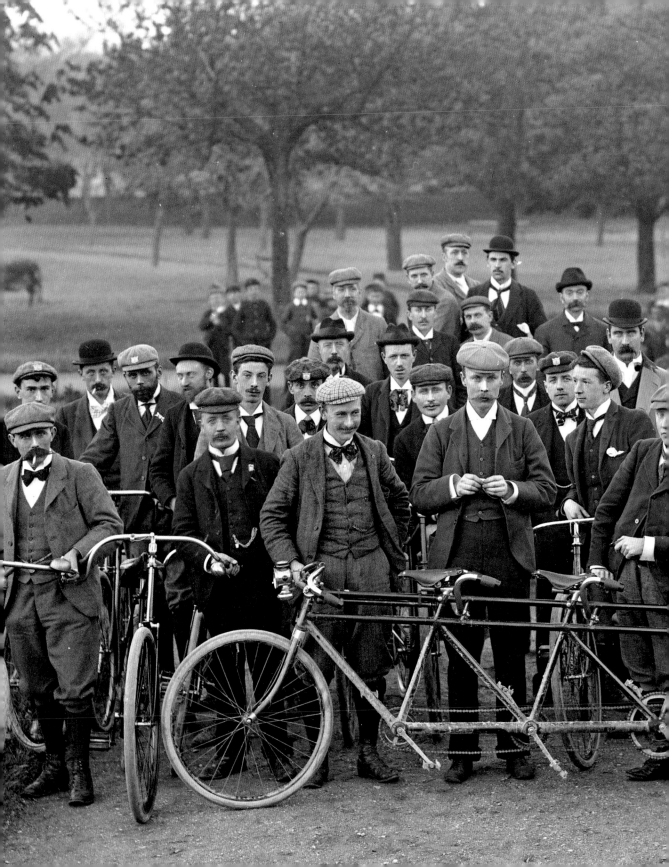

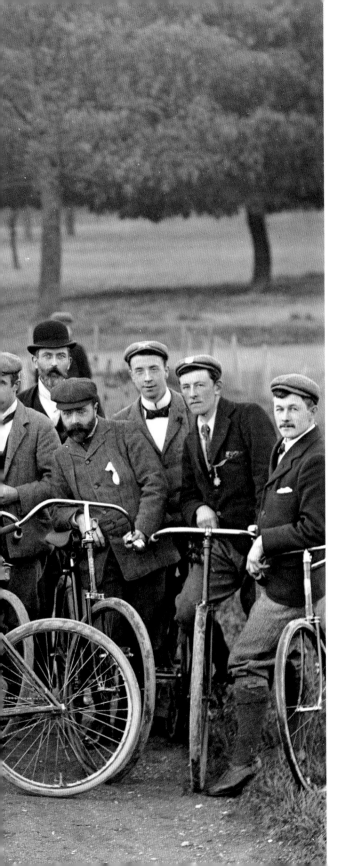

A BICYCLE MADE FOR THREE

*c.*1897, Waterford

Members of the Waterford Bicycle Club smiling behind a 'triplet'. In the late nineteenth century, the cost of bicycles in Ireland meant that cycling was an activity mainly for the middle and upper classes. The first cycling club in Ireland was established in Dungarvan in 1869. In 1888, to make 'safety bicycles' faster and more comfortable over long distances, the Belfast-based John Dunlop (1840–1921) invented a pneumatic tyre. These rubber tyres filled with compressed air quickly replaced all other wheel coverings.

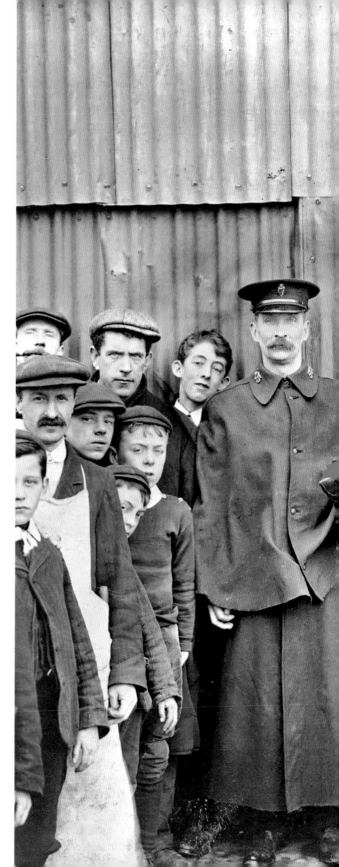

THE PICKPOCKETS' HARVEST

9 February 1912, Celtic Park, Belfast

Scene photographed on the day after a Home Rule meeting addressed by Winston Churchill, showing three policemen holding bundles of empty purses and surrounded by a group of onlookers. Churchill came to Belfast to give a speech in favour of Home Rule at the Ulster Hall, but that speech was moved to Celtic Park on the Donegall Road (the home ground of Belfast Celtic) after local unionists physically blocked the use of the initial venue. The *Irish Independent* estimated that 7,000 were present in Celtic Park on a very rainy day. The meeting was presided over by William Pirrie, the chairman of Harland & Wolff. Churchill shared the platform with John Redmond and Joe Devlin as he assured a cheering crowd that a Home Rule Bill was imminent.

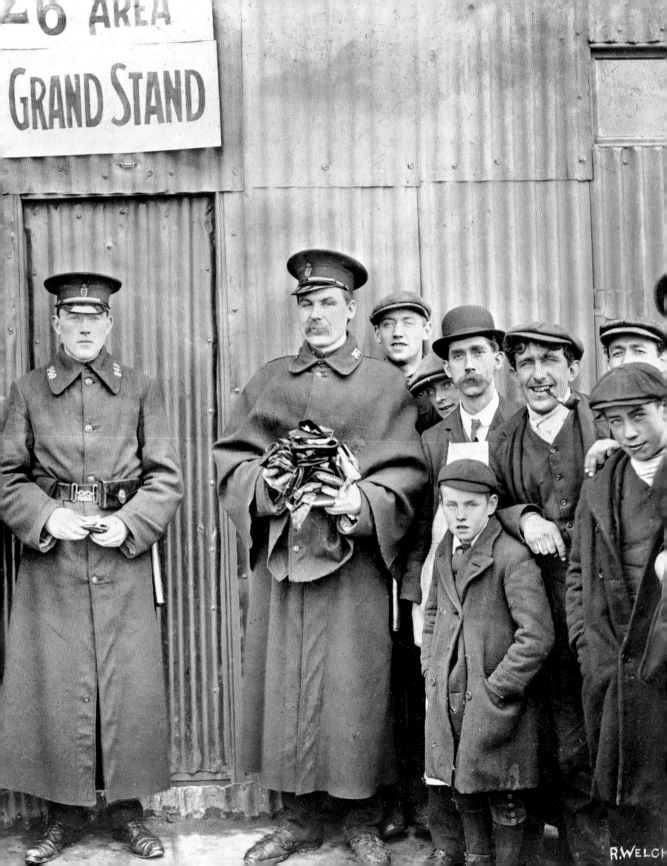

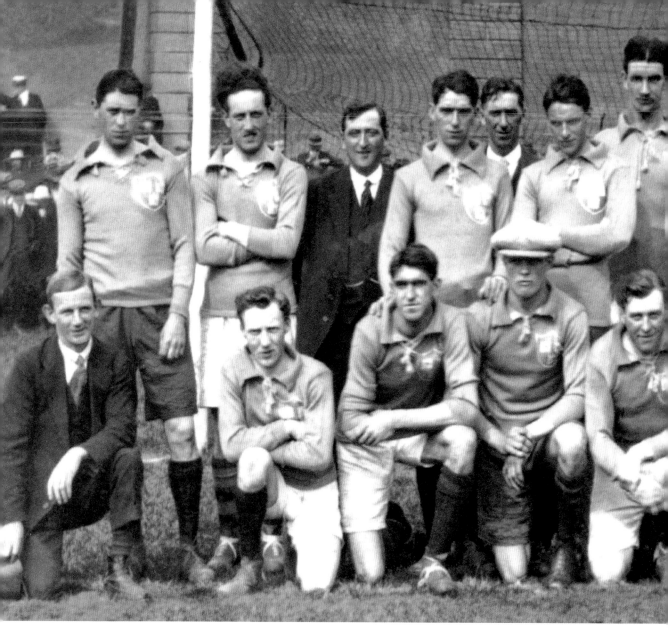

BLOODY SUNDAY

1920, Croke Park, Dublin

On the morning of 21 November 1920, Michael Collins's 'Squad' targeted British agents in Dublin and a number of shootings took place. This resulted in fifteen deaths, including six intelligence agents and two members of the Auxiliaries. Later that afternoon, Dublin

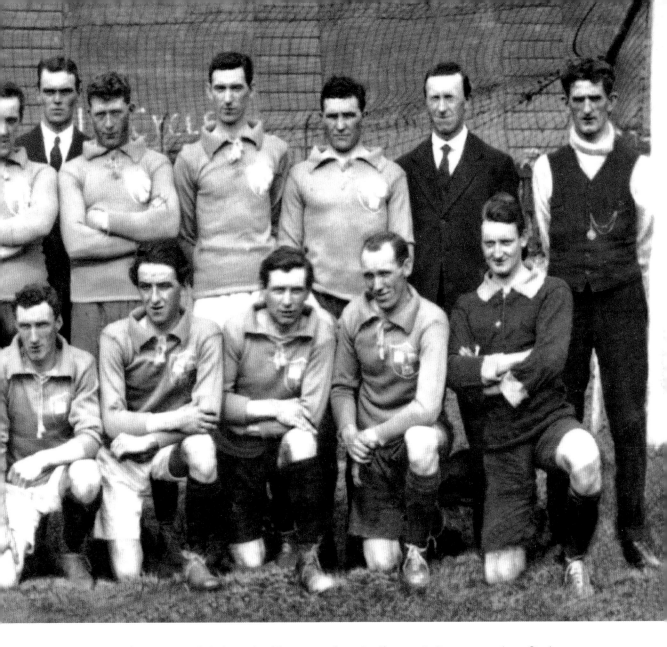

(pictured here) were scheduled to play Tipperary (overleaf) in a challenge match at Croke Park, the proceeds of which were in aid of the Republican Prisoners Dependents' Fund. The images above and overleaf show the two teams prior to the game. A crowd of almost 10,000 were present and while throw-in was scheduled for 2.45 p.m., the match did not start until 3.15 p.m. A mixed force of RIC, Auxiliaries and military then stormed into Croke Park and opened fire on the crowd. Fourteen people, including one player (Michael Hogan, Tipperary), died and it is estimated that sixty to a hundred people were injured.

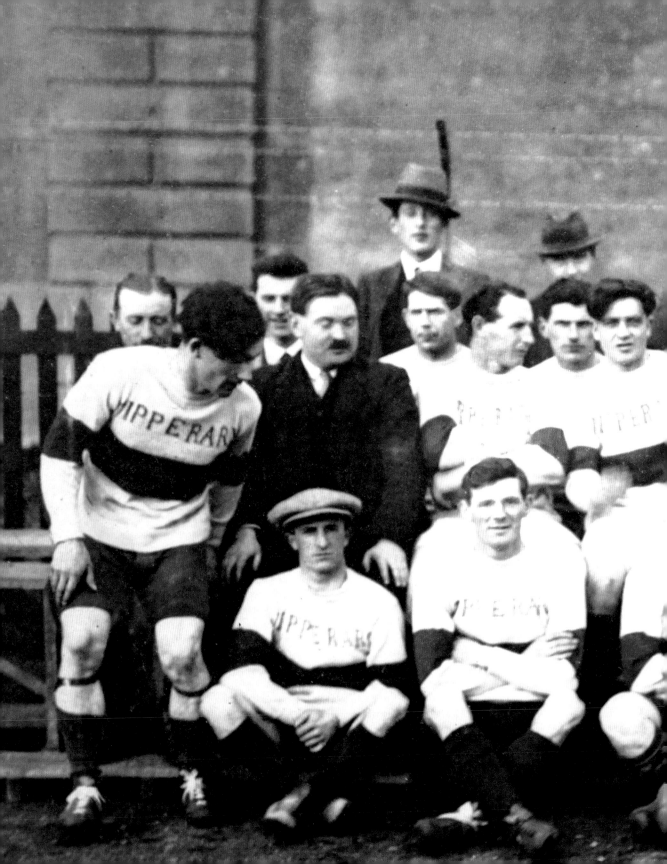

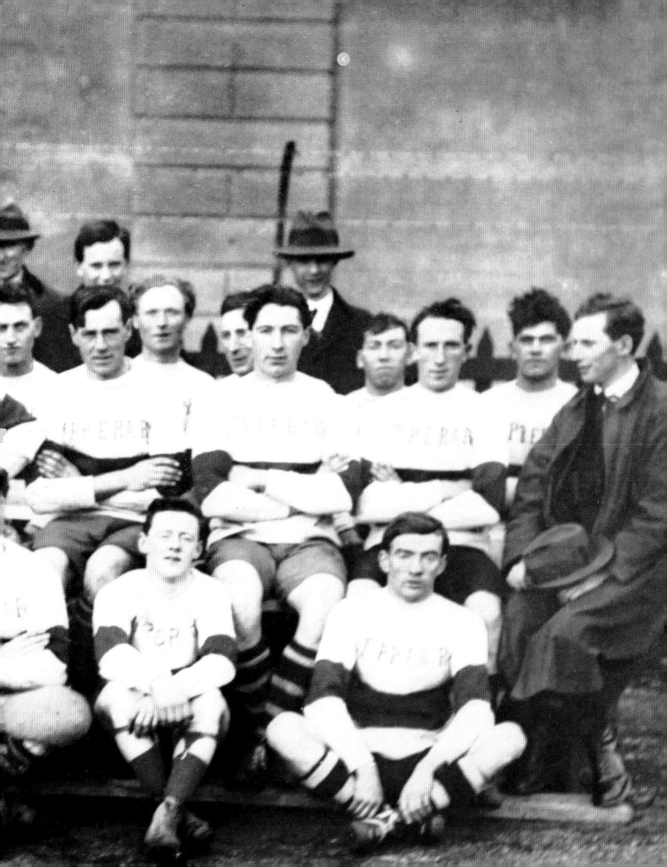

DAN BREEN

11 June 1922, Croke Park, Dublin

The 1920 All-Ireland series saw Dublin take on Cavan, and Mayo face Tipperary, with Tipp and Dublin facing off in the final, a match which was played almost two years later. Dan Breen threw the ball in that day as civil war loomed. Tipperary emerged victorious and the following day *The Freeman's Journal* wrote: 'The 1920 football final, played yesterday at Croke Park, will rank with the best and most exciting championships in the history of the GAA. On a baked ground and under a broiling sun the pace was set a cracker and never flagged, but rather intensified to the last whistle. And it was the pace that told, and to Tipperary's tremendous stamina and indomitable spirit must their success be attributed.'

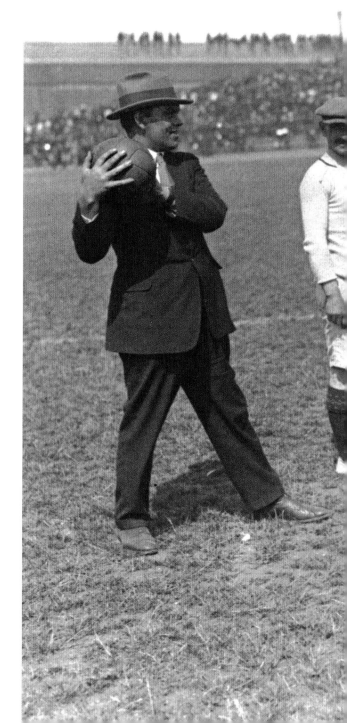

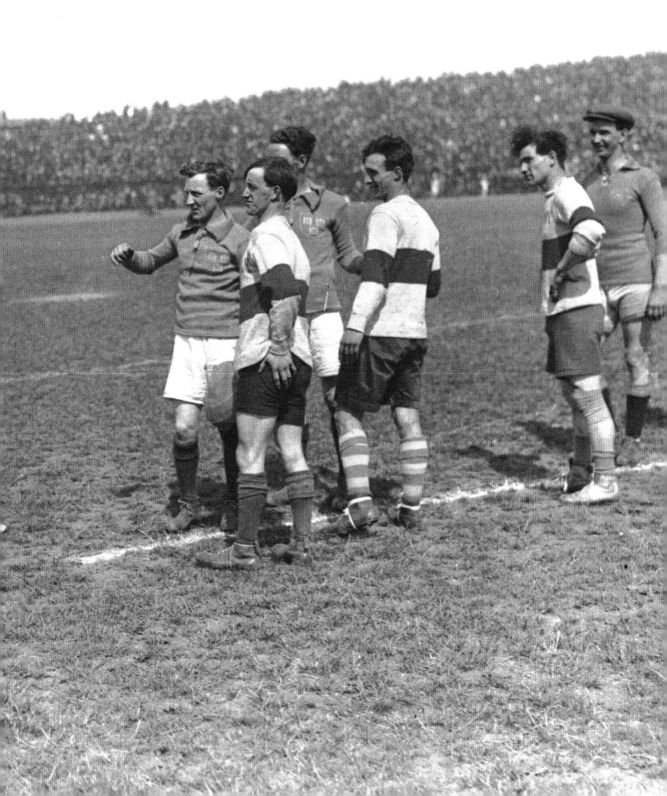

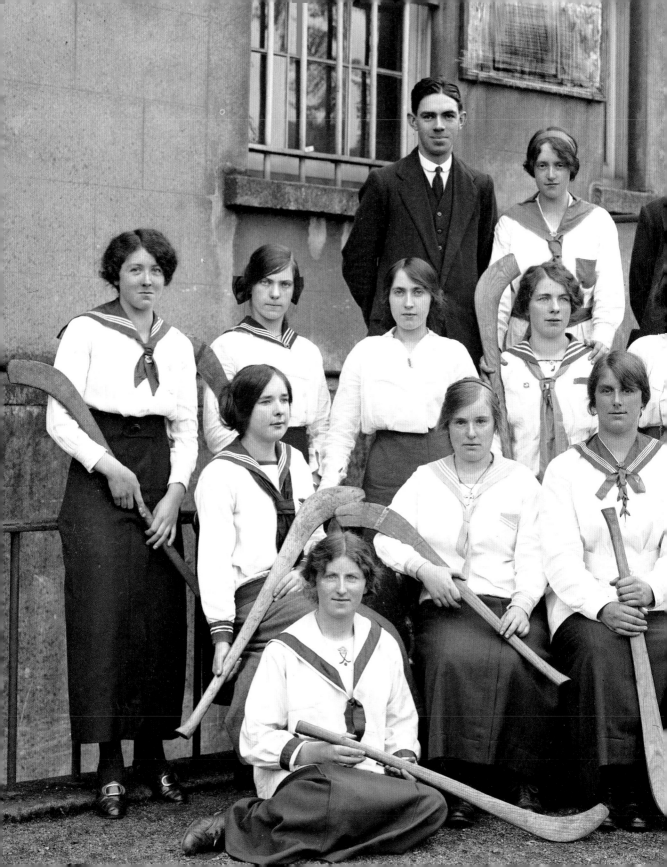

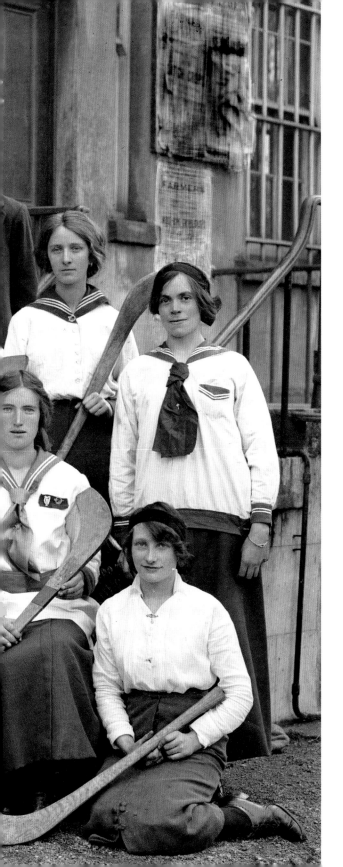

MISS HOOKEY AND HER CAMOGIE TEAM

17 October 1915, Waterford

Miss Hookey (front left) of Bank Lane, Waterford, with her camogie team. The image was taken at the back of the Waterford Courthouse. The Camogie Association was founded in 1904 and the first All-Ireland Championship was played in 1932. As we can see in this image, players wore gym frocks that covered the knee and went to the ankles, long black stockings, canvas boots and long-sleeved blouses, and some wore a belt or sash around the waist. The shape of the hurley lent itself to good ground strokes and play was predominantly on the ground.

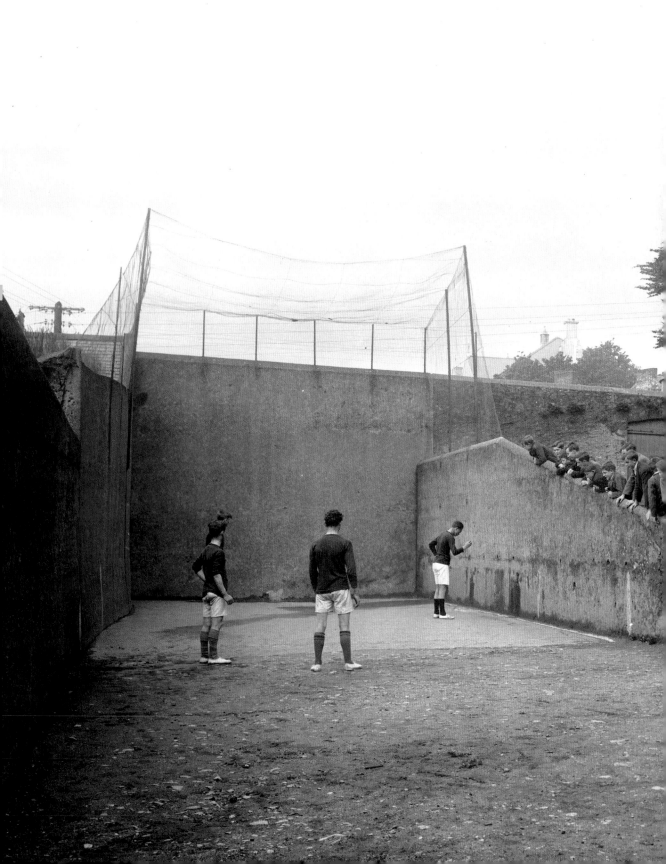

HANDBALL ALLEY

30 May 1931, Co. Wexford

The modern game of handball originated in Ireland and Scotland; the earliest written record of a handball game is in the town statutes of Galway, which, in 1527, forbade the game being played against the walls of the town. Purpose-built handball alleys first emerged in the late 1700s, although these seem to have remained the exception for at least a further century. Later versions lengthened the walls and raised the height of the playing wall, culminating in the familiar three-wall alley, which would become the standard by the early twentieth century and a feature of many individuals' youth! In rural and urban settings alike, it was to endure for a further fifty years. Irish immigrants brought the game to many countries from the eighteenth century, and it is still played in the United States, Canada, Mexico, Australia, New Zealand, Wales and England.

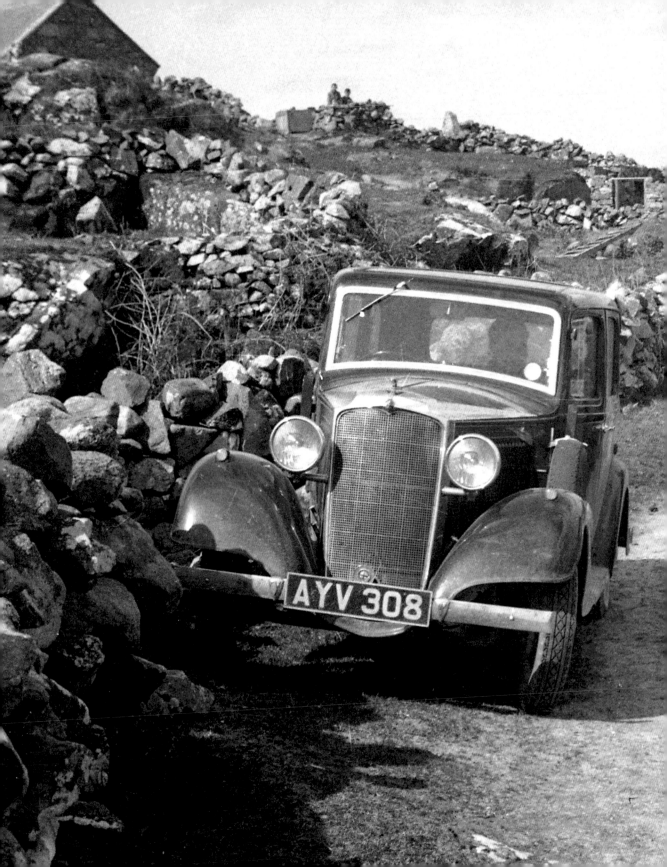

CAPTAIN GEORGE

1937, Connemara, Co. Galway

From the mid-nineteenth century, Connemara became a key tourist area due to increasing transport links. The car has an English registration, and was driven by either George Brodrick or a friend of his when they toured Ireland together in 1937. Captain George Sinclair Gould Brodrick, MBE, was the grandson of the American railway magnate Jason (Jay) Gould, once the richest man in the world. His mother, Guinevere Sinclair, was Irish (her grandfather, Sir Edward Sinclair, had been provost of Trinity College Dublin), and Brodrick himself joined the Irish Guards after graduating from university.

MAYO ALL-IRELAND SENIOR FOOTBALL TEAM

23 September 1951, Croke Park, Dublin

In the 1951 All-Ireland Senior Football Final at Croke Park, Mayo faced Meath. Mayo won by 2–8 to 0–9, making it their second title in a row, but most infamously this was the match from which tales of a 'Mayo curse' originate. Apparently, the victorious team failed to pay due respect to a funeral as they returned to Mayo with the Sam Maguire Cup and the enraged priest decried that they would never win another All-Ireland while any member of the team was still alive. Whatever truth there is to the story, Mayo have failed to win an All-Ireland since, losing ten finals since 1951. Paddy Prendergast, the last surviving member of the team, can be seen in the front row, third from the right.

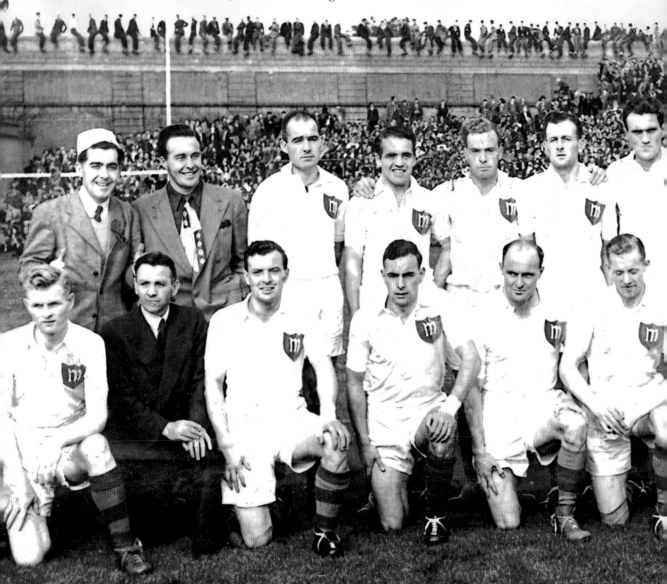

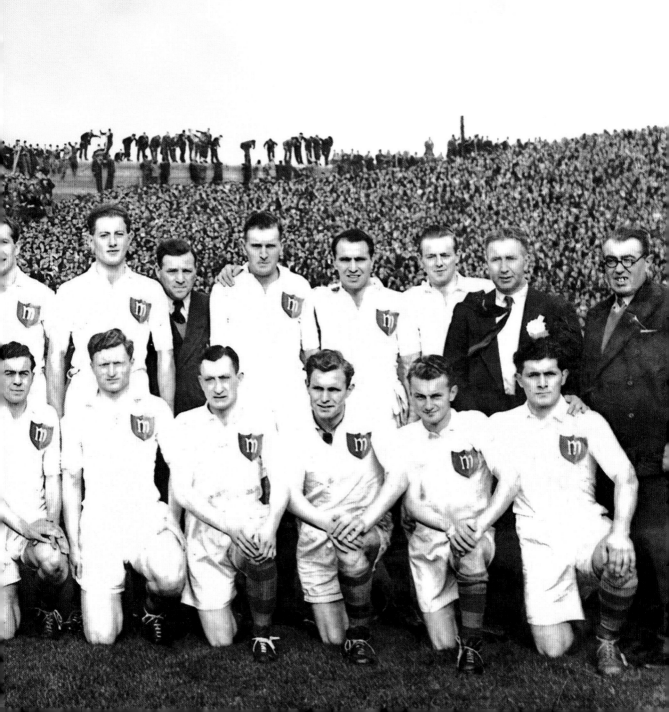

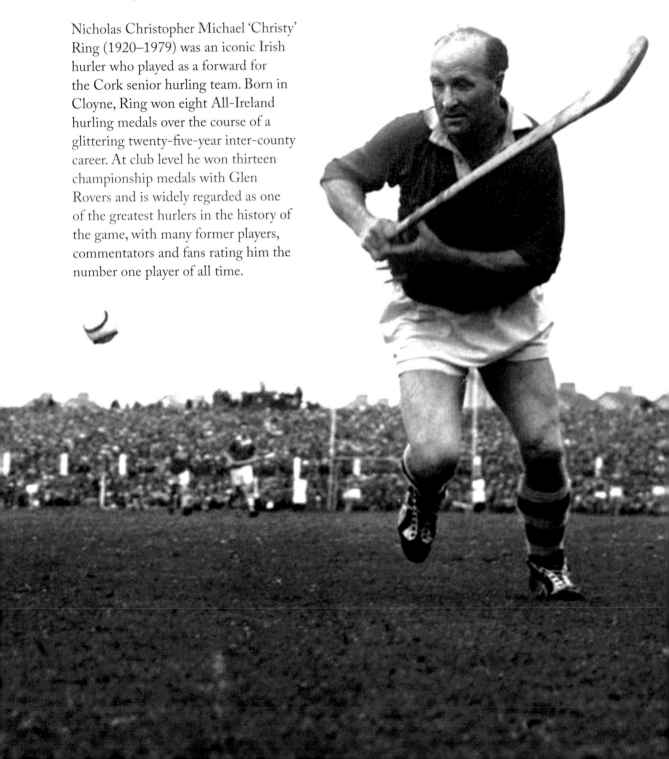

CHRISTY RING

1960, Douglas, Co. Cork

Nicholas Christopher Michael 'Christy'
Ring (1920–1979) was an iconic Irish
hurler who played as a forward for
the Cork senior hurling team. Born in
Cloyne, Ring won eight All-Ireland
hurling medals over the course of a
glittering twenty-five-year inter-county
career. At club level he won thirteen
championship medals with Glen
Rovers and is widely regarded as one
of the greatest hurlers in the history of
the game, with many former players,
commentators and fans rating him the
number one player of all time.

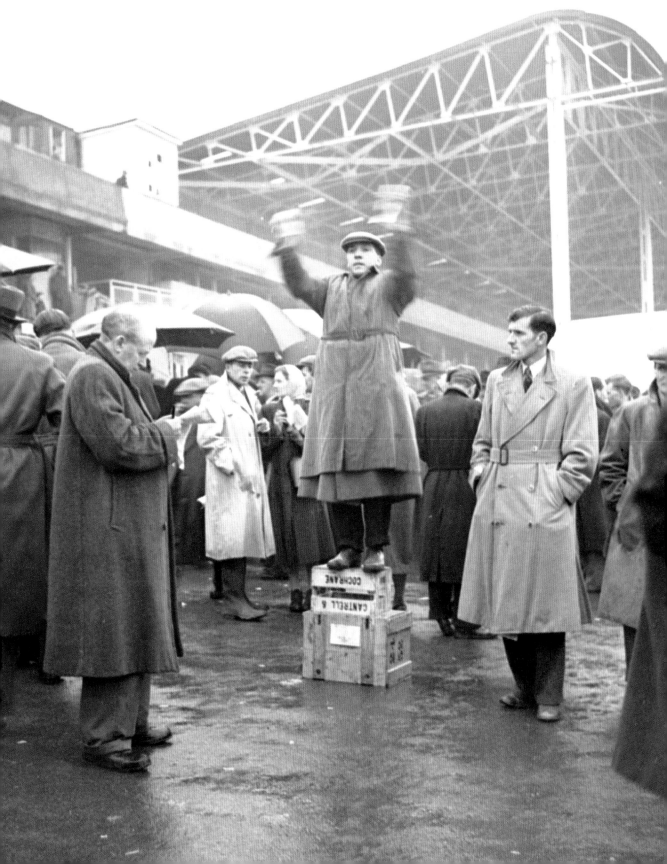

PLACE YOUR BETS!

1952, The Curragh, Co. Kildare

A bookie signals the odds while standing on a box at a race meeting at the Curragh. The name 'Curragh' comes from the Irish word *Cuirreach*, meaning 'place of the running horse'. The first recorded race on the plain took place in 1727 and the first Derby was held in 1866. The course is right-handed, horseshoe-shaped, about two miles long and is the venue for all five Irish Classics.

FIRST BLOOMSDAY

16 June 1954, Monkstown, Dublin

Bloomsday celebrates Thursday, 16 June 1904, the day depicted in James Joyce's novel *Ulysses*, and is named after Leopold Bloom, the central character. The novel follows the life and thoughts of Bloom and a host of other characters – real and fictional – from 8 a.m. through to the early hours of the following morning. Pictured here are poets Patrick Kavanagh (*left*) and Anthony Cronin (*right*) in front of Monkstown Church. It was taken at the first Bloomsday, when the poets visited the Martello Tower at Sandycove, Davy Byrne's pub and 7 Eccles Street, reading parts of *Ulysses* and drinking as they went.

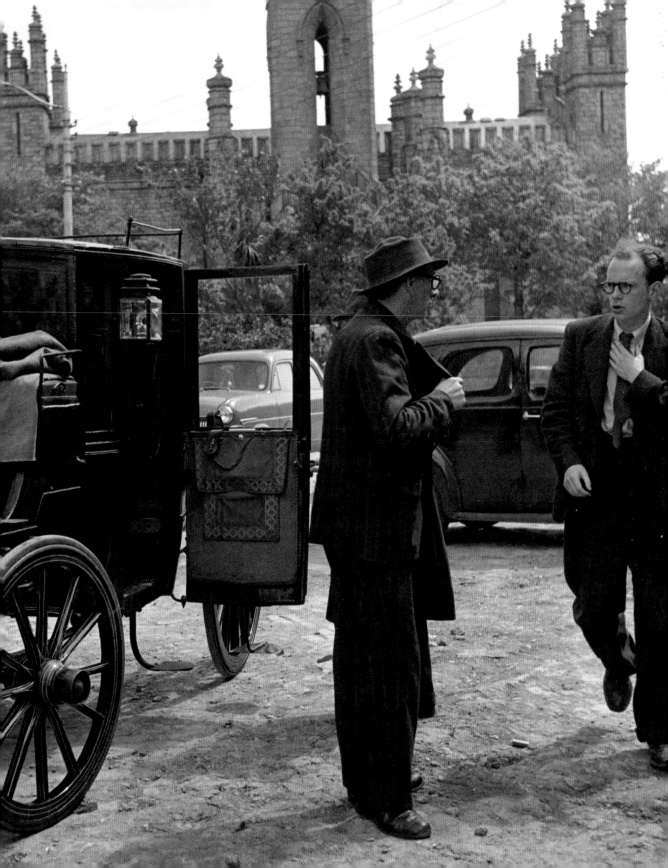

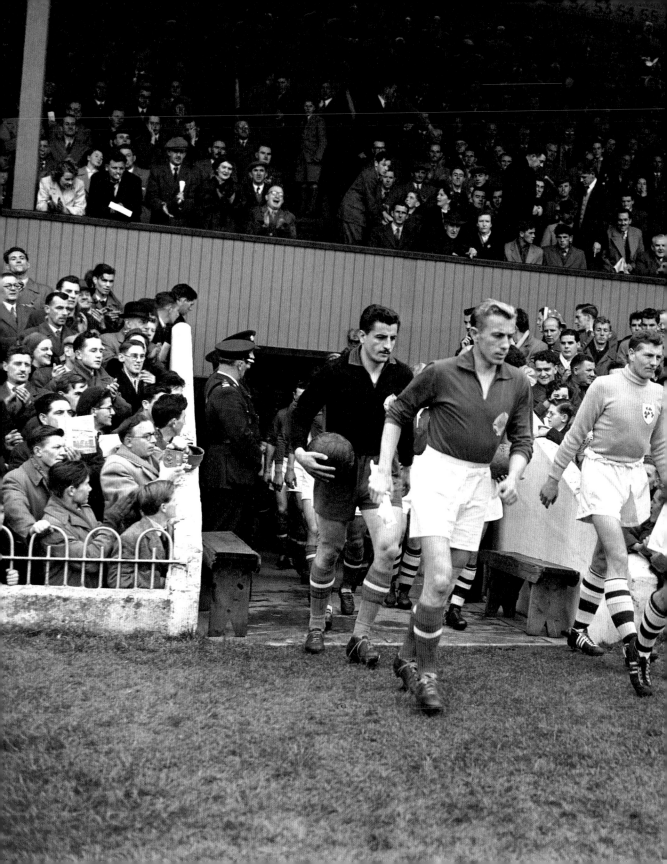

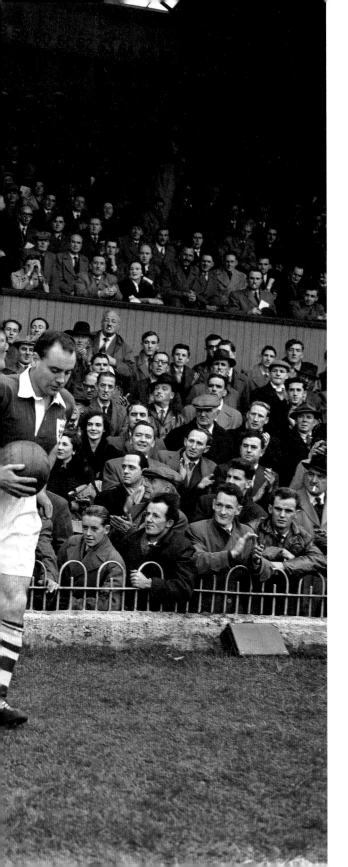

THE BIG CLASH

19 October 1955, Dalymount Park, Dublin

In 1952 Ireland and Yugoslavia were scheduled to meet in a friendly soccer match in Dalymount Park. Due to fears of 'communism', Archbishop John Charles McQuaid lobbied the FAI to cancel the game and they capitulated. In 1955, the fixture was scheduled again. McQuaid was furious and accused the FAI of entertaining the 'tools of Tito [the Yugoslavian leader] in the capital city of Catholic Ireland'. People were warned not to attend as it would be a 'mortal sin', yet, on the evening of Wednesday 19 October, just under 22,000 supporters turned out at Dalymount Park. We used a programme from the original game for the colours of the one being held by the man towards the bottom left. Beside him, the man at the edge of the tunnel is holding an 8mm film camera. Ireland lost the match 4–1.

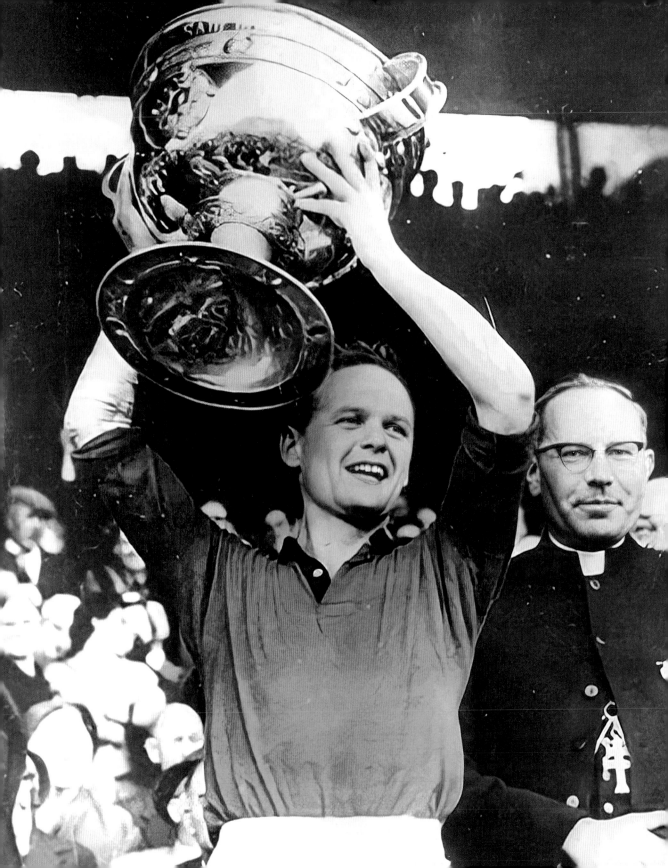

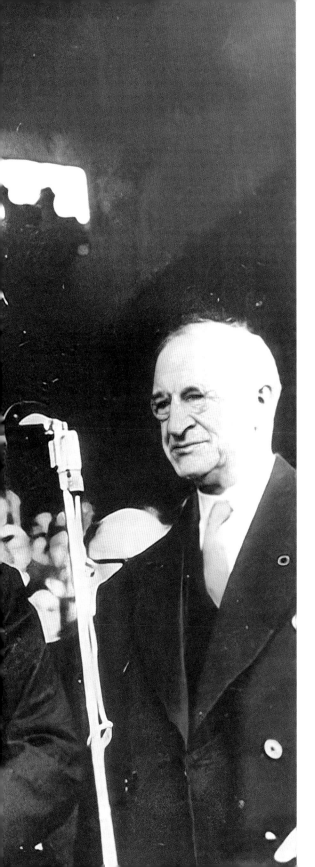

UP DOWN!

25 September 1960, Croke Park, Dublin

Down's eight-point winning margin over Kerry, in front of a record crowd of 88,000, in the 1960 All-Ireland Senior Football Final was hugely significant. It was the first time that the Sam Maguire Cup would cross the border and, with it, Down brought about a revolution in the way the game was played and heralded its modernisation. Guided by the pioneering vision of County Secretary Maurice Hayes, and with exceptional talent such as Sean O'Neill, Paddy Doherty, Joe Lennon and James McCartan, Down played with a new style built on superior fitness levels, fluid movement and fast passing, keeping the ball moving and linking in with their six inter-changeable forwards. They burst onto the field at Croke Park that day with a collective swagger and confidence that was almost impossible to defend against. Down's achievement in 1960 was all the more remarkable given that they had only won their first Ulster title the year before, and they would go on to win three All-Irelands and six more Ulster titles before the close of the decade. But that day in September 1960 will be long remembered for Down captain Kevin Mussen stepping formally across the exact line of the border at Killeen to scenes of wild jubilation. There had been no homecoming like it in the history of the GAA.

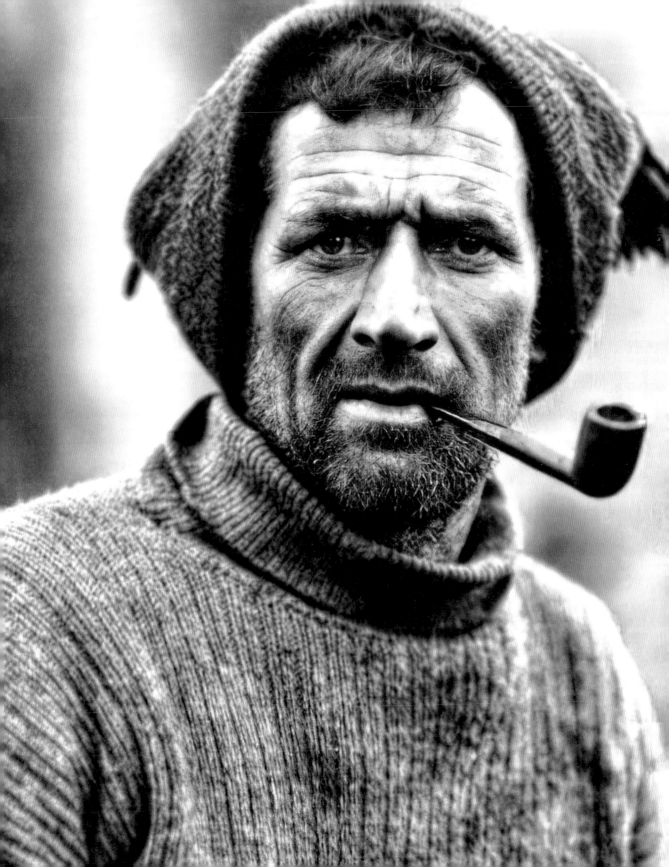

THE IRISH AND THE WORLD

A MAN OF ENDURANCE

February 1915, Antarctica

Taken during Tom Crean's third and final Antarctic adventure, aboard the *Endurance*, where he was second officer on Ernest Shackleton's Imperial Trans-Antarctic Expedition. After the *Endurance* was slowly crushed by the pack ice and sank, Crean and the ship's company spent nearly five months drifting on the ice before taking the ship's lifeboats to Elephant Island. Crean, originally from the farming area of Gortacurrane, near the village of Annascaul, Co. Kerry, was one of the most famous Irish seamen and explorers. His previous expeditions were on the *Discovery* and *Terra Nova*.

THE WORLD'S FIRST FEMALE MEDICAL PHYSICIST

Early 1890s, England

Edith Stoney was born in Dublin in 1869 and appointed a physics lecturer at the London School of Medicine for Women in 1899. She later became a pioneering figure in the use of X-ray machines in a military hospital at Troyes during the First World War. She is remembered for her bravery and resourcefulness in the face of extreme danger, and her imagination in contributing to clinical care under the most difficult conditions. A strong advocate of education for women, she set up a fund to enable young graduate women to spend time on research overseas.

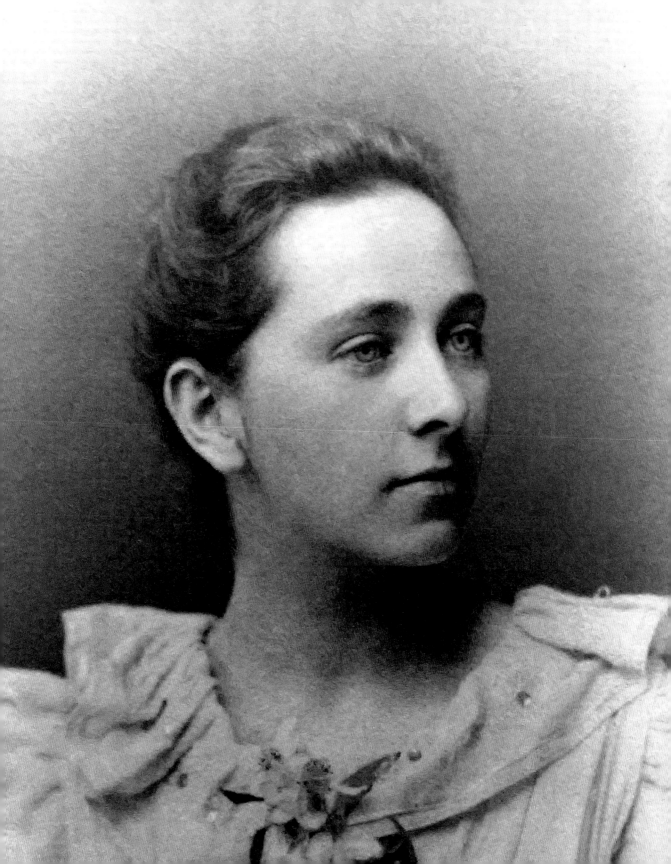

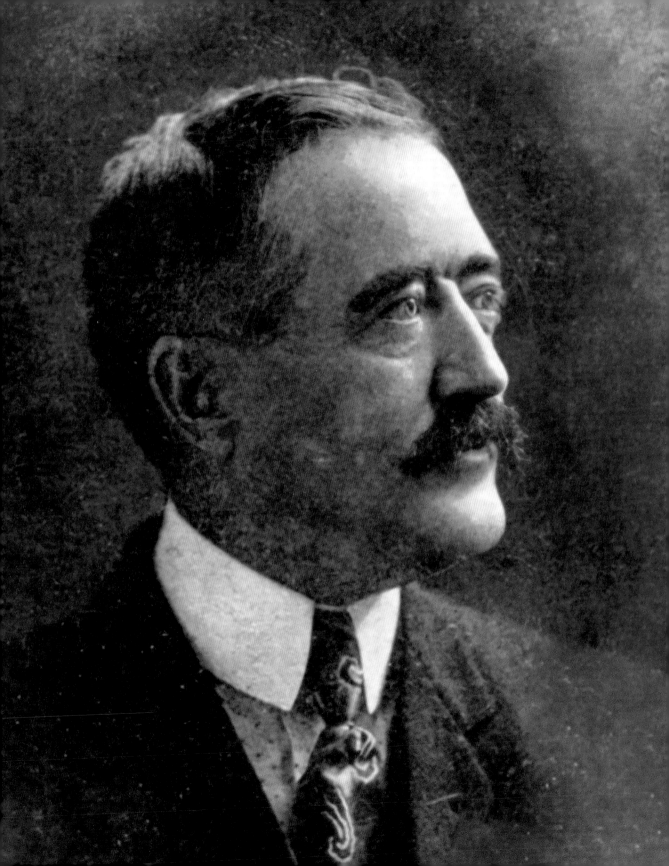

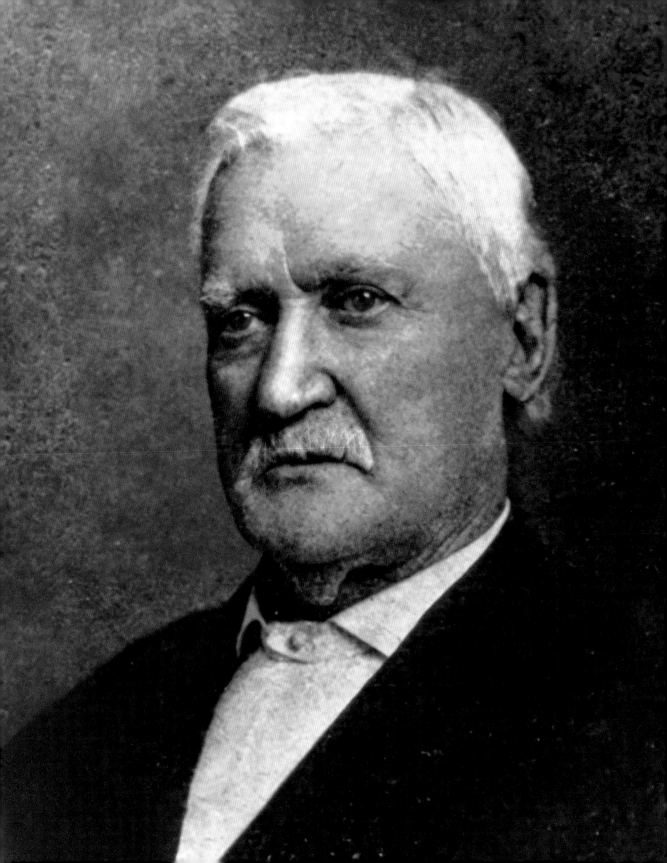

PRESIDENT BIDEN'S IRISH ANCESTORS

1906, Scranton, Pennsylvania, USA

The 46th President of the United States has Irish roots that stem from two different families: the Blewitts of Co. Mayo and the Finnegans from Co. Louth. On the left is his great-grandfather Edward F. Blewitt, and to the right is his great-great-grandfather Patrick Pius Blewitt. Patrick was born in Ballina in 1832 and emigrated to the US in 1850 at the height of the Great Famine. He later returned to Ireland to bring his parents, Edward and Mary, and siblings back with him to America. Before he emigrated, Edward is credited with saving thousands of lives through public work schemes in Co. Mayo during the Famine. President Biden still has several distant family members who live in Ballina, where a mural has been painted in the town's Market Square in his honour.

ABSOLUTE KELVIN

1902, Glasgow, Scotland

William Thomson Kelvin (1824–1907), mathematical physicist and engineer, was born on 26 June 1824 at College Square East, Belfast. Among many significant achievements in thermodynamics and telegraphy, Kelvin determined the correct value of absolute zero, and absolute temperatures are stated in units of kelvin in his honour. He mostly lived in Scotland and was a professor in the University of Glasgow for fifty-three years. After the Irish Home Rule Bill, he became a Liberal Unionist, believing the measure would damage Ireland's best interests and create socio-economic instability. He is posing here with a compass and inclinometer that he designed, as used on the *Titanic*.

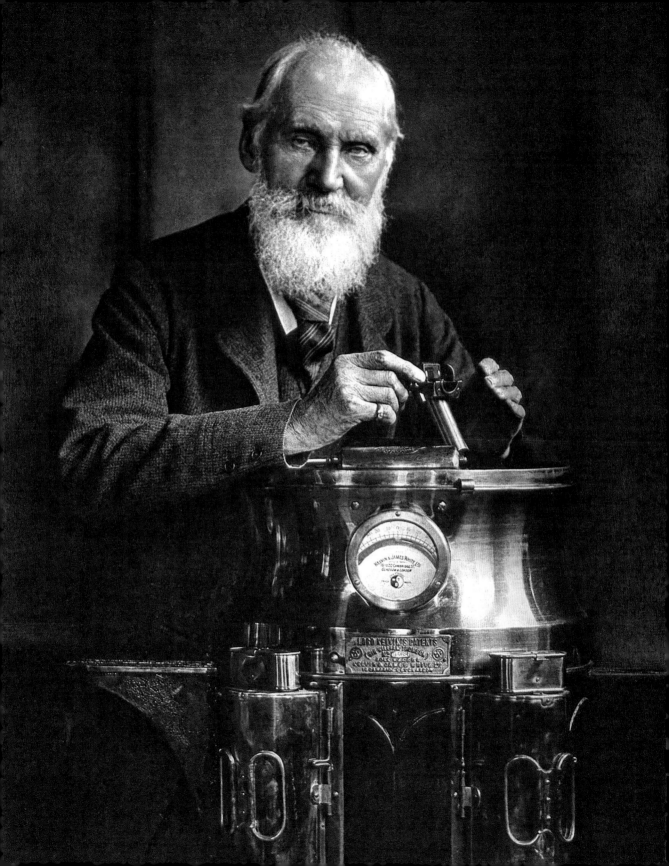

NANNIE FLORENCE DRYHURST (1865–1930)

1892, London

Dublin-born N.F. Dryhurst, née Robinson, was a journalist and translator who spoke French, German, Irish and Georgian, and combined wide-ranging radical activism with enormous sociability and varied artistic interests. As a result, she was an important link between Irish nationalist, anarchist, feminist and international anti-imperialist circles. Best known for her work with Peter Kropotkin and the anarchist Freedom group, she was also an early Sinn Féin supporter, an enthusiastic member of the London Gaelic League, and campaigned for the freedom of Georgia, travelling there in 1906. Unhappily married to A.R. Dryhurst (Roy), an early Fabian, Nannie had two daughters, Norah (1885–1973) and Sylvia (1888–1952). They both appeared in W.B. Yeats's *The Land of Heart's Desire* in 1904. Norah later married Florence Farr's nephew, and nursed in war hospitals in Albania and Cairo. Sylvia became an influential writer and critic, and married Robert Lynd, the celebrated journalist and essayist from Belfast, who shared Nannie's deep commitment to Irish independence.

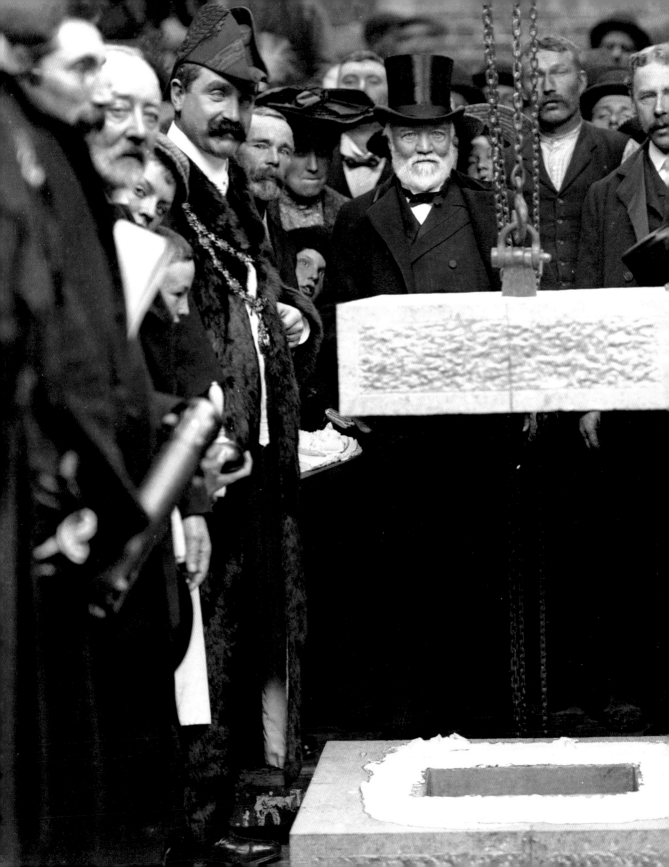

CARNEGIE

19 October 1903, Lady Lane, Waterford

Born in **Scotland**, Andrew Carnegie emigrated with his family to the US in 1848. At twelve, he began working in the cotton industry and through his entrepreneurship became one of the world's richest men. In his later life he focused his energies on philanthropy and gave almost $40 million to build 1,200 libraries, of which eighty were pledged to Ireland. Of these, sixty-six were built and sixty-two are still in use today. This image was taken at the laying of the foundation stone of Waterford Free Library.

CHILD LABOURERS

17 June 1916, Massachusetts, USA

Two child labourers whose ancestors were Irish, Evelyn Casey and James Donovan were recorded for the National Child Labor Committee (NCLC). Evelyn was born on 22 November 1901 to Johanna Harrington and Michael Casey, and she began work in Borden Mills cleaning harnesses at 14. Her testimony states that she had left due to lack of work and was learning how to weave in Flint mill. James was an Irish sweeper in Fall River Iron Works. He said he was 17 years old at the time of this photograph. Lewis Hine (1874–1940) was an investigative photographer for the NCLC and his photographs helped change child labour laws in the USA.

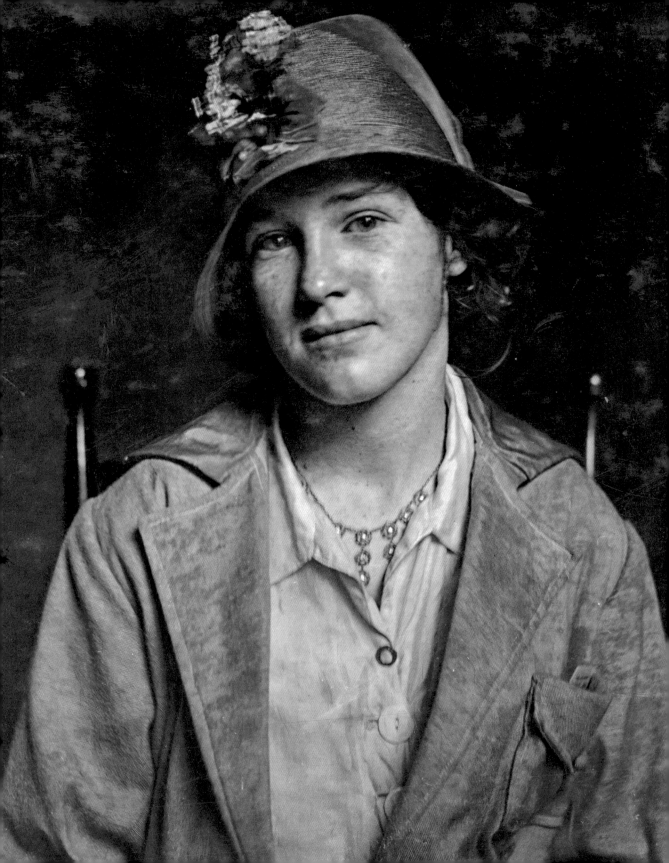

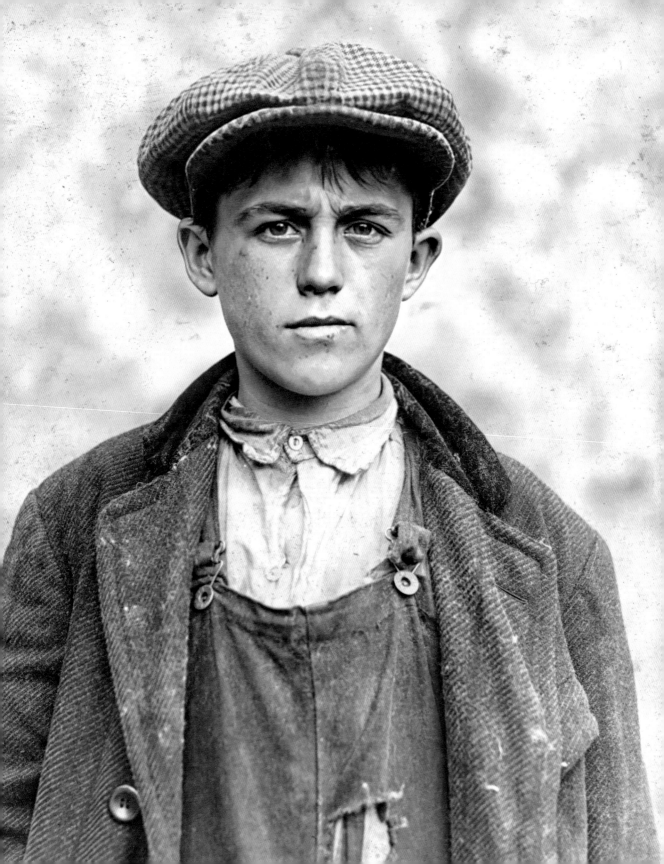

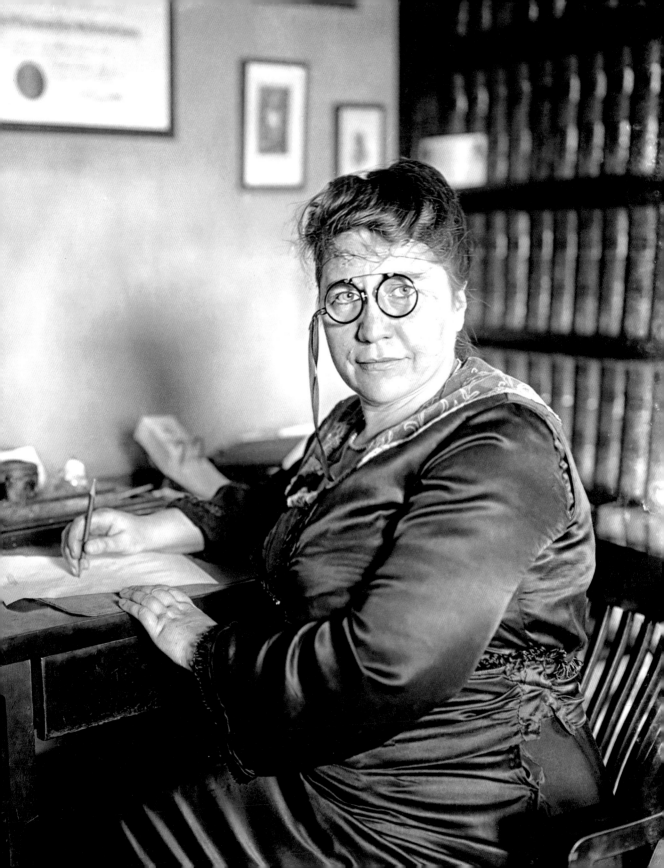

MURIEL MURPHY MacSWINEY (1892-1982)

8 December 1922, USA

Muriel Murphy was born in Cork City to a wealthy Catholic family – the owners of Murphy's Brewery. In 1915 she met Terence MacSwiney, who would go on to become the Lord Mayor of Cork. The couple married in June 1917 and Muriel gave birth to a daughter, Máire, in June 1918. On 25 October 1920, Terence died after seventy-four days on hunger strike. In 1922, Muriel travelled to the US and received the Freedom of New York City, the first woman to do so.

JUDGE MARY O'TOOLE (1874-1954)

*c.*1920s, USA

Judge Mary O'Toole was the first woman municipal judge in the United States. Born in Hacketstown, Co. Carlow, in 1874, she was also the first woman naturalised in Steuben, New York, in 1900. She was appointed Judge of the Municipal Court of Washington, DC by President Harding in 1921. O'Toole campaigned for women's suffrage, and a column for a local newspaper written by her started with the lines: 'Why do I favor suffrage for the District? As well ask me why I want to eat. One seems quite as obvious as the other.'

LADY MARY HEATH (1896-1939)

1928, Soesterberg, The Netherlands

Born Sophie Peirce-Evans in Limerick, Mary Heath was the first person to fly solo across Africa, when she made the 10,000-mile journey from South Africa to London. A woman of firsts, she became the first female commercial pilot in the UK. The International Commission for Aviation had previously stated that women's menstrual cycles made them unfit to serve as commercial pilots. An athlete herself, in 1925 she spoke at the Olympic Congress in Prague campaigning to have women's athletics accepted at the Olympic Games. Her signature style was furs, pearls and high heels, which she often wore while flying.

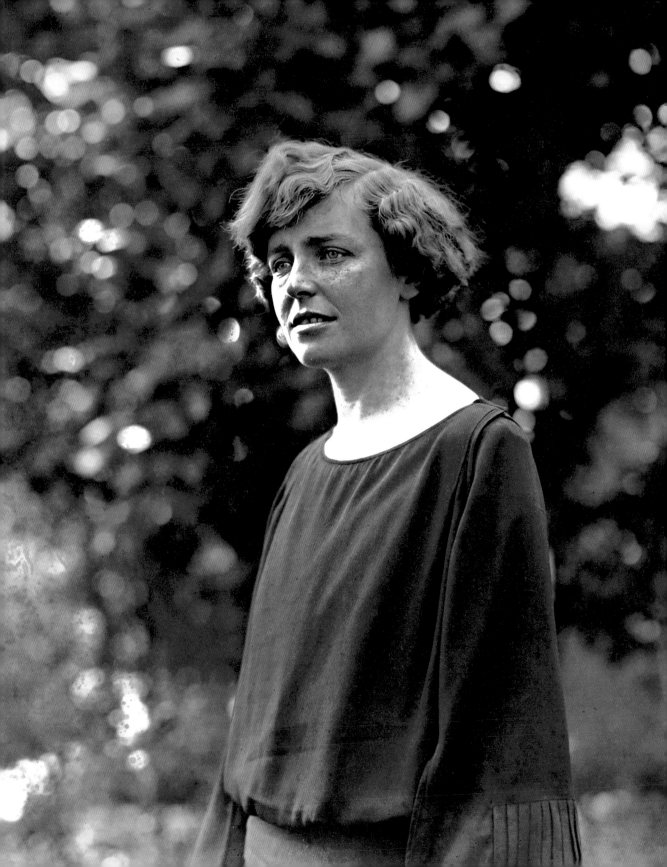

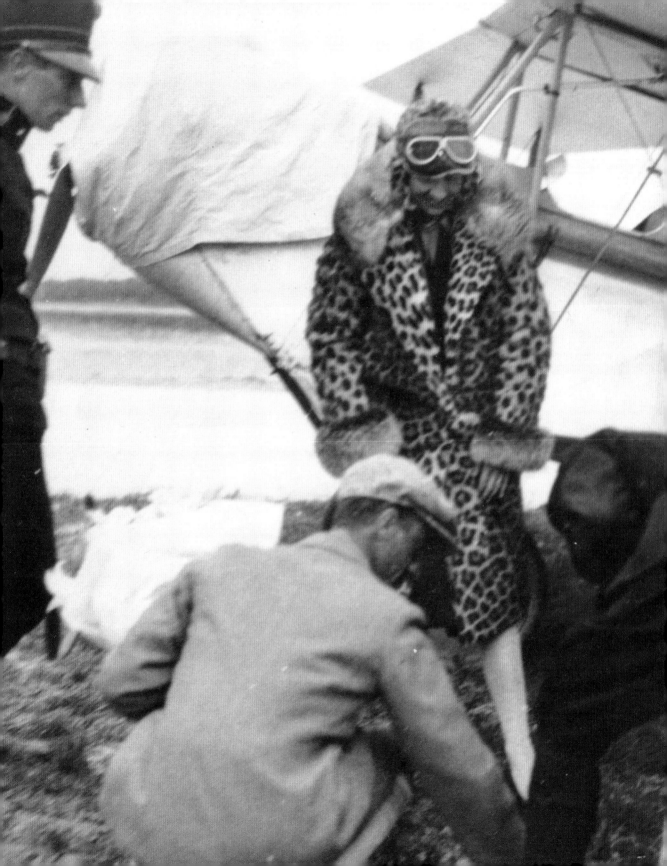

PRAYERS AT DOWNING STREET

14 July 1921, London

A republican prayer vigil at Downing Street on the day Éamon de Valera and David Lloyd George met to discuss paths to peace in Ireland. It was the first of four meetings between the pair in July 1921. *The Irish Times* reported that as the meeting progressed, a 'large crowd of Irish sympathisers knelt in the rain at Whitehall, at the end of Downing Street, recited the rosary, and sang several hymns. Before the prayers started, they sang "Ireland a Nation".' The article goes on to state that the singing and prayers did not cease. The politicisation of prayer was a powerful tactic during the Irish revolution, with mass vigils often being organised by Cumann na mBan and taking place at prisons, military barracks and public spaces.

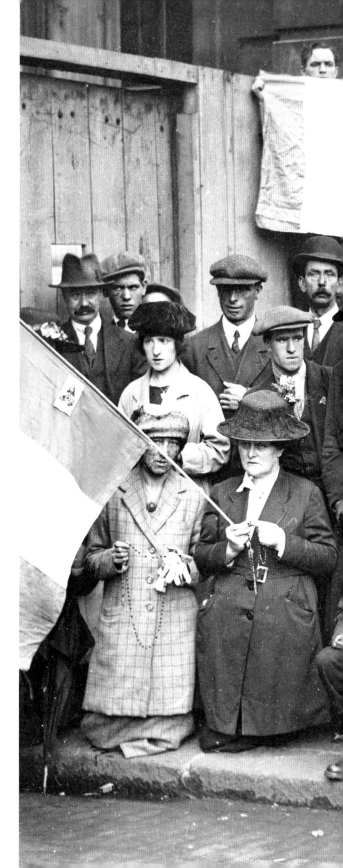

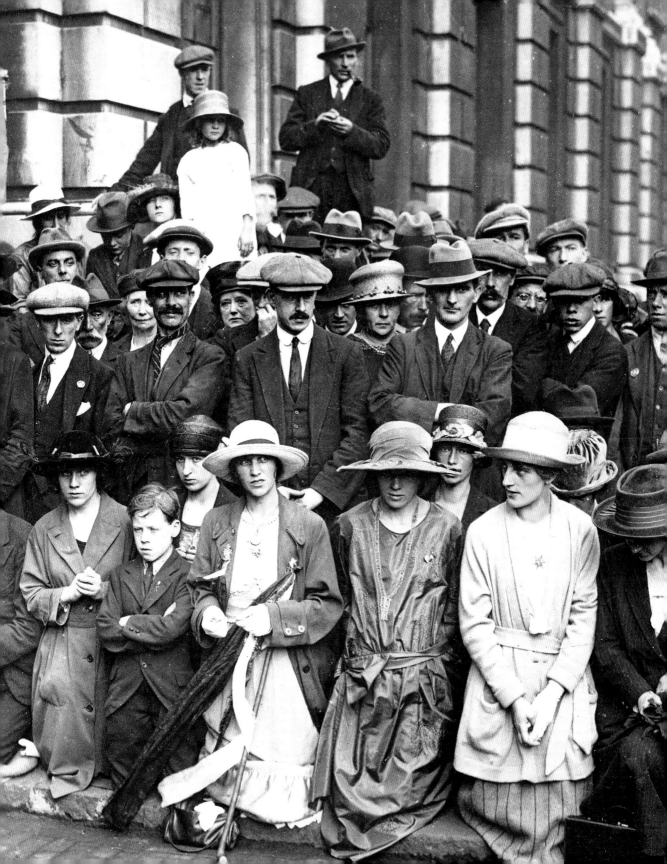

SHAMROCK PAVILION

1939, New York

In April 1939 the New York World's Fair opened in Flushing Meadow with the theme of 'a new world of tomorrow'. Ireland's section was designed by architect Michael Scott and was known as the 'Shamrock Pavilion'. Scott went for a modern architectural showcase with art, history and commerce all integrated. Limerick-born Sean Keating was commissioned to paint a mural for the pavilion, and this photograph shows him supervising the fifty-four painted panels telling the story of a new industrial Ireland, with the Ardnacrusha hydroelectric power plant occupying an enormous 22m stretch of the building.

CUTTING THE CAKE

12 September 1953, USA

Jacqueline Lee Bouvier and John F. Kennedy were married on 12 September 1953, in St Mary's Roman Catholic Church in Newport, Rhode Island. Jackie wore a dress of 'ivory tissue silk, with a portrait neckline, fitted bodice, and a bouffant skirt embellished with bands of more than fifty yards of flounces'. The cake, pictured here, was over four feet tall. There were 800 guests at the ceremony and over 1,200 at the reception at Hammersmith Farm. JFK's ancestors came from Cavan, Clare, Cork, Fermanagh, Limerick and Wexford.

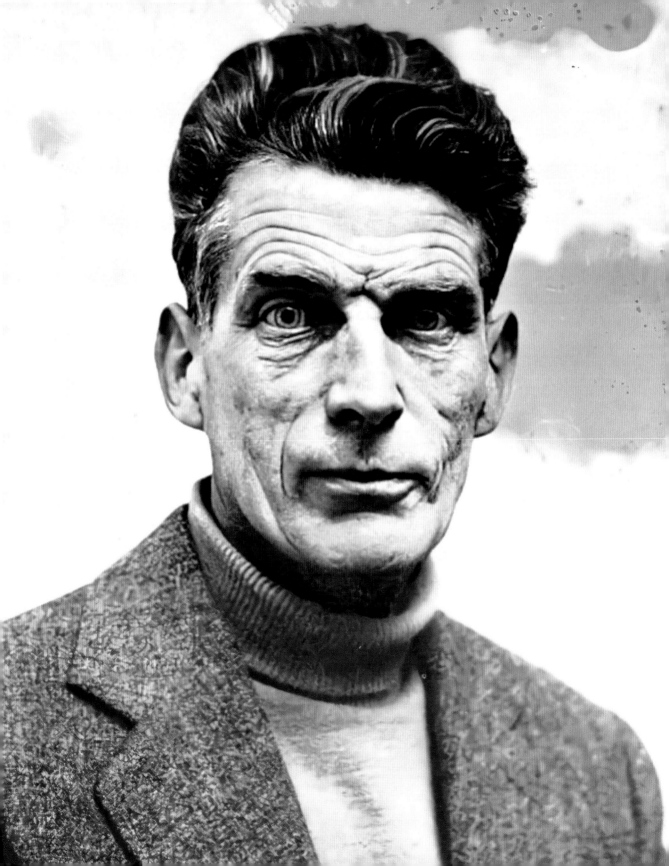

WAITING FOR BECKETT

*c.*1964, France

Samuel Barclay Beckett, born in Foxrock in 1906, was an Irish novelist, playwright, short story writer, theatre director, poet and literary translator. He lived in Paris for most of his adult life and worked with the Resistance during the Second World War. In the late 1940s he wrote his most famous work, *Waiting for Godot*. In 1969 he was awarded the Nobel Prize for Literature. He died in December 1989.

ST PATRICK'S DAY

1950, New York City

Two girls, Dorothy Belaski (left) of Ozone Park, Queens, and Patricia Caserta of Brooklyn, hold 'Erin Go Bragh' banners while waiting for the St Patrick's Day Parade in New York City. By 1762, the Irish presence in America was already so strong that the first official St Patrick's Day Parade was held in the city. Since then, it has not been without friction – factions of the Irish community boycotted the parade completely during the Irish Civil War. 'A Long Way to Tipperary' was even banned on the parade route as it was seen to represent a recruiting tool for British soldiers during the First World War. In 1948, Harry Truman became the first president to visit the parade, and one year later, it was broadcast on TV for the first time.

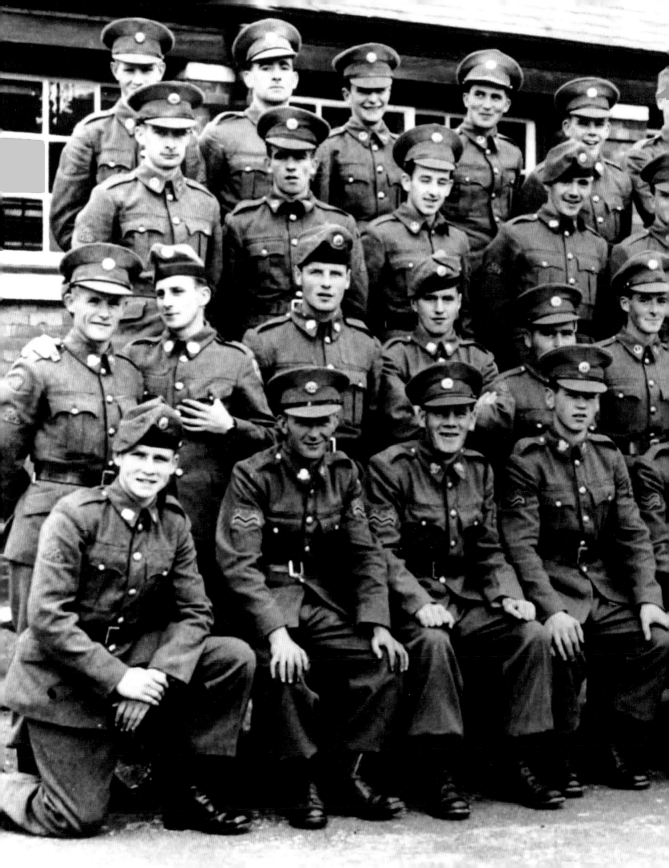

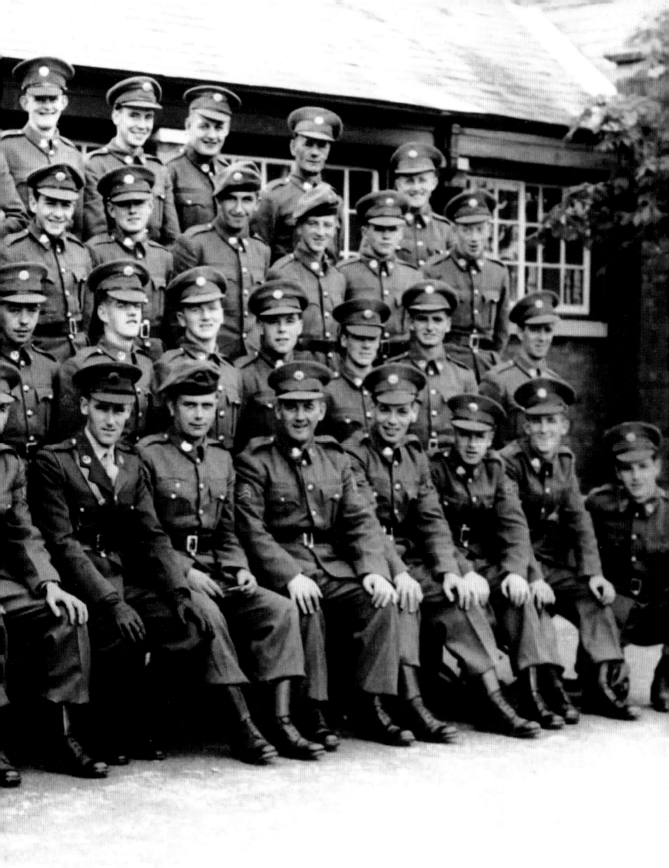

BOUND FOR AFRICA

1960, The Curragh, Co. Kildare

Lieutenant Kevin Gleeson's platoon before deployment in the Congo. In 1960 the Irish Defence Forces began four years of service as part of the United Nations Operation in the Congo. Between 1960 and 1964, over 6,000 Irishmen served there. During this operation twenty-six Irish soldiers lost their lives, nine of whom were killed during the Niemba Ambush on 8 November 1960, when a patrol led by Gleeson was attacked by members of the Luba people.

WHEN BRENDAN MET JACKIE

1960, New York

Brendan Behan, born in Dublin in 1923, is one of Ireland's best-known writers, particularly noted for his satire and powerful political commentary. Behan landed in New York for the Broadway premiere of *The Hostage* in September 1960 holding a bottle of milk and telling reporters he was on the wagon. The play was a hit and, other than Behan taking to the stage drunk at the Cort Theatre, the trip was a success. He is pictured here with legendary American actor and comedian Jackie Gleason in Gleason's dressing room at his show *Take Me Along*.

"LOW-BACK CAR" OR WHEEL-CAR, ROSTREVOR, CO. DOWN. R.W. 1756.

SCENIC IRELAND

ROSTREVOR

1914, Rostrevor, Co. Down

Two men pass the time beside an Irish 'low-back car', in the village of Rostrevor, which lies at the foot of Slieve Martin on the coast road between Newcastle and Newry. In the nineteenth century it became a popular seaside resort and Messrs Norton & Shaw, who operated a horse-and-carriage transport business from the nearby railhead at Warrenpoint, commissioned a new hotel, which can be seen at the far end of the street. Completed in April 1876, it was originally named The Mourne Hotel and was later renamed the Great Northern Hotel. There was a skating-rink attached to the hotel which had been built by the 3rd Earl of Kilmorey and had a capacity of 2,000 but tragically burned down in 1903. The hotel was firebombed and destroyed during the Troubles in 1978.

IRELAND'S EARLIEST PHOTOGRAPH?

1843, Dublin

Located in Hardwicke Place, Temple Street, St George's Church was built between 1802 and 1813 by the architect Francis Johnston. With its graceful 200-foot spire, it is one of his finest works. The church was photographed by William Henry Fox Talbot, who revolutionised photography with his calotype negatives. This is one of his earliest images. The design of the church followed a trend at the time to have a congregation in the round – so instead of the usual long nave leading up to an altar, its longest side is its width. After years of unsuccessfully trying to raise funds for the restoration, the Church of Ireland sold St George's in 1991.

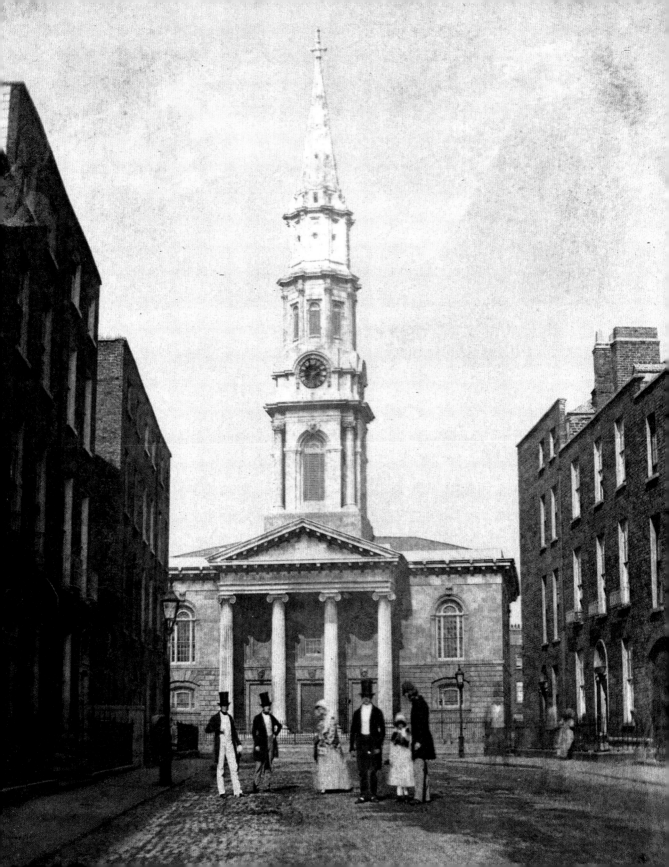

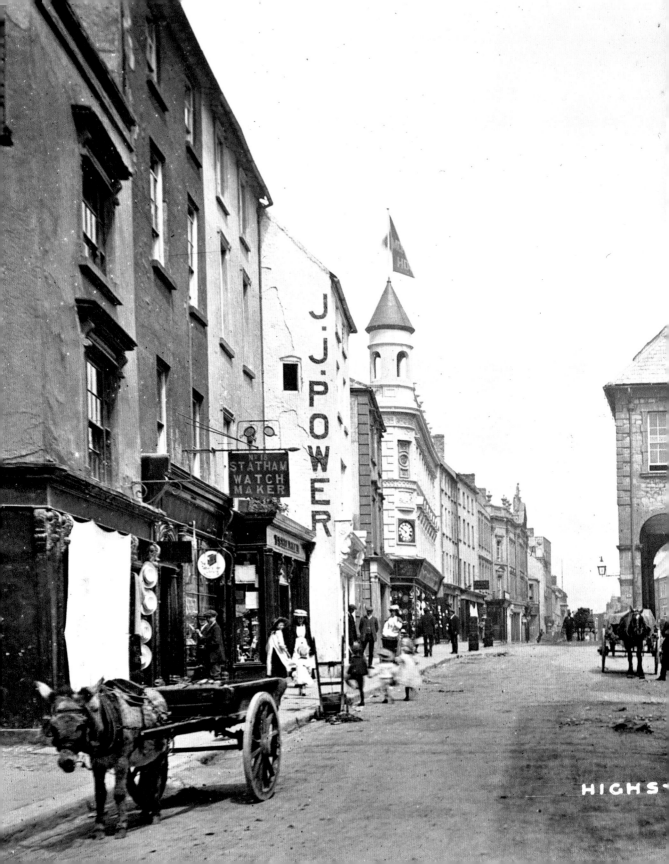

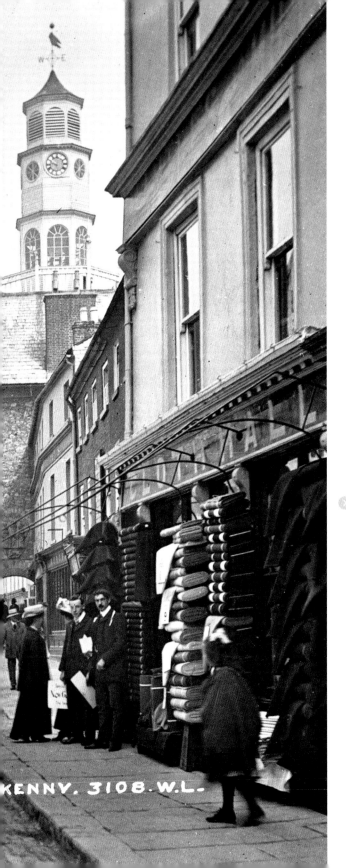

KENNY. 3108. W.L.

HIGH STREET

*c.*1872–1914, Kilkenny

Kilkenny's history can be traced to the foundation of the sixth-century church built in honour of St Canice, now St Canice's Cathedral. The city received its charter in 1609. High Street was referred to as Tholsel Street by Kilkenny Corporation in 1730 but is marked High Street on Rocque's map of 1758 and the Ordnance Survey map of the town from 1841. Statham's Watch Maker is still there today as O'Connor's jewellers; the name changed when the original owner's great-nephew took over.

DOON WELL

*c.*1860–1883, Kilmacrenan, Co. Donegal

Doon Well's significance, like many holy wells in Ireland, may have started in pre-Christian times, but it was apparently blessed in the fifteenth century by Lector O'Friel. Holy wells were known for their curative properties and were often visited on 'pattern' days or at particular times of the day. They were believed to cure mental illness, eye disease, toothache and barrenness, as well as protecting children and keeping away plagues and epidemics.

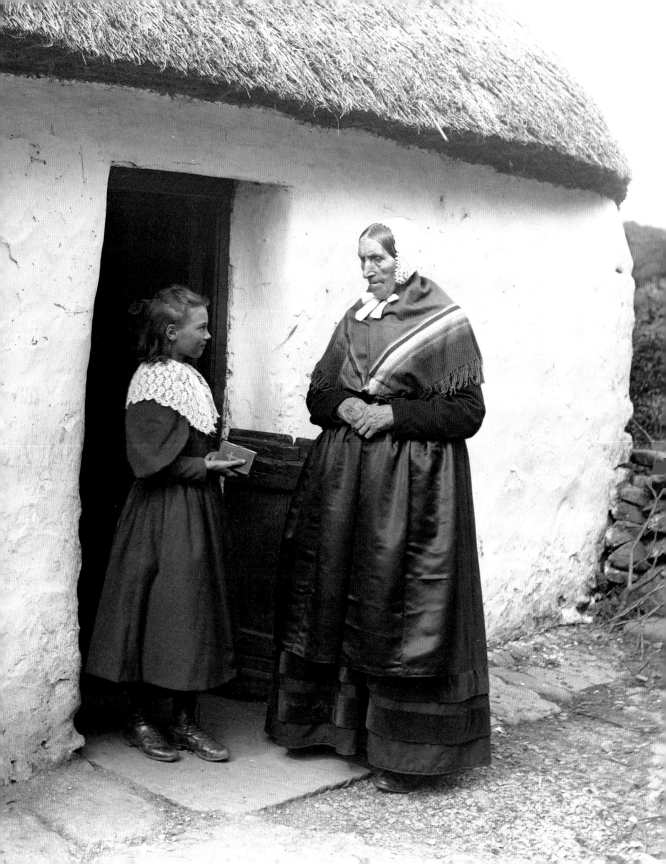

FIRST COMMUNION

*c.*1890s, Waterford

This image depicts Kitty Merryman with a young girl who is celebrating her First Holy Communion. Historian Cara Delay notes how at this time, with the separation of girls and boys in the Church, Communion was a very feminised event, involving the girls' female relatives and friends, and no cost was spared to dress the girls appropriately.

THE STREETS OF ATHENRY

*c.*1880–1900, Co. Galway

Athenry is Ireland's best-preserved medieval town, with over 70 per cent of the town walls still standing, as well as an Anglo-Norman castle, a ruined Dominican Priory and a rare late medieval market cross. The town has been made famous by Pete St John's 1970s ballad, 'The Fields of Athenry'. It tells the story of Michael, a fictional man from Athenry, who is sentenced to exile in Botany Bay for stealing food for his starving family during the Great Famine, and in recent years has been adopted as an unofficial anthem by Irish rugby fans and sung the world over.

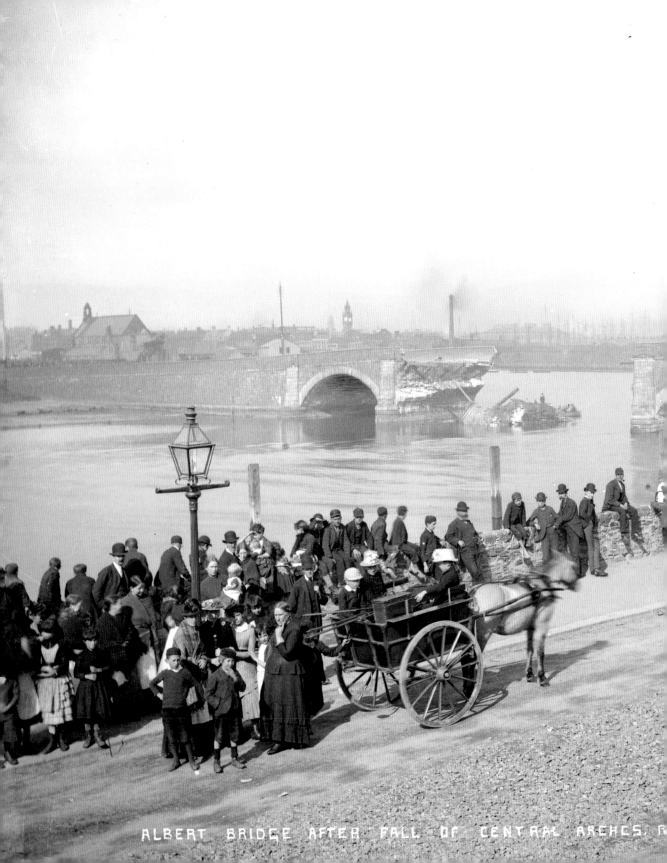

ALBERT BRIDGE AFTER FALL OF CENTRAL ARCHES.

THE FALL OF THE CENTRAL ARCHES

16 September 1886, Belfast

This photo depicts the Albert Bridge the day after two of the original five arches collapsed. The incident resulted in one death, and a temporary wooden bridge was erected until the completion of the new bridge. The current cast-iron bridge was designed by J.C. Bretland, the Borough Surveyor of Belfast at the time, and was constructed by Messrs Henry of Belfast at a cost of £36,500. It was opened in 1890 and named after Queen Victoria's grandson, Prince Albert Victor, who laid a foundation stone in 1889.

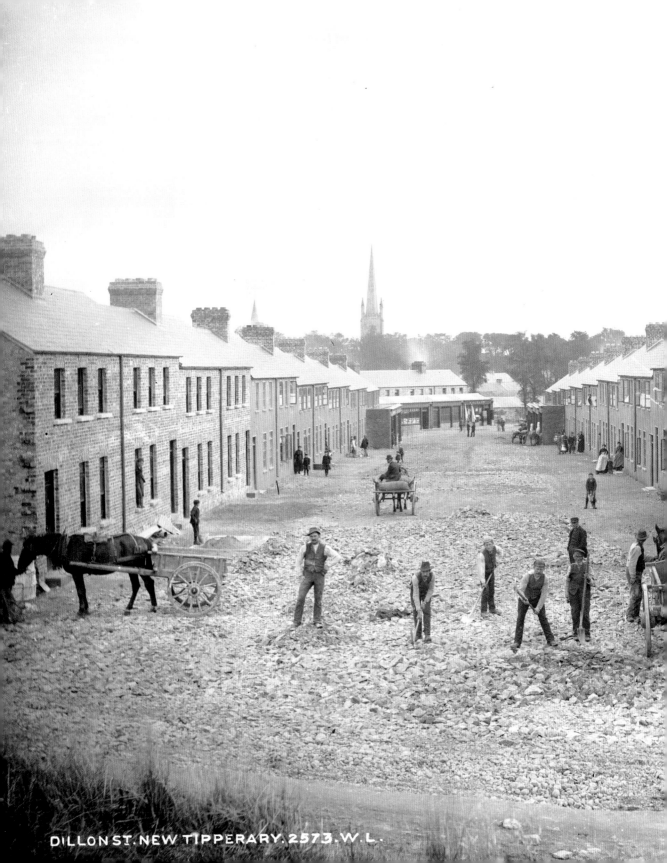

DILLON ST. NEW TIPPERARY. 2573. W.L.

NEW TIPPERARY

*c.*1890, Dillon Street, Co. Tipperary

In the late 1880s, tenants of the Smith Barry estate in Tipperary and Cork withheld their rent. After the Tipperary tenants were evicted, a local cooperative, funded in large part from the USA and Australia, began to build them a new town in what is now the area around Dillon and Emmet Streets. The *Catholic Telegraph* reported on 22 May that when officials arrived to open the new suburb, there were 'flags and mottoes which decorated the walls, and hearty cheers from men, women and children'.

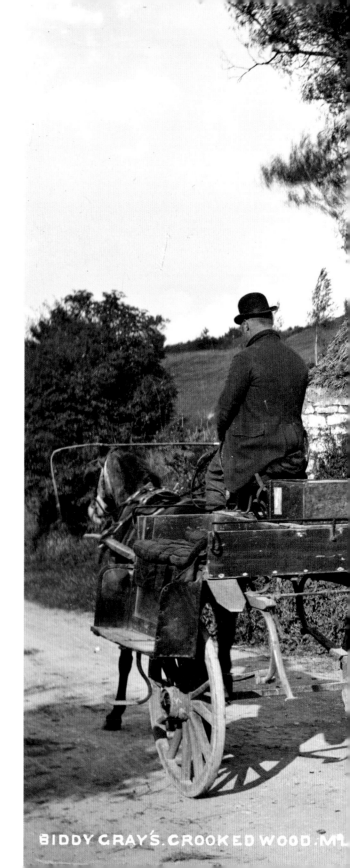

BIDDY GRAY'S CROOKED WOOD

*c.*1890, Mullingar, Co. Westmeath

A typically rural Irish scene at the end of the nineteenth century. We can see the children's clothing is slightly torn, but the woman is wearing boots and the thatch cottage appears to be in good condition.

BIDDY GRAY'S. CROOKED WOOD. M1

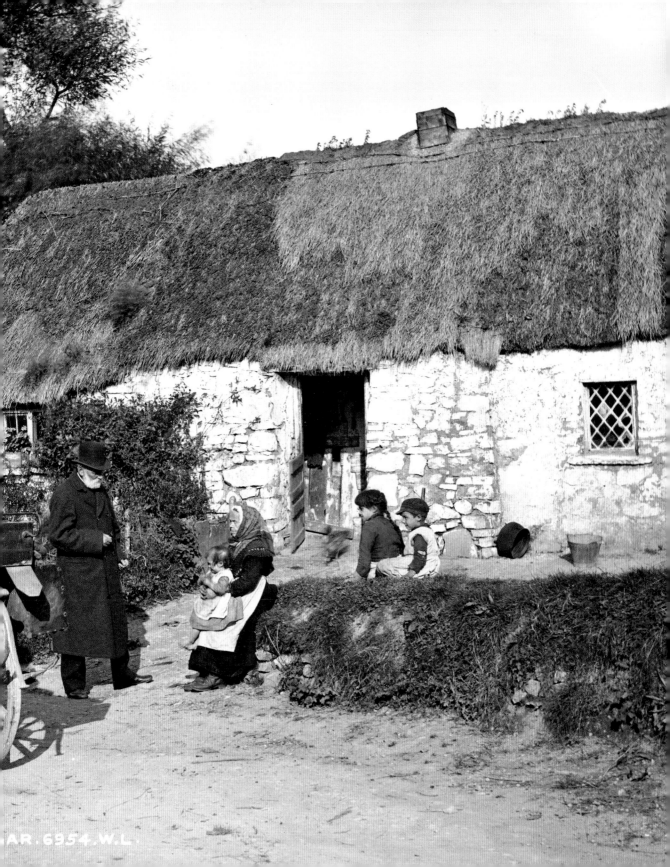

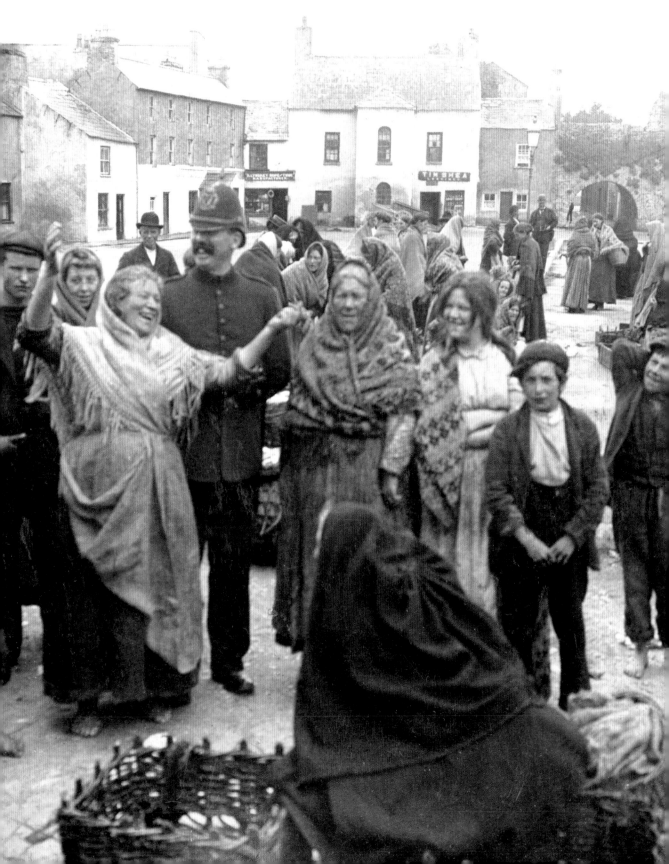

JOVIAL IN THE MARKETPLACE

*c.*1900, Spanish Arch, Galway

This image from the Breslin Archive shows a busy town scene – with fish hawkers from the Claddagh, children and even a local policeman. It appears as if the woman to the left is singing or reciting something. The Spanish Arch, an extension of the twelfth-century Norman town wall and visible in the background to the right, was built in 1584 as a measure to protect the city's quays and the 'Fish Market'. In 1755, it was partially destroyed by a tsunami caused by an earthquake off the coast of Portugal.

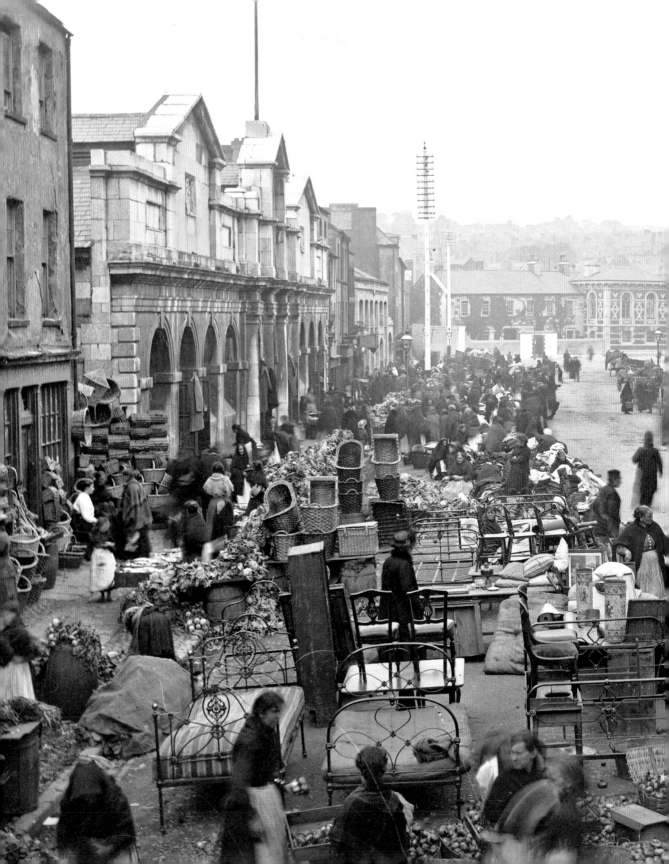

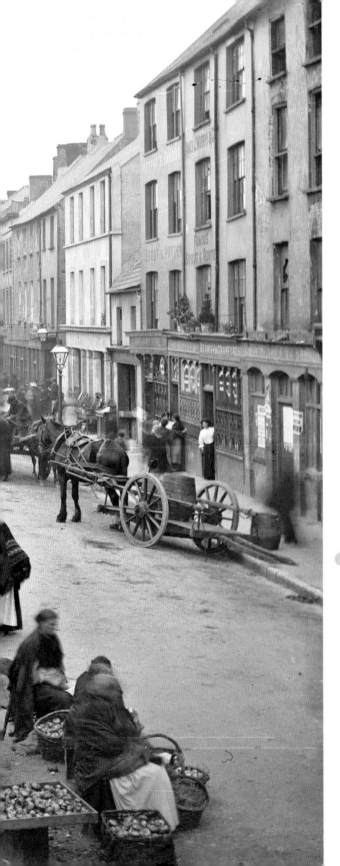

PADDY'S MARKET

*c.*1890–1900, Cork

The first municipal corn market was constructed in 1719 overlooking a square that was located on a filled-in portion of a channel (est. *c.*1695) of the River Lee. Unfortunately, the name of this square is not recorded, but it was located on what is now Corn Market Street. Over the centuries, the square grew to be the traditional central market area of the city, known locally at this time as Paddy's Market. It would have been thronged with dealers and customers, purchasing anything from a needle to an anchor. Several stalls still operate here today.

HOLY WELL

1901, Lough Gill, Co. Sligo

In this image of a holy well in Lough Gill, we can see a man standing at the edge of the wellspring poised to drink from a cup, and a woman, kneeling, peering down into the well, with the stone shrine altar in the background. The therapeutic properties of holy wells were well known.

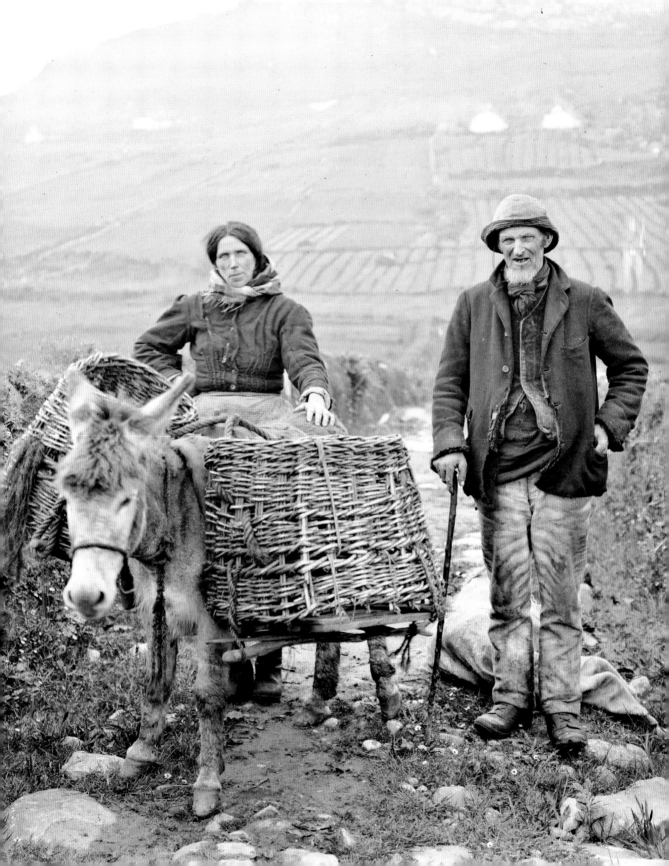

THE GLENS OF ANTRIM

*c.*1900–1920

The Glens of Antrim cover some 80km of shoreline and feature a varied environment of grasslands, forests, peat bogs and mountain uplands. The Antrim Coast Road, built in the 1830s, stretches for nearly 160km and boasts some spectacular scenery. There are nine glens in all: Glentaisie, Glendun, Glenshesk, Glencorp, Glenaan, Glenballyemon, Glenarm, Glencloy and Glenariff. This image shows a couple collecting seaweed with a 'Long saddle' instead of a cart, with the near basket turned upside down.

BALLYVAUGHAN

*c.*1880–1900, Co. Clare

For a period in the nineteenth century, Ballyvaughan was the official capital of north-west Clare, with its own workhouse, coastguard station and a large police barracks. Fishing was an important part of its economy. In 1841, the census recorded a population of 235 people living in thirty-one houses. While the development of a more sophisticated road network decreased its importance as a fishing port, today the piers are used mainly for pleasure craft and for charters to Galway or the islands. McNamara's Hotel, which we can see in this image, is featured in many nineteenth-century guidebooks and the street remains quite similar in its appearance today.

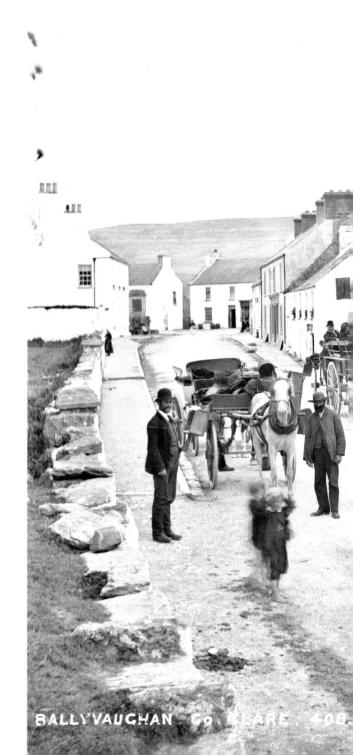

BALLYVAUGHAN Co. CLARE. 408

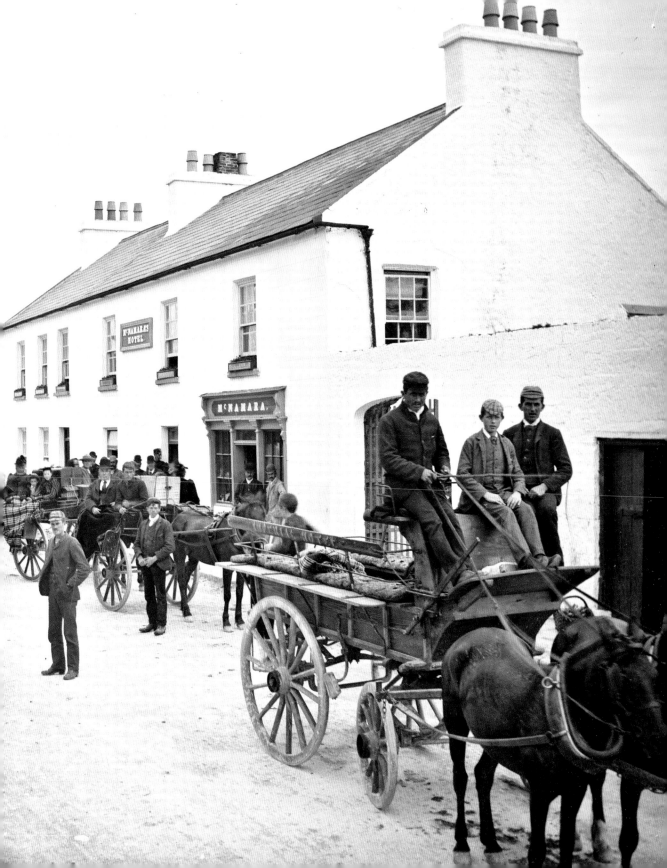

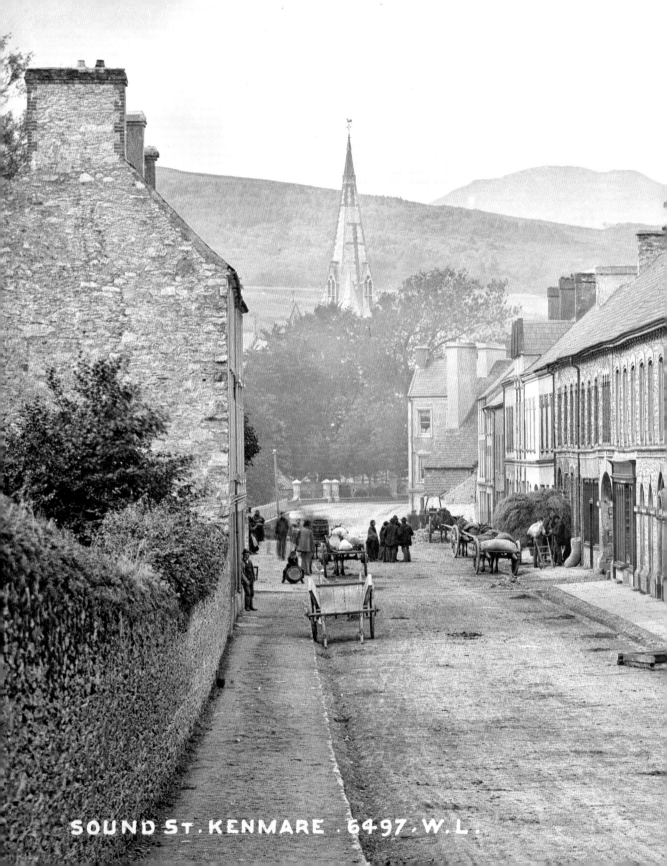

SOUND St. KENMARE . 6497 . W. L .

SOUND STREET

*c.*1865–1914, Kenmare, Co. Kerry

This portrays a streetscape image of what is now Henry Street. The entire area was gifted to Sir William Petty by Oliver Cromwell in the seventeenth century. The town was designed around three main streets which form a triangle – Main Street (formerly William Street), Henry Street and Shelbourne Street. It served as a market town, has one of the Carnegie libraries and is known for a number of key incidents during the War of Independence. Today, it is a popular tourist town.

ARMAGH

*c.*1905, English Street, Armagh

Armagh county has played a critical part in Ireland's history, from its association with St Patrick, and its invasion by the Vikings in the ninth century, to the impact of the Tudor conquest in the sixteenth century. Armagh City is the ecclesiastical capital of Ireland, the seat of the Archbishops of Armagh, the Primates of All Ireland for both the Roman Catholic Church and the Church of Ireland. Sadly, the lovely post office on the right of the picture is no longer standing. Businesses visible include Orr's Drug Stores, the Armagh Guardian offices and the City Medical Hall and there is a poster calling for volunteers to the Royal Regiment of Artillery.

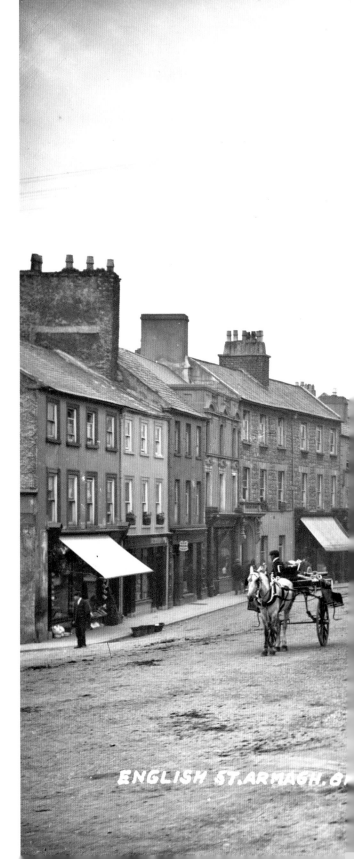

ENGLISH ST. ARMAGH. 6

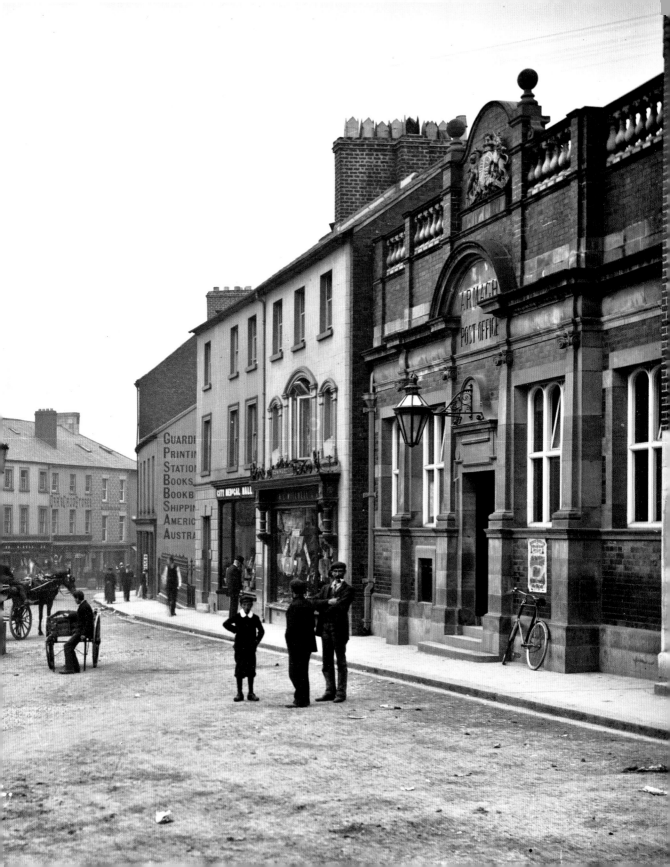

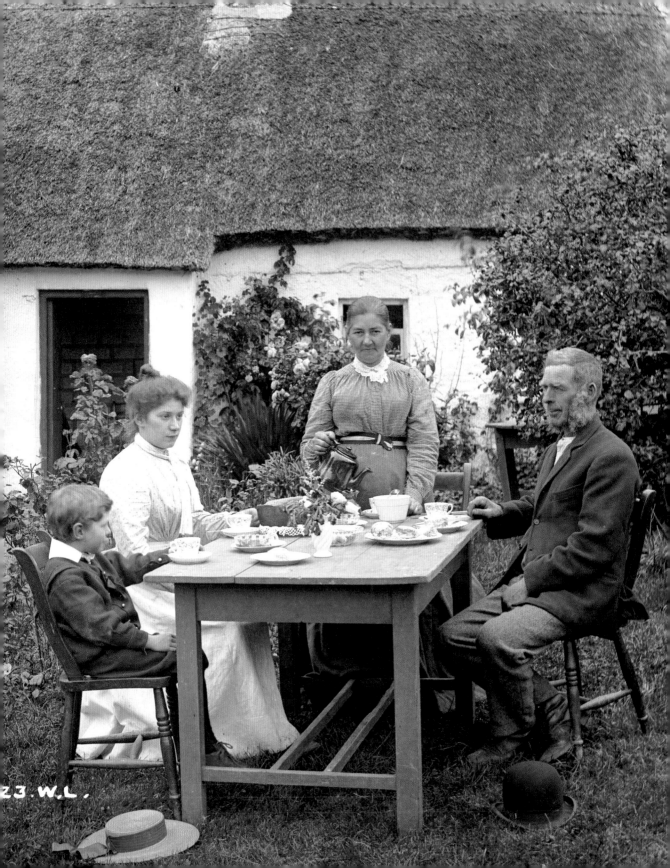
23.W.L.

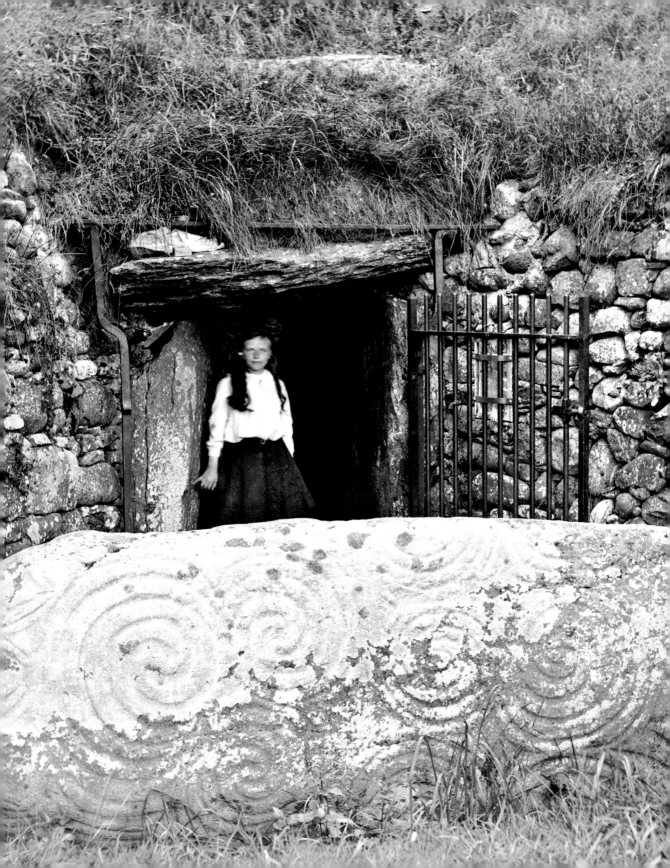

TEATIME

*c.*1900, Glencar, Co. Leitrim

A staged image of a family at a tea house eating scones and drinking tea. Although labelled Sligo on the glass negative, this image is from Co. Leitrim. It has been suggested that this is Margaret Jane Sibbery, her husband Robert, and two of their children from Largadoon, Glencar. Afternoon tea was a nineteenth-century phenomenon that emerged in England, and the popularity of tea in Ireland had grown exponentially from the eighteenth century.

NEWGRANGE

*c.*1900 to 1910, Donore, Co. Meath

Ireland's most famous passage tomb, Newgrange dates to *c.*3,200 BC. The mound is approximately 80m in diameter and is surrounded by a kerb of ninety-seven stones. The most impressive is the highly decorated Entrance Stone, seen here. The site, which is famous for the penetration of the sun's rays at dawn during the winter solstice, has a long tradition of being one of Ireland's leading tourist attractions.

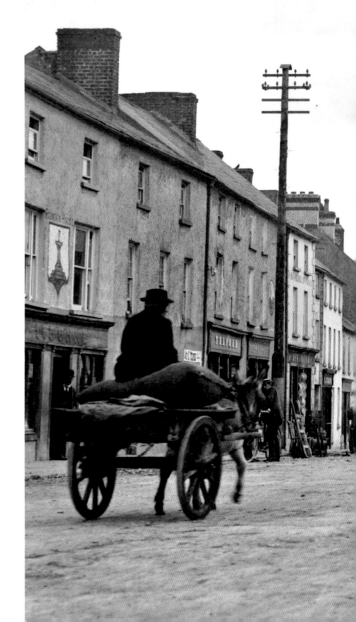

MAIN STREET

March 1912, Mountrath, Co. Laois

A quiet day on the main street of Mountrath. At the beginning of the seventeenth century, the lands around Mountrath became the property of Charles Coote, and it was the Coote family who built the market house on the right of the image in the eighteenth century. It was demolished in 1964. An entry to the National Folklore Collection's Schools' Collection states: 'The people who lived in Mountrath long ago were mostly Protestants and no Catholic could take possession of a business house there. Nearly all the buildings are three storeys high.'

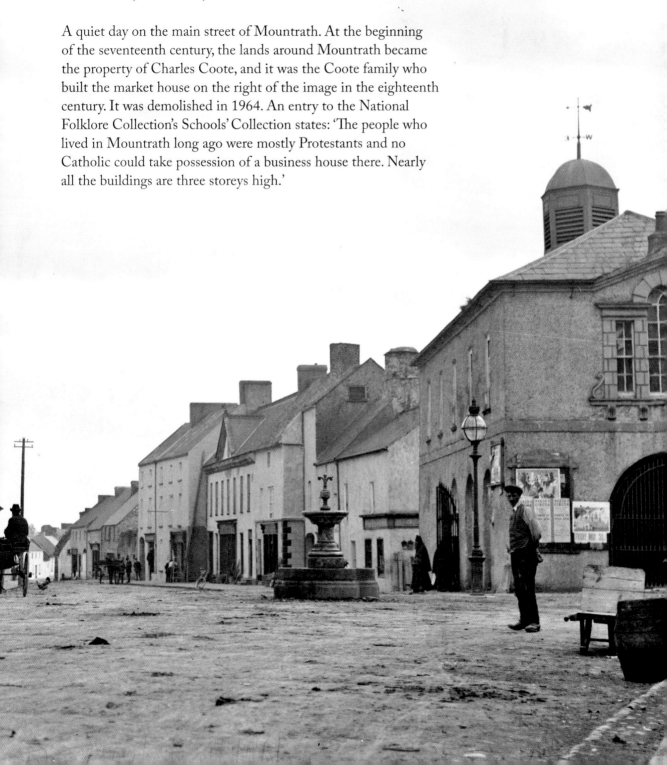

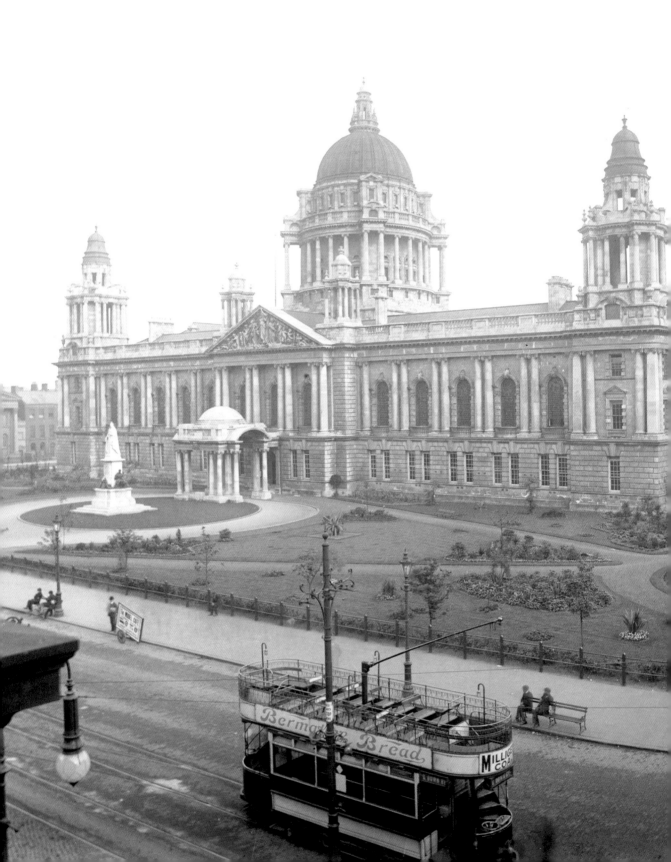

BELFAST CITY HALL

*c.*1910

Belfast City Hall sits on the site of the previous White Linen Hall and was designed by Sir Alfred Brumwell Thomas. It opened on 1 August 1906 and cost £369,000 to construct. It features towers at each of the four corners, with a lantern-crowned 173ft green copper dome in the centre. F.W. Pomeroy, helped by local carver J. Edgar Winter, created the pediment sculpture, which shows Hibernia with, among others, symbolic figures highlighting Belfast's trade and industry. The roof above the Banqueting Hall was destroyed during the Belfast Blitz on the night of 4/5 May 1941 and had to be rebuilt.

HALL. BELFAST. 2386, W.L.

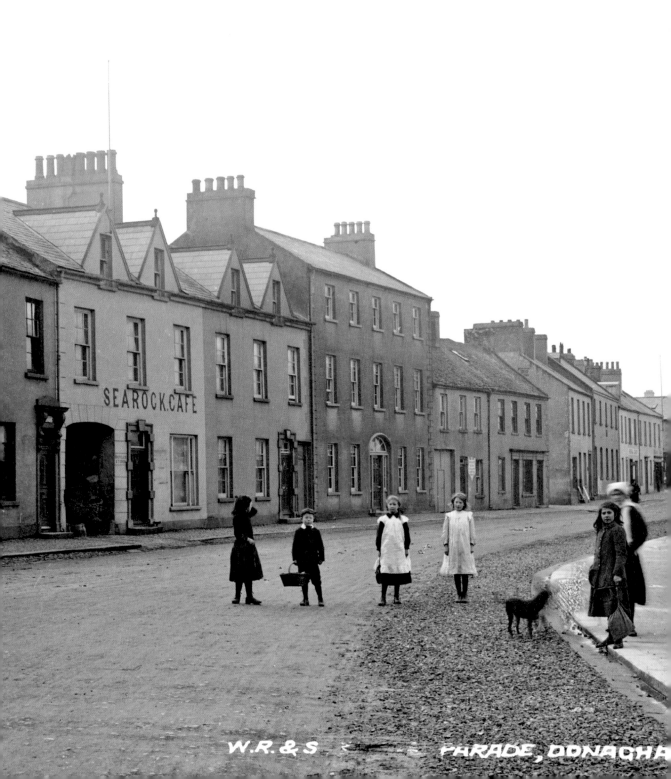

SEAROCK.CAFE

W.R.&S. PARADE, DONAGHA

THE PARADE

1913–1916, Donaghadee, Co. Down

A group of children and younger people at Donaghadee Parade. The children are dressed in clothing associated with middle-class children at the time including sailor suits and pinafores. Donaghadee was used in the eighteenth and nineteenth centuries by couples going to Portpatrick in Scotland to marry. It was also one of the sites of the 1798 Rebellion. In 1910, the lifeboat station was founded and famously, on 31 January 1953, crew rescued thirty-two survivors from the stricken Larne–Stranraer car ferry, MV *Princess Victoria*.

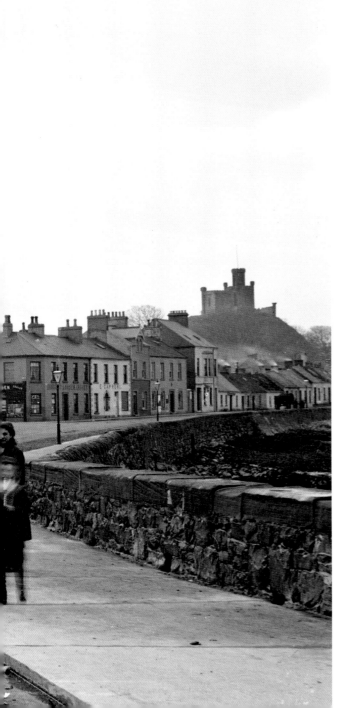

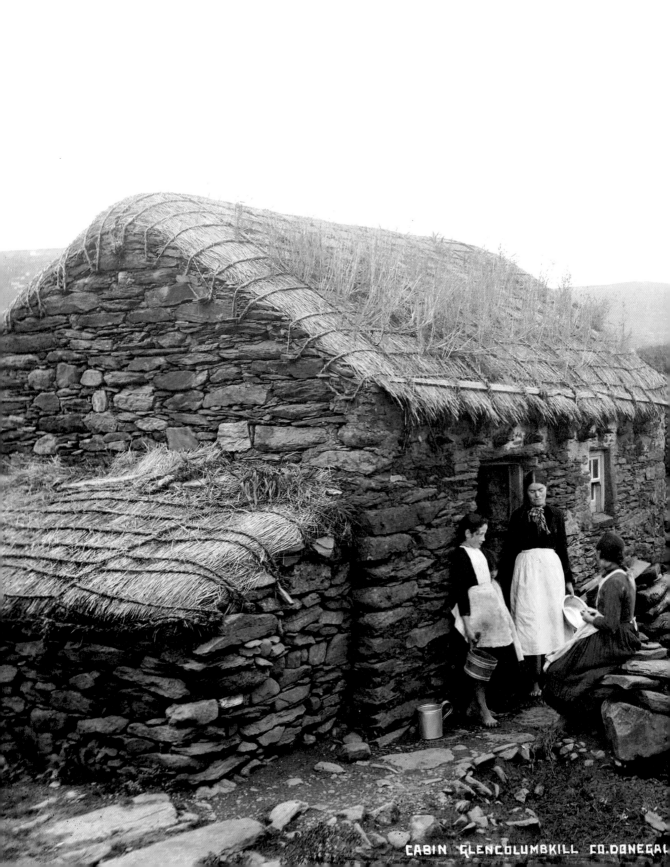

CABIN GLENCOLUMBKILL CO.DONEGAL

GLENCOLUMBKILL

*c.*1914, Donegal

The history of Glencolmcille (Glencolumbkill) spans 5,000 years, with evidence of Stone Age settlers still apparent in the Court Cairns. In 1729, the Church of the Spaniard in Faugher (*Cill an Spainnigh*) was built after a shipwrecked Spanish sailor being given the Last Rites by the local priest gave him some gold coins and asked him to build a church. There are still examples of surviving thatched cottages, like the one in this image, which were built of local stone and whitewashed. Particular to this area was the rounded roof – the thatch was held down by a network of ropes placed over it and fastened beneath the eaves and on the gables.

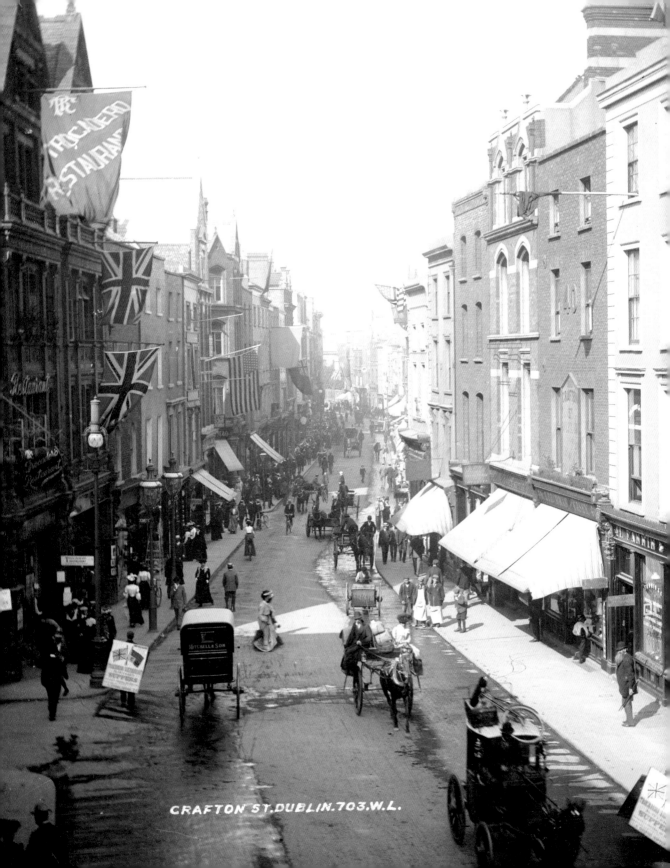

GRAFTON ST. DUBLIN. 703. W.L.

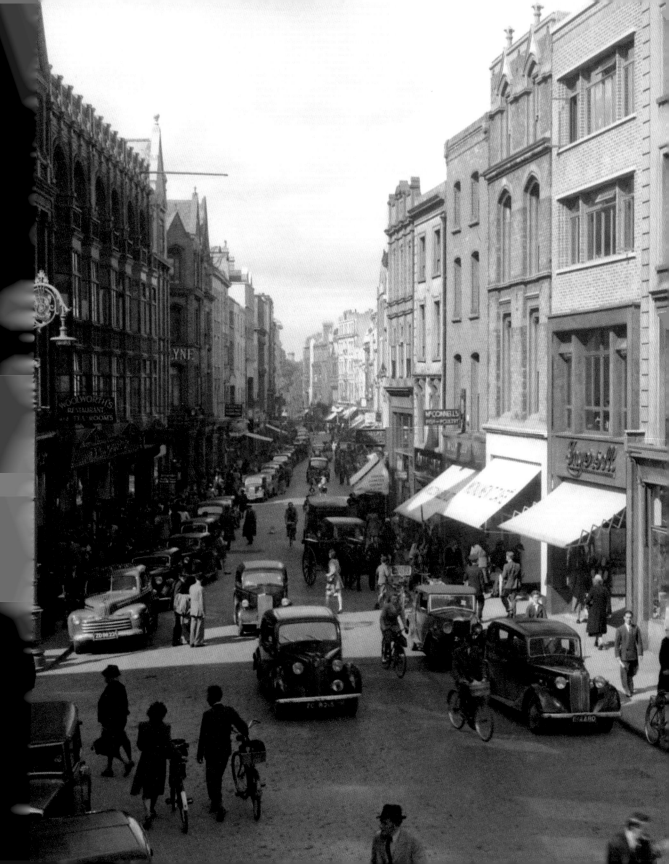

GRAFTON STREET

*c.*1880–1890, and *c.*1947, Dublin

Grafton Street began as a laneway connecting College Green to St Stephen's Green before its expansion in the eighteenth century. It was named after Charles FitzRoy, second Duke of Grafton and the illegitimate grandson of King Charles II. In the latter part of the nineteenth century, the street was primarily commercial, but from the 1860s it was also increasingly known for prostitution. Hodges Figgis was the first bookshop, established at 104 Grafton Street in 1797 before moving to Dawson Street in 1920. Bewley's Oriental Café opened in 1927 and has remained a feature of the street treasured by many.

SOUTH SIDE OF SHAFTESBURY SQUARE

12 July 1923, Belfast, Co. Antrim

Shaftesbury Square is at the southern end of Great Victoria Street and the Dublin road. The area is commonly known as the Golden Mile. This image was taken on 'the Twelfth' – an annual commemoration on 12 July involving the Orange Order and Loyalist marching bands that celebrates the victory of William of Orange over James II at the Battle of the Boyne in 1690. In this image we can see a number of Orange lodge banners, which we have colourised accordingly.

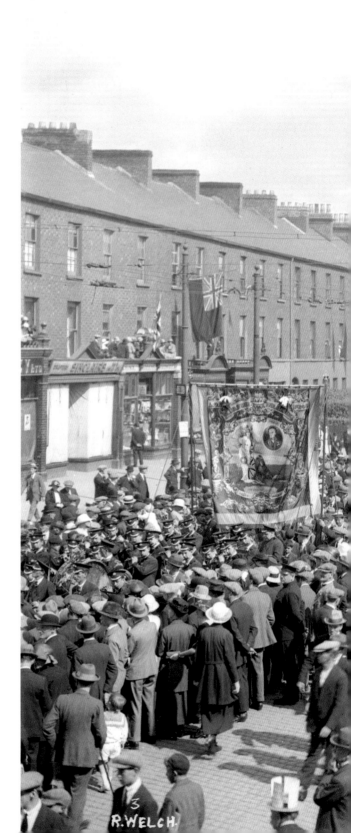

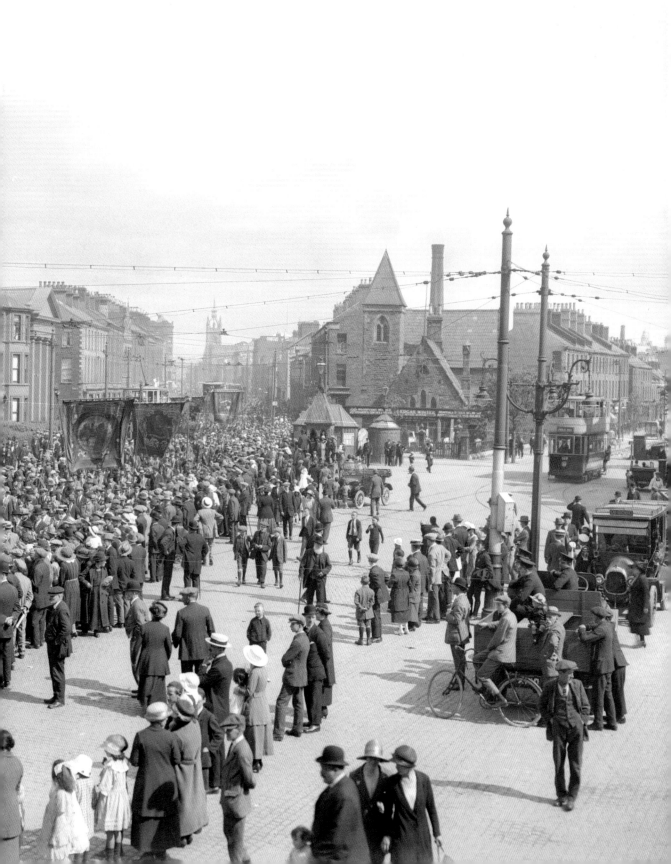

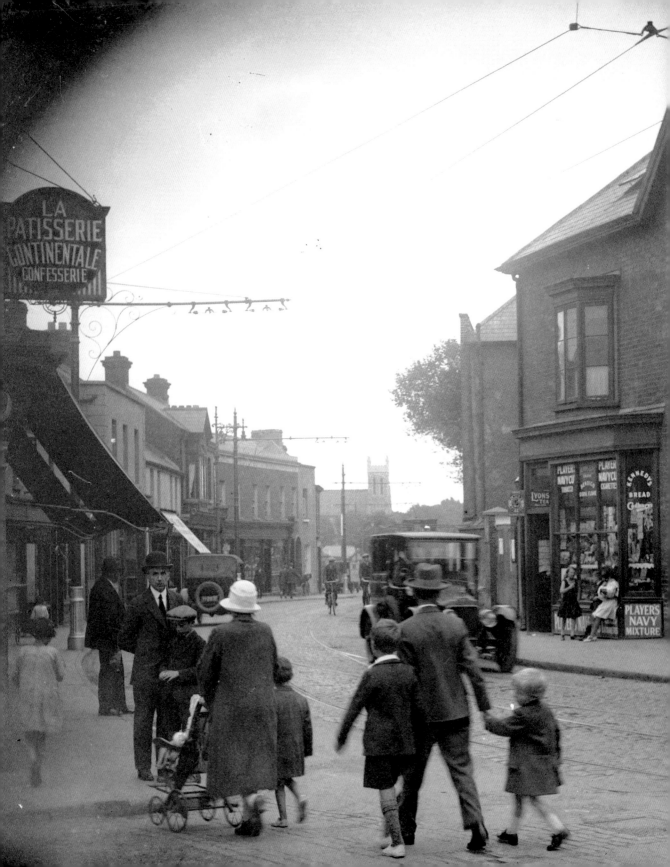

DONNYBROOK

1927, Donnybrook Road, Dublin

La Patisserie Continentale Confesserie [*sic*] is at number 30 Donnybrook Road, across from John McCaffrey (greengrocers) at number 39. We colourised the Players and Lyons Tea signs according to photographs of similar signs from that time period. The image was dated after eagle-eyed users on the NLI's flickr spotted the headline 'Religious War in Mexico', which was the front page of *The Irish Times* on 15 August. Donnybrook Fair famously ran from 1205 to 1855, but in the latter years fell into disrepute due to drunkenness and brawling. Today, the studios of the national television and radio stations (RTÉ) are located in the Dublin 4 district.

ONE MAN AND HIS DOG

*c.*1905, Wicklow Hills, Co. Wicklow

The ivy-covered Dargle Bridge near Enniskerry. *Notes on Travel* by Underwood and Underwood recorded 'the beauty of this deep, wooded glen is famous through all parts of Ireland. The stream that comes racing and tumbling and dancing along under the bridge is hurrying to carry to the sea … the rainfall from the Wicklow mountains.'

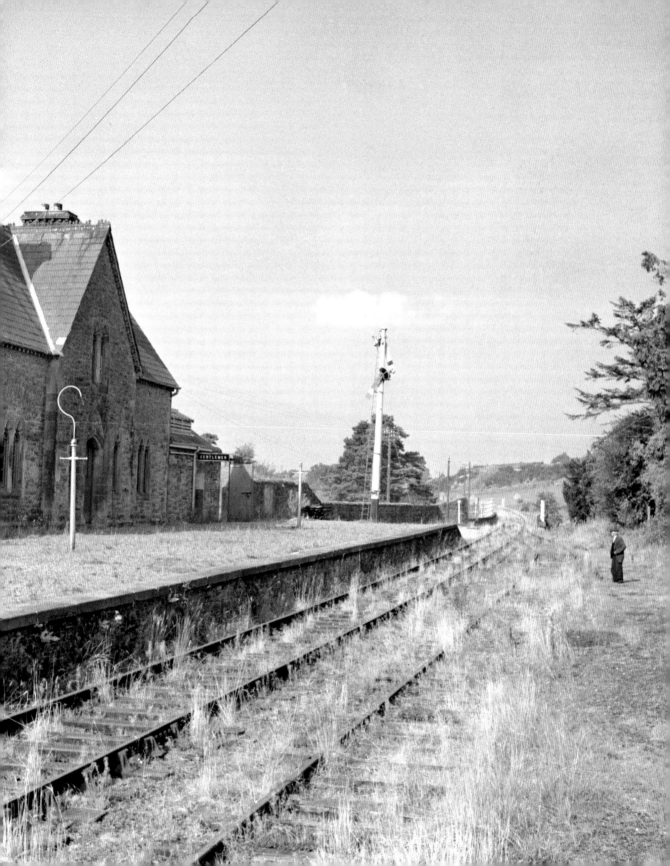

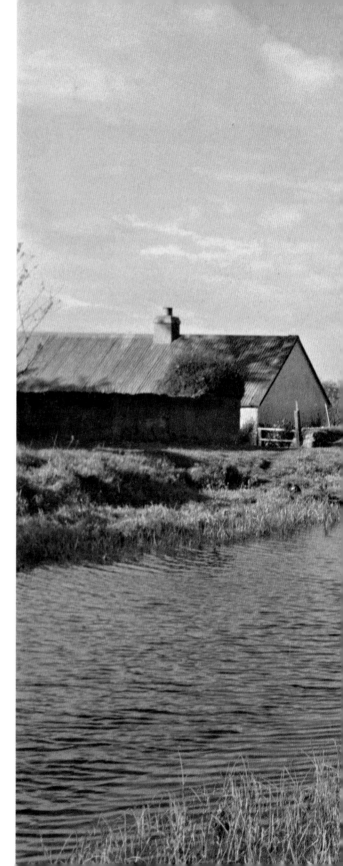

WAITING FOR THE TRAIN THAT WILL NEVER COME

1 September 1959, Lisbellaw,
Co. Fermanagh

This image was taken nearly a year after the closure of the train station at Lisbellaw on 1 October 1958. The station was designed by William Murray (1822–1871), who planned stations for the Dundalk, Enniskillen & Londonderry Railway Company. Nothing remains today, as the line was paved over for part of the A4 road. The station was on the Dundalk to Enniskillen line, which went on to Derry. It was one of a number of stations that were closed in the late 1950s after the policy of railway nationalisation was abandoned.

WHO PAYS THE FERRYMAN?

23 October 1961, Royal Canal, Downs,
Co. Westmeath

The Royal Canal was originally built for freight and passenger transportation from Dublin to Longford. This photograph was taken in the year of its closure. One-third of the canal runs through Co. Westmeath and although there were forty-five locks along its length, it was often easier for locals to use their own methods of getting across, as seen here.

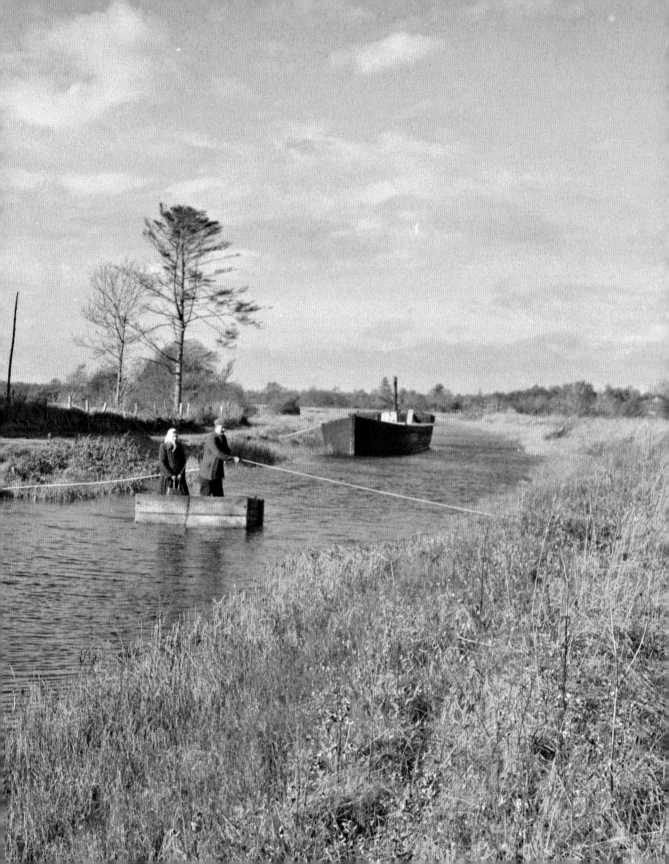

Photographic and Archival Collections

For this book, we have tried to use either public domain or Creative Commons photos as much as possible. There are some fantastic national photographic collections available in Ireland, particularly the National Library of Ireland, who have given us generous access to their photographic collections. Similarly, we are very grateful to The Board of Trinity College Dublin, Clonduff GAC, the Cork Public Museum, Dublin City Library and Archive, the GAA Museum, the *Irish Examiner*, the Irish Photo Archive, Kieran Campbell, *The Mayo News*, the Military Archives, the National Museum of Ireland, NUI Galway Library Archives, the Royal Society of Antiquaries of Ireland, RTÉ Archives, and University College Cork.

We have also chosen images from a range of archives and collections in Northern Ireland and abroad. Thanks in particular to Gallica Bibliothèque Nationale de France, Getty Images, the Getty Museum, the Internet Archive, the Library of Congress, the LIFE Picture Collection at Shutterstock, the London School of Economics Library, the National Digital Archive of Poland, National Museums of Northern Ireland, the National Portrait Gallery of Australia, the Netherlands Institute for Military History, New York Public Library, the Public Record Office of Northern Ireland, and Wikimedia Commons, all of which have many wonderful photographs of Ireland and the Irish abroad.

We have chosen photographs from key collections, such as the Poole Collection, the R.J. Welch Collection, the Lawrence Collection, the Keogh Collection, the Hogan Collection, and the Elinor Wiltshire Collection. We have used works from both professional and amateur photographers, such as Joseph Cashman, James Simonton, Frederick Holland Mares, James H. Tuke, William D. Hogan, Harry Tempest, Kieran J. Campbell, Thomas Wynne, Robert Stawell Ball, Eva Chichester, Alexander Campbell Morgan, Fergus O'Connor, James P. O'Dea, George Pickow, Frank Hurley, Frederick Hollyer, Lewis Wickes Hine, Al Raveena, William Henry Fox Talbot, Alfred Capel-Cure and Andrew Charles, amongst others who have been credited overleaf.

The Robert J. Welch Photographic Collection

> 'Few books or articles published in the first half of this century (twentieth century) … were without photographic illustrations from R.J. Welch.'
>
> E. Estyn Evans and Brian S. Turner, *Ireland's Eye: The Photographs of Robert John Welch*

The Robert J. Welch photographic collection, held in the National Museum of Northern Ireland, consists of glass negatives, original prints, lantern slides, original photographic albums and published series of views. Dating from *c*.1880 to *c*.1935, it contains material of topographical, scientific, anthropological, archaeological, transport and industrial interest, covering the whole of Ireland, with particular emphasis on the north and west. In addition to the photographical material, the museum holds Welch's diaries and field notes, and also his annotated maps. Welch was born in Strabane, Co. Tyrone, on 22 July 1859, the second son of David Welch, a Presbyterian shirt manufacturer. His mother was Martha Welch, previously Martha Graham. David became interested in photography and took it up professionally in 1863. After his father's death in 1875, the Welch

family moved to 49 Lonsdale Street, Belfast, where Welch would live for sixty years. He set up his own business in 1883.

A.H. Poole Collection, National Library of Ireland.

The family firm of A.H. Poole operated as commercial photographers in Waterford from 1884–1954. This large collection of glass plates contains studio portraits of people from Waterford and reflects the social and economic life of the city. In addition to Waterford City and county, there are photographs from Wexford, Kilkenny and Cork, as well as individualised postcards for local business firms and other institutions.

The Lawrence Collection

On 20 March 1865, William Mervin Lawrence opened a photographic studio opposite the GPO in Sackville Street, Dublin. In 1880, he employed Robert French as his chief photographer, and he is responsible for over 30,000 photographs in the Lawrence Collection.

The Keogh Photographic Collection

The Keogh Collection comprises a range of political and social images from the 1916 Rising, the 1917 elections and the Irish Civil War. In particular, it contains a large number of portraits of personalities, and images recording key groups and buildings – from Liberty Hall to the funeral of Jeremiah O'Donovan Rossa and key events like the sitting of the Second Dáil – used in this volume.

The Hogan Collection

William D. Hogan was a commercial and press photographer located in Henry Street in Dublin from 1920 and 1935. It is likely that Hogan took the 160 photographs in the National Library of Ireland Collection under contract. The 5" x 7" black and white photographs show life in early June and July 1922 in Dublin during the early Civil War period, with armed and uniformed men on the streets.

The Wiltshire Collection

The Wiltshire Collection, of 1,000 negatives and 300 prints, spans a twenty-year period from 1951. They were taken by Elinor Wiltshire of the Green Studios in Dublin. The bulk of the images feature Dublin, providing a view of life in the capital during that period. Wiltshire used a Rolleiflex camera held at waist level looking down at the 6cm-square screen rather than directly at the subjects, resulting in more natural compositions. She was a celebrated photographer, botanist and artist, who adopted digital photography in her 80s.

The Breslin Archive

John Breslin created the Breslin Archive in 2019 to digitally preserve analogue photographs of Ireland from the late nineteenth and early twentieth centuries. It includes a collection that is believed to be the work of the famed Poole Studio of Waterford: this consists of nearly 100 glass plates taken during the 1890s to 1900s of people across different classes, stately homes, houses, fishing ports and landscapes, mainly around Co. Waterford; some of these photographs are featured in this book. The Breslin Archive has also acquired some thousands of negatives and prints of Ireland and the Irish, to be digitised in the future.

Photographer and Source

Cover images
SUBLICHS; Photographer: Elinor Wiltshire; Source: National Library of Ireland Ref.: WIL 13[54]. **BALLYVAUGHAN**; Photographer: Robert French; Source: National Library of Ireland; Ref.: L_ROY_04085.

Opening credits
MR WYNNE; Photographer: Thomas Wynne; Source: National Library of Ireland; Ref.: WYN1. **EUCHARISTIC CONGRESS**; Photographer: Poole Studio; Source: National Library of Ireland; Ref.: POOLEWP 3922. **KILKENNY HURLER**; Photographer: WD Hogan; Source: National Library of Ireland; Ref.: HOG94. **ALL CREATURES GREAT AND SMALL**; Photographer: Fáilte Ireland; Source: Dublin City Library and Archive; Ref.: vital:17400. **'THE IRISH WOMEN DEMAND THE VOTE'**; Photographer: Unknown; Source: LSE Library; Ref.: TWL.2002.588. **CATHERINE 'KITTY' KIERNAN (1893–1945)**; Photographer: Unknown; Source: Wikimedia Commons; Ref.: Kitty_Kiernan.jpg.

Politics and Revolution
A 1798 REBEL; Photographer: Unknown; Source: Wikimedia Commons; Ref.: Miles_Byrne,_Irish_patriot_1798.jpg. **THOMAS MEAGHER (1823–1867)**; Photographer: Unknown; Source: Library of Congress; Ref.: 2018667494. **JOHN MITCHEL (CENTRE) WITH JOHN MARTIN AND FATHER JOHN KENYON (DETAIL)**; Photographer: Edouard Gatel; Source: National Portrait Gallery, Australia; Ref.: 2016.16. **JEREMIAH O'DONOVAN ROSSA (1831–1915)**; Photographer: Unknown; Source: NYPL; Ref.: b11848378. **JOHN DEVOY (1848–1928)**; Photographer: Unknown; Source: National Library of Ireland; Ref.: NPA JDEV13. **THE INVINCIBLES**; Photographer: Unknown; Source: National Library of Ireland and Wikimedia Commons; Ref.: NPA INV15, NPA INV21, NPA INV24 and Lord_Frederick_Charles_Cavendish_-_Politiker.jpg. **CARDINAL PAUL CULLEN (1803–1878)**; Photographer: Unknown; Source: UCC. **ANTI-HOME RULE RALLY**; Photographer: Bain News Service; Source: Library of Congress; Ref.: 2014694494. **THE 1913 DUBLIN PEACE CONFERENCE**; Photographer: Keogh Brothers; Source: National Library of Ireland; Ref.: KE_205. **FUNERAL OF O'DONOVAN ROSSA**; Photographer: Keogh Brothers; Source: National Library of Ireland; Ref.: Ke 234. **WOMEN OF THE REVOLUTION**; Photographer: Unknown; Source: National Museum of Ireland; Ref.: HE-EW-2970-016. **PEAKY POLITICIANS**; Photographer: Joseph Cashman; Source: RTÉ Archives; Ref.: 0506/077. **TERENCE MacSWINEY (1879–1920)**; Photographer: Unknown; Source: Cork Public Museum; Ref.: 1945.81 D3.1. **JOURNEY'S END**; Photographer: Unknown; Source: Cork Public Museum; Ref.: 1945.83 D3.1. **THE BURNING OF CORK**; Photographer: WD Hogan; Source: National Library of Ireland; Ref.: HOGW 100. **IN SOLIDARITY**; Photographer: Joseph Cashman; Source: RTÉ Archives; Ref.: 0504/040. **THE CAIRO GANG**; Photographer: Unknown; Source: Wikimedia Commons; Ref.: Cairo_gang.jpg. **CHARGE!**; Photographer: Agence Rol; Source: Gallica BnF; Ref.: ark:/12148/btv1b53052384p. **ARMED RIC MEN IN CORK CITY**; Photographer: WD Hogan; Source: National Library of Ireland; Ref.: HOGW 52. **THE SECOND DÁIL ÉIREANN**; Photographer: Keogh Brothers; Source: National Library of Ireland; Ref.: KE 119. **TAKING OVER THE BARRACKS**; Photographer: WD Hogan; Source: National Library of Ireland; Ref.: HOGW 54. **'THE BIG FELLA'**; Photographer: London News Agency Photos Ltd; Source: National Library of Ireland; Ref.: NPA CIVP6. **THE BURNING OF THE FOUR COURTS**; Photographer: Joseph Cashman; Source: RTÉ Archives; Ref.: 0504/068. **FERMOY BARRACKS**; Photographer: Unknown; Source: the Breslin Archive; Ref.: 00353CNG-CAFEB032-D. **COMRADES IN ARMS**; Photographer: WD Hogan; Source: National Library of Ireland; Ref.: HOG216. **PRISONER UNDER ESCORT**; Photographer: WD Hogan; Source: National Library of Ireland; Ref.: HOG106. **LARKIN**; Photographer: Joseph Cashman; Source: RTÉ Archives; Ref.: 0511/017. **MARCH OF THE CARDINALS**; Photographer: Eason & Son; Source: National Library of Ireland; Ref.: EAS_4001. **BLUESHIRTS**; Photographer: Koncern Ilustrowany Kurier Codzienny; Source: National Digital Archive, Poland; Ref.: 1-E-8155. **ST ULTAN'S HOSPITAL**; Photographer: Unknown; Source: The Board of Trinity College Dublin; Ref.: TCD MS 7534/139. **IRISH REPUBLIC DECLARED**; Photographer: Unknown; Source: Military Archives; Ref.: MA_061_090. **THE REPUBLIC CELEBRATES**; Photographer: Larry Burrows; Source: LIFE Picture Collection; Ref.: 12141566a.

Childhood and Youth
MASTER O'BRIEN; Photographer: Poole Studio; Source: National Library of Ireland; Ref.: POOLEWP 2226b. **FAMILY PORTRAIT**; Photographer: Andrew Charles; Source: Getty Museum Open Content; Ref.: 84.XD.1157.378. **AFTER THE GREAT FAMINE**; Photographer: Alfred Capel-Cure; Source: Getty Museum Open Content; Ref.: 84.XO.1142.2. **GAP GIRLS**; Photographer: Unknown; Source: National Library of Ireland; Ref.: STP_2852 and STP_2857. **ST ANNE'S**; Photographer: Unknown; Source: National Library of Ireland; Ref.: ALB116 Page 5. **THE O'HALLORAN SISTERS**; Photographer: Unknown; Source: National Library of Ireland; Ref.: EB_2664. **THE CONGESTED DISTRICTS BOARD**; Photographer: Major Ruttledge-Fair; Source: National Library of Ireland; Ref.: TUKE37. **DRESSING UP**; Photographer: Poole Studio; Source: the Breslin Archive; Ref.: 00178GNG-PLELP050-D. **THE TREATY STONE**; Photographer: American Stereoscopic Company; Source: Library of Congress; Ref.: 2004668178. **ADD AND SUBTRACT**; Photographer: Poole Studio; Source: National Library of Ireland; Ref.: POOLEWP 0950. **LIFE'S A BEACH**; Photographer: Harry Tempest; Source: National Library of Ireland; Ref.: TEM 43. **BLEEDING STATUES**; Photographer: WD Hogan; Source: National Library of Ireland; Ref.: HOG183. **PRAYING FOR THE LORD MAYOR OF CORK**; Photographer: Agence Rol; Source: Gallica BnF; Ref.: ark:/12148/btv1b53051682k. **THE DOLL'S HOSPITAL**; Photographer: Poole Studio; Source: National Library of Ireland; Ref.: P_WP_3171. **THE BIG SNOW**; Photographer: Kieran J Campbell; Source: Kieran Campbell, geograph.ie; Ref.: 1039046. **THROUGH THE GENERATIONS**; Photographer: Fáilte Ireland; Source: Dublin City Library and Archive; Ref.: vital:19270. **OFF TO THE HORSE FAIR**; Photographer: Elinor Wiltshire; Source: National Library of Ireland; Ref.: WIL m12[54].

Working Life
DRIVER JOE; Photographer: James P O'Dea; Source: National Library of Ireland; Ref.: ODEA 18/1. **LEVIATHAN**; Photographer: Robert French; Source: National Library of Ireland; Ref.: L_ROY_03237. **PIG STRIKE**; Photographer: Poole Studio; Source: National Library of Ireland; Ref.: POOLEWP 0770. **COCKLE PICKERS**; Photographer: Poole Studio; Source: the Breslin Archive; Ref.: 00179GNG-PLELP051-D and 00181GNG-PLELP053-D. **SAILORS IN THE CLADDAGH**; Photographer: Robert French; Source: National Library of Ireland; Ref.: L_CAB_06184. **DOHERTY'S SHOP**; Photographer: Poole Studio; Source: the Breslin Archive; Ref.: 00164GNG-PLELP036-D. **SILENCE IS REQUESTED!**; Photographer: Robert French; Source: National Library of Ireland; Ref.: NPA NLIRR1. **FISH HAWKERS**; Photographer: Robert Welch; Source: NMNI; Ref.: BELUM.Y.W.05.03.17. **BAZAAR**; Photographer: Robert French; Source: National Library of Ireland; Ref.: L_ROY_06742. **TRAIN CRASH**; Photographer: Unknown; Source: Dublin City Library and Archive; Ref.: vital:24566. **PEGGY IS EARNING WHAT PADDY IS BURNING**; Photographer: Unknown; Source: Getty Museum Open Content; Ref.: 84.XC.979.10931. **WALING SPUDS**; Photographer: Robert Welch; Source: NMNI; Ref.: BELUM.Y.W.01.51.6. **FISHING SHOOT**; Photographer: Robert French; Source: National Library of Ireland; Ref.: L_ROY_01409. **BUILDING FASTNET LIGHTHOUSE**; Photographer: Robert Stawell Ball; Source: National Library of Ireland; Ref.: NPA CIL136. **CUTTING AND CARTING TURF**; Photographer: Underwood & Underwood; Source: Library of Congress; Ref.: 00651061. **NURSING IN ARRANMORE**; Photographer: Robert Welch; Source: National Library of Ireland; Ref.: CDB55. **THE POST IS HERE**; Photographer: Eva Chichester; Source: PRONI; Ref.: D4563_1_7_9~Postman~A. **OUTSIDE FLYNN AND YOUNG'S**; Photographer: Poole Studio; Source: National Library of Ireland; Ref.: POOLEWP 0520. **HARLAND & WOLFF**; Photographer: Robert Welch; Source: Wikimedia Commons; Ref.: Harland & Wolff drawing room 1.jpg. **FAIR DAY**; Photographer: Robert French; Source: National Library of Ireland; Ref.: L_ROY_09763. **CATTLE FAIR**; Photographer: Robert French; Source: National Library of Ireland; Ref.: L_CAB_06803. **THE RMS OLYMPIC**; Photographer: Robert Welch; Source: Wikimedia Commons; Ref.: Olympic_rudder_before_launch.jpg. **THE *JOHN STEVENS* CREW**; Photographer: Poole Studio; Source: National Library of Ireland; Ref.: WP2537. **SWEET TREATS**; Photographer: Poole Studio; Source: National Library of Ireland; Ref.: POOLEWP 2679. **ALCOCK AND BROWN**; Photographer: Joe Cashman; Source: RTÉ Archives; Ref.: 0506/089. **'LADY LINDY'**; Photographer: Independent Newspapers; Source: National Library of Ireland; Ref.: INDH2848. **SUGAR BEET FACTORY**; Photographer: Capuchin Order; Source: Wikimedia Commons; Ref.: Carlow Beet Factory 1935.jpg. **BULLOCK AT ARAN**; Photographer: Independent Newspapers; Source: National Library of Ireland; Ref.: INDH3344. **AER LINGUS BLESSING**;

Photographer: Alexander Campbell Morgan; Source: National Library of Ireland; Ref.: NPA MOR102.

Sport and Leisure
'FIDDLER'; Photographer: James Simonton or Frederick Holland Mares; Source: National Library of Ireland; Ref.: STP_1391. **COUNTRYMAN**; Photographer: James Simonton or Frederick Holland Mares; Source: National Library of Ireland; Ref.: STP_1402. **SALMON TAKE**; Photographer: Robert French; Source: National Library of Ireland; Ref.: L_CAB_04876. **ON THE HURL**; Photographer: Unknown; Source: RSAI; Ref.: BOX4_078. **SALOON**; Photographer: Robert French; Source: National Library of Ireland; Ref.: L_CAB_05513. **A BICYCLE MADE FOR THREE**; Photographer: Poole Studio; Source: National Library of Ireland; Ref.: POOLEWP 0792. **THE PICKPOCKETS' HARVEST**; Photographer: Robert Welch; Source: NMNI; Ref.: BELUM.Y.W.10.36.15. **BLOODY SUNDAY**; Photographer: Unknown; Source: GAA Museum and Archive, Croke Park. **DAN BREEN**; Photographer: Joseph Cashman; Source: RTÉ Archives; Ref.: 0506/056. **MISS HOOKEY AND HER CAMOGIE TEAM**; Photographer: Poole Studio; Source: National Library of Ireland; Ref.: POOLEWP 2627. **HANDBALL ALLEY**; Photographer: Poole Studio; Source: National Library of Ireland; Ref.: POOLEWP 3810. **CAPTAIN GEORGE**; Photographer: Unknown; Source: the Breslin Archive; Ref.:00081CNG-BROTN036-D. **MAYO ALL-IRELAND SENIOR FOOTBALL TEAM**; Photographer: Unknown; Source: Mayo News. **CHRISTY RING**; Photographer: Unknown; Source: Irish Examiner; Ref.: 742046210. **PLACE YOUR BETS!**; Photographer: George Pickow; Source: NUI Galway Library Archives; Ref.: p110405. **FIRST BLOOMSDAY**; Photographer: Elinor Wiltshire; Source: National Library of Ireland; Ref.: WIL pk12[3]. **THE BIG CLASH**; Photographer: Unknown; Source: Irish Photo Archive; Ref.: 906-A2373.jpg. **UP DOWN!**; Photographer: Unknown; Source: Clonduff GAC.

The Irish and the World
A MAN OF ENDURANCE; Photographer: Frank Hurley; Source: Wikimedia Commons; Ref.: Tom_Crean2b.JPG. **THE WORLD'S FIRST FEMALE MEDICAL PHYSICIST**; Photographer: Unknown; Source: Wikimedia Commons; Ref.: Edith_Anne_Stoney.jpg. **PRESIDENT BIDEN'S IRISH ANCESTORS**; Photographer: Unknown; Source: Internet Archive; Ref.: urn:oclc:record:1051751515. **ABSOLUTE KELVIN**; Photographer: Unknown; Source: Wellcome Collection; Ref.: 15322i. **NANNIE FLORENCE DRYHURST (1865–1930)**; Photographer: Frederick Hollyer; Source: LSE Library; Ref.: SHAW PHOTOGRAPHS/1/12/899. **CARNEGIE**; Photographer: Poole Studio; Source: National Library of Ireland; Ref.: POOLEWP 1313. **CHILD LABOURERS**; Photographer: Lewis Wickes Hine; Source: Library of Congress; Ref.: 2018678125 and 2018678219. **JUDGE MARY O'TOOLE (1874–1954)**; Photographer: Harris & Ewing; Source: Library of Congress; Ref.: 2016855523. **MURIEL MURPHY MacSWINEY (1892–1982)**; Photographer: Unknown; Source: Library of Congress; Ref.: 2016833423. **LADY MARY HEATH (1896–1939)**; Photographer: Unknown; Source: Netherlands Institute for Military History; Ref.: 2157-092-003. **PRAYERS AT DOWNING STREET**; Photographer: WD Hogan; Source: National Library of Ireland; Ref.: HOG1. **SHAMROCK PAVILION**; Photographer: Unknown; Source: Merrion Press. **CUTTING THE CAKE**; Photographer: Toni Frissell; Source: Library of Congress; Ref.: 2015645223. **WAITING FOR BECKETT**; Photographer: Unknown; Source: Wikimedia Commons; Ref.: Franz_Kafka_(tsjechische_schrijver)_Oostenrijker_(kop),_Bestanddeelnr_916-2499.jpg. **ST PATRICK'S DAY**; Photographer: Al Ravenna; Source: Library of Congress; Ref.: 2002699201. **BOUND FOR AFRICA**; Photographer: Unknown; Source: Military Archives; Ref.: P-157-011. **WHEN BRENDAN MET JACKIE**; Photographer: Walter Albertin; Source: Wikimedia Commons; Ref.: Brendan_Behan_and_Jackie_Gleason_NYWTS.jpg.

Scenic Ireland
ROSTREVOR; Photographer: Robert Welch; Source: PRONI; Ref.: D1403_2~023~A. **IRELAND'S EARLIEST PHOTOGRAPH?**; Photographer: William Henry Fox Talbot; Source: National Science and Media Museum; Ref.: 1937-4238. **HIGH STREET**; Photographer: Robert French; Source: National Library of Ireland; Ref.: L_CAB_03108. **DOON WELL**; Photographer: James Simonton or Frederick Holland Mares; Source: National Library of Ireland; Ref.: STP_1720. **FIRST COMMUNION**; Photographer: Poole Studio; Source: the Breslin Archive; Ref.: 00176GNG-PLELP048-D. **THE STREETS OF ATHENRY**; Photographer: Robert French; Source: National Library of Ireland; Ref.: L_ROY_11299. **THE FALL OF THE CENTRAL ARCHES**; Photographer: Robert Welch; Source:

NMNI; Ref.: BELUM.Y.W.10.60.1. **NEW TIPPERARY**; Photographer: Robert French; Source: National Library of Ireland; Ref.: L_ROY_02573. **BIDDY GRAY'S CROOKED WOOD**; Photographer: Robert French; Source: National Library of Ireland; Ref.: L_CAB_06954. **JOVIAL IN THE MARKETPLACE**; Photographer: HC White; Source: the Breslin Archive. **PADDY'S MARKET**; Photographer: Robert French; Source: National Library of Ireland; Ref.: L_ROY_02677. **HOLY WELL**; Photographer: Underwood & Underwood; Source: Library of Congress; Ref.: 00651067. **THE GLENS OF ANTRIM**; Photographer: Eason & Son; Source: National Library of Ireland; Ref.: EAS_4054. **BALLYVAUGHAN**; Photographer: Robert French; Source: National Library of Ireland; Ref.: L_ROY_08125. **SOUND STREET**; Photographer: Robert French; Source: National Library of Ireland; Ref.: L_NS_07138. **ARMAGH**; Photographer: Robert French; Source: National Library of Ireland; Ref.: L_ROY_08125. **TEATIME**; Photographer: Robert French; Source: National Library of Ireland; Ref.: L_CAB_00123. **NEWGRANGE**; Photographer: Tempest Family; Source: National Library of Ireland; Ref.: TEM 129. **MAIN STREET**; Photographer: Eason & Son; Source: National Library of Ireland; Ref.: Eas 2749. **BELFAST CITY HALL**; Photographer: Robert French; Source: National Library of Ireland; Ref.: L_CAB_00123. **THE PARADE**; Photographer: Eason & Son; Source: National Library of Ireland; Ref.: EAS_1262. **GLENCOLUMBKILL**; Photographer: Robert Welch; Source: The Deputy Keeper of the Records, Public Record Office of Northern Ireland and National Museums of Northern Ireland; Ref.: D1403_2~024~A. **GRAFTON STREET**; Photographer: Robert French; Source: National Library of Ireland; Ref.: L_ROY_00703. **GRAFTON STREET**; Photographer: Valentine Studios; Source: National Library of Ireland; Ref.: VAL 1678. **SOUTH SIDE OF SHAFTESBURY SQUARE**; Photographer: Robert Welch; Source: NMNI; Ref.: BELUM.Y.W.10.29.53. **DONNYBROOK**; Photographer: Fergus O'Connor; Source: National Library of Ireland; Ref.: OCO 105. **ONE MAN AND HIS DOG**; Photographer: Underwood & Underwood; Source: Library of Congress; Ref.: 2020682298. **WAITING FOR THE TRAIN THAT WILL NEVER COME**; Photographer: James P O'Dea; Source: National Library of Ireland; Ref.: ODEA13/45. **WHO PAYS THE FERRYMAN?**; Photographer: James P O'Dea; Source: National Library of Ireland; Ref.: ODEA 28/77.

References

Barry, Michael B., *An Illustrated History of the Irish Revolution, 1916–1923* (Dublin: Andalus Press, 2020).

Bartlett, Thomas (ed.), *The Cambridge History of Ireland Volume 4: Ireland, c.1880 to the Present* (Cambridge: Cambridge University Press, 2018).

Bayne, Samuel G., *On an Irish Jaunting Car through Galway and Donegal* (1902).

Breathnach, Ciara, *The Congested Districts Board of Ireland, 1891–1923* (Dublin: Four Courts Press, 2005).

Breathnach, Ciara (ed.), *Framing the West: Images of Rural Ireland, 1891–1920* (Dublin: Irish Academic Press, 2007).

Campbell, Arthur, *Looking Back* (Belfast: Friar's Bush Press, 1989).

Carville, Justin, *Photography in Ireland* (London: Reaktion Books, 2011).

Costume: The Journal of the Costume Society, Irish Special Edition (2014).

Crowley, John, Donal Ó Drisceoil and Mike Murphy (eds), *Atlas of the Irish Revolution* (Cork: Cork University Press, 2016).

Delay, Cara, 'The First Communion Dress: Fashion, Faith and the Feminization of Catholic Ireland', *Nursing Clio*, July 2017.

Dunlevy, Mairead, *Dress in Ireland: A History* (Cork: Collins Press, 1999, 2nd edition).

Evans, E. Estyn and Brian S. Turner, *Ireland's Eye: The Photographs of Robert John Welch* (Belfast: Blackstaff Press, 1977).

Gorham, Maurice, *Ireland from Old Photographs* (London: Batsford, 1971).

Gorham, Maurice, *Dublin from Old Photographs* (London: Batsford, 1972).

Hanna, Erika, *Snapshot Stories: Visuality, Photography, and the Social History of Ireland, 1922–2000* (Oxford: Oxford University Press, 2020).

Hatfield, Mary, *Growing Up in Nineteenth-Century Ireland: A Cultural History of Middle-Class Childhood and Gender* (Oxford: Oxford University Press, 2019).

Hickey, Kieran, *The Light of Other Days: Irish Life at the Turn of the Century in the Photographs of Robert French*, (London: Allen Lane, 1973).

Jones, Mary, *The Other Ireland: The Way We Lived 1870–1920* (Gill & Macmillan, 2011).

Kelly, James (ed.), *The Cambridge History of Ireland, Volume 3: Ireland, c.1730–c.1880* (Cambridge: Cambridge University Press, 2018).

Kennedy, Tom (ed.), *Victorian Dublin* (Dublin: Albertine Kennedy with the Dublin Arts Festival, 1980).

Kissane, Noel, *Ex Camera, 1860–1960: Photographs from the Collections of the National Library of Ireland* (Dublin: National Library of Ireland, 1990).

Kinealy, Christine, Jason King and Gerard Moran (eds), *Children and the Great Hunger in Ireland* (Cork: Cork University Press, 2018).

Livingston, Helen, *Ireland: Photographic Memories* (Salisbury: Frith, 2000).

Mason, Thomas H., *The Islands of Ireland* (London: Batsford, 1936).

McGowan, Brendan and Tanya Williams, *Galway City Through Time* (Stroud: Amberley Publishing, 2013).

McMahon, Seán, O'Broin, Art & Brian Walker, *Faces of Ireland: A Photographic and Literary Picture of the Past 1875–1925* (Amaryllis Press, 1984).

Morrison, George, *An Irish Camera* (London: Pan Books, 1979).

National Library of Ireland, *Ireland 1860–80 from Stereo Photographs: Facsimile Documents* (Dublin: National Library of Ireland, 1981).

Ó Corráin, Donnchadh & Tomás O'Riordan (eds), *Ireland, 1815–1870: Emancipation, famine and religion* (Dublin: Four Courts Press, 2011).

Ó Muircheartaigh, Tomás, *An Muircheartach Grianghrafanna* (Dublin: Clódhanna Teoranta, 1970).

Ó Ruairc, Pádraig Óg, *Revolution: A Photographic History of Revolutionary Ireland 1913–1923* (Cork: Mercier Press, 2014).

O'Dowd, Anne, *Common Clothes and Clothing* (Dublin, 1990).

Schofield, Carey and Seán Sexton, *Ireland: Photographs, 1840–1930* (London: Laurence King Publishers, 1994).

Sexton and Christine Kinealy, *The Irish: A Photohistory, 1840–1940* (New York: Thames and Hudson, 2002).

Schull, Maggie, 'The Three Funerals of MacSwiney', *The Irish Times*, 24 Oct 2020.

Slattery, Peadar, 'The uses of photography in Ireland 1839–1900', unpublished PhD thesis, Trinity College Dublin, Department of History, 1992.

Van Camp, Julie C., 'Colorization Revisited', *Contemporary Aesthetics*, Vol. 2 (2004).

Walker, Brian Mercer, *Shadows on Glass: A Portfolio of Early Ulster Photographs* (Belfast: Appletree Press, 1976).

Whelan, Daire, *The Managers* (Dublin: Hachette, 2013).

Wiltshire, Elinor and Orla Fitzpatrick, *If You Ever Go To Dublin Town* (Women's History Project, 1999).

Whitmarsh, Victor, *Shadows on Glass: Galway 1895–1960* (Galway: self-published, 2003).

Websites and Databases

The National Library of Ireland

dúchas.ie

RIA Dictionary of Irish Biography Project

The Irish Times

Irish Independent

The Irish Press

The Irish Story

The New York Times

Century Ireland website

Wikimedia Commons

Central Statistics Office of Ireland

gaa.ie